PRAISE FOR *GOD ON STAGE*

"Made in his image, we have it in our DNA to be creators of worlds on the sub-level of art and specifically theater. Kreeft's insights into the art of the human drama evoke what Karol Wojtyła meant when he said, 'Outside of the drama . . . man cannot fulfill himself as a person.'"

—**John Walker**, Associate Professor of Theater, Franciscan University of Steubenville

"The world's a stage, and we are all called to play our part in the drama of life and love. Peter Kreeft doesn't merely play a part. He plays many parts, and he plays them all so well. He is one of our age's greatest philosophers. He is a great apologist. He is a very good writer. He entertains. He makes us smile. He makes us laugh. He makes us look at ourselves and each other in a new light. And now, this tried and tested guide to life guides us through some of the greatest plays ever written. Those wishing to go deeper into the meaning of life and death, and the mystery of love and suffering, will find no better guide than Peter Kreeft."

—**Joseph Pearce**, author of *Through Shakespeare's Eyes: Seeing the Catholic Presence in the Plays*

"Peter Kreeft modestly calls himself a 'tour guide' of these fifteen plays, but he's something better than that: he's a gregarious fellow sightseer, an enthusiastic rambler holding forth less systematically and more vividly than the tour guide. I'm reminded a bit of Sister Wendy Beckett's art commentary, disparaged by some professional art critics, but beloved by ordinary people who learned more about art appreciation from a few minutes of her rapturous discourse than from pages of typical art criticism."

—**Deacon Steven D. Greydanus**, creator of DecentFilms.com

# GOD
## ON
# STAGE

# GOD
## ON
# STAGE

## 15 PLAYS THAT ASK
## THE BIG QUESTIONS

**PETER KREEFT**

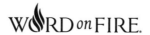

Published by Word on Fire, Elk Grove Village, IL 60007
© 2024 by Peter Kreeft
Printed in the United States of America
All rights reserved

Cover design, typesetting, and interior art direction by
Katherine Spitler and Rozann Lee

ISBN: 978-1-68578-102-6

Library of Congress Control Number: 2023946605

# Contents

# Introduction

Why should you read this book?

First of all, because it is *interesting*.

Why is it interesting? Because it is about the two things that are the most interesting things of all: yourself and your life and the meaning of your life, and God. Even if God is only a fairy tale, he is at least the most interesting fairy tale ever invented. God is wild. "Aslan is not a tame lion." God is *not* like Ned Flanders on *The Simpsons*!

Second, because the fifteen dramas it explores, like all great art, will show you great gobs of the three things that you, like every other member of the human species, long for most deeply and passionately: truth, goodness, and beauty and the joy in beauty. We appreciate all three of these most keenly not by abstract concepts of the ideals themselves but by dramas of the concrete struggle with their opposites and enemies: ignorance, evil, and misery. Light shines brightest in the conquest of darkness; goodness in the conquest of evil; joy in the conquest of sorrow. That is why God allows darkness, evil, and sorrow: for the sake of the greater light, love, and life. For life is not a timeless formula but a story, a drama; and it is not a problem to be solved but a mystery to be lived.

Philosophy is the love of wisdom, and I am a professor of philosophy (i.e., a professional "lover of wisdom"). (The word for "professional lover" also begins with a *p*.) My most successful

courses are always the least abstract ones, the ones that explore not the profound problems of metaphysics and epistemology or the history of philosophical controversies, but the concrete dramas of human life, in courses like "Philosophy in Literature," "Philosophy in Cinema," "Philosophy in Great Plays," and "The Philosophy of Tolkien." Of all the philosophical classics, the one the students both "get into" the most and "get the most out of" is the most dramatic one, Augustine's *Confessions*.

A third reason to read this book, even if you are an unbeliever, is that a book entitled *God on Stage* will give you insight into how believers perceive the difference God makes to human life. Any belief, including both atheism and theism, is best appreciated by contrast to its opposite. William James, the founder of pragmatism, went so far as to say that if any idea makes no *difference* to your life and your experience, it is neither true nor false for you.

Fourth, if you are a believer, this book will help you both to learn and to share more about your faith and about the difference it makes.

It will help you to learn, because a God-created universe is like an enormous and endlessly amazing work of art, and everything in a work of art reveals the artist.

And the divine artist is revealed by at least four dimensions of his art: the setting, which is the cosmos that we inhabit; the plot, which is the events that we live; the characters, which are ourselves; and the theme, which some say is nonexistent, meaninglessness, or whatever you want it to be, but I say is love. "All the world's a stage, / And all the men and women . . . players." And according to Christianity, "all the men and women" includes God, the Creator who once became a creature, a player.

It will help you to share, because truth, goodness, and beauty are given to us not only to enjoy but also to be passed on. And this is usually done in many anonymous and indirect ways, for everything we say and do reflects to others what we are, what is

in us. And what we are is what we have become by all our interactions with the world. And reading and reflecting on great dramas, great plays, is a powerful way of expanding our world and expanding our interactions with it, and therefore expanding ourselves and what we have to give others. And that is the whole purpose of a human self: to give itself away to others.

*

Reading fiction is like having friends: it is acquiring multiple sets of eyes. Even when we are alone, we already have two eyes, not just one, so that a dimension of depth and perspective opens up; and when we add friends (including artists and authors), we add other sets of eyes. We look not only *at* these friends, whether real or fictional, but also look *along* them, or with them, or by means of them, at their world and ours, especially at the truth, goodness, and beauty in it.

And we learn lasting lessons from all the works of art that we love because love lets us enter into other people and see with their eyes, and in plays those "other people" include the authors and their characters. Love (and friendship, which is a form of love) is a kind of metaphysical magic: it is not just a feeling in us about other people, but it can let our soul actually enter into their souls. Even old Aristotle knew that when he defined a friend as "the other half of my soul." Two bodies cannot occupy the same physical space at the same chronological time, but two souls can occupy the same spiritual place (which is more than "space") at the same kairological time (which is more than chronological time).

*

This book will not teach you anything about the history of theater, or of these plays, or the "correct" scholarly interpretation of them,

or about the structure and technique of a play, or how to create or perform one. Nor is it a philosophy or theology of literature or of theater. Nor will it help you to think logically about tricky philosophical issues raised in these plays, like most of the "Philosophy in . . ." books about popular culture that are always written by "analytic" philosophers, who love to analyze, define, and argue. Nothing wrong with that, but it's not what I do. What *do* I do with these plays? I read, and smile, or frown, or fall in love, or ponder, or open my mouth to make an *O*, the syllable of awe and wonder—wonder at both life and art, and at both God and man, who is God's art.

\*

*God on Stage* will probably strike you as a strange title, for God is a spirit, and invisible, and therefore cannot literally be on stage as an actor, unless he becomes incarnate. But if God is God, he is present everywhere, invisibly, as any artist is present in all his works. And this presence, even when anonymous, makes a difference that we can sense. It is the difference between the book of Job, written by a Jewish believer, and *J.B.*, the same story written by a modern unbeliever.

\*

The ultimate source of the power of God on stage and of every work of art, great or small, is the presence of the Holy Spirit. The Father "dwells in unapproachable light" (1 Tim. 6:16), and the Son becomes a visible and accessible man, like us "in every respect . . . yet without sin" (Heb. 2:17, 4:15), but the presence of the Spirit is, in a way, somewhere between these two. He "swept over the face of the waters" in the creation of the universe (Gen. 1:2), and he does the same creative work in our souls. He enters

into some of us (as he did to the prophets and to Mary), and he exits from some of us (as he did to Judas, so that Satan could enter him). He "inspires" (in-breathes) us. He speaks in whispers, like the wind. He creates form in the formless waters of our imagination, as the wind creates waves. He is the most anonymous person of the Trinity.

*

Another reason for surprise at my title *God on Stage* is the irreligious reputation of the stage. The institution of the theater has turned almost 180 degrees from religious to irreligious. In its origins in ancient Greece, it was a religious ritual, a liturgy, a paean and poem of praise and piety toward the gods. Today, it is one of the most secular and often deliberately "transgressive" institutions in the world. Yet the true God still loves to infiltrate the ranks of his apparent enemies and inspire the spirits of unbelievers, just as he inspired pagan polytheists to make myths that were often truer than their makers ever knew. He has not abandoned post-Christians today any more than he abandoned pre-Christians then. Some of the most religious plays in our secular culture were written by "heretics," agnostics, and atheists.

*

If you are still wondering whether to bother to read this book, just look at the Table of Contents. That will tell you what the book is about. Nothing else. I offer no guarantees, no tricks, no salesmanship. I don't work for the inventor of the world's oldest profession, advertising (see Genesis 3). I work for the other guy.

*

Stories are humanity's oldest and most universal art. All stories, whether movies or plays or novels or epics or short stories or just parables or jokes, have five aspects, five dimensions: characters, plot, setting, theme, and style. This book focuses on themes, and further focuses on theological themes. Themes are not necessarily moral lessons, and not necessarily "preachy." All plays have themes; that is, they are "about" something. Sometimes the themes are theological. Many great plays, modern as well as pre-modern, have theological themes.

I have selected three plays for each of five subjects or themes or philosophical or theological issues.

The first is the most general, the most global and intuitive: the meaning of and attitude toward human life as a whole. Is there any kind of faith, love, and above all joy, or at least hope for joy, or is there not?

The second is the relation between man and God or the gods, which is the essence of "religion."

The third is the problem of suffering, especially the suffering of a hero or "culture hero."

The fourth is the meaning of death.

The fifth is damnation—a neglected but crucial and passionate theme. It is the other half of the ultimate drama, what Kierkegaard called the "infinite passion." If there is the possibility of salvation, there must be the possibility of damnation.

For each of these five themes I have selected three plays: one that exemplifies the pagan or pre-Christian or generic, universal, natural point of view; one the distinctively Christian point of view; and one the post-Christian, typically modern point of view.

The post-Christian is as distinct from the pre-Christian as it is from the Christian, just as a divorcée is as distinct from a virgin as she is from a wife.

The historical comparison between the three ages is not the main point of this book, but it is a frame that is as visible as the pictures inside it.

The three greatest dramas of all time are not stage plays, though they could become stage plays. They are treated in the appendix.

Three of these fifteen plays were not published as plays, but they are dramas that are natural to the stage. *The Great Divorce* was published as a novel, but has often been staged as a play, with consistent success. *The Dream of Gerontius* is a dramatic poem, but it could work as an impressionistic movie. The same could be said of *Under Milk Wood*, which was performed as a radio drama. (Its one existing movie version is—well, forgettable.) The theater of the ear can be as dramatic as the theater of the eye, just as music can be as dramatic as painting or architecture.

Most of these plays have been made into movies, sometimes very good ones. The transition from stage to screen sometimes has worked very well (e.g., *A Man for All Seasons*, *Shadowlands*, and *Hamlet*, especially Mel Gibson's version) and sometimes not (e.g., *Waiting for Godot* and *Our Town*). What makes the difference between failure and success in that enterprise is a question that is interesting and important but too complex and technical for this book to explore.

My role is only as a tour guide, not even a mapmaker. My point is just "Look at these!" Or, better, "Look at yourself and your life through these eyes." My point is not how these plays fit into my outline or illustrate my point, as if my point were some great new original discovery. My point is simply their fifteen points, and their relation to your life and your mind.

# Three Dramas About Life and Joy

# 1

# Under Milk Wood

## BY DYLAN THOMAS

It may seem odd to begin a book entitled *God on Stage* with a play that is not, apparently, about God, and that has no stage.

*Under Milk Wood* is a radio play, which bears essentially the same relation to a stage play as a stage play bears to a movie. A movie supplies its own ultra-realistic setting in the "real world," so that nothing is left to your own imagination, while a stage play's setting can only be a few props that are suggestive of the larger world around them, so you have to use more of your own imagination when you watch it. The radio drama appeals even more to the imagination than the stage because it supplies only sound and no sight at all, except your own inner sight.

It is especially challenging to create a radio drama whose protagonist is really the imagined setting itself. In *Under Milk Wood*, the protagonist is really the setting—namely, "Llareggub," the fictional Welsh town that poet Dylan Thomas invented by spelling "bugger all" backward.

The play's strongest dimension is its style—that is, the poet's words. In this play, the prose keeps bursting into poetry, and the poetry keeps turning into music. If you are bored with beauty,

mute with music, weary of words, and puerile about poetry, you will hate this play. I don't expect all the readers of this book to love it as I do, so it is probably an unwise example to begin with. But I never claimed to be wise.

All writers use words, but some love to play with them, like G.K. Chesterton. Whenever I have used some of his books and essays in my classes at Boston College, I always get two radically opposite reactions to his writing style from my students. Some fall instantly in love with *his* falling in love with words and their endless possibilities of combination and recombination, especially surprising and paradoxical ones. Others hate this wordplay, this poetic prose. Some people don't like jugglers, as some people don't like clowns or mimes, and poets are word jugglers. I don't know whether the reason for that dislike is envy, or whether it's simply a lack of sympathy for Chesterton's utterly unpragmatic, childlike delight in language, or whether it's some other, more sympathizable reason. But love of words and love of play are both necessary if the reader or hearer is to enjoy wordplay, especially one as extravagant as Chesterton's. Impatience and the demand to "get to the point" and the "bottom line" are utterly incompatible with appreciating any poetry, especially when the poetry intrudes in areas that we do not expect to be poetic: plays, novels, or essays. I think the very same two opposite reactions are true of Dylan Thomas as are true of Chesterton, especially to this, his longest poem, and for the same reasons, whatever they are.

Style is usually the least important of the five dimensions of any narrative (plot, characters, setting, theme, style), but it is the main reason for the charm of this one. *Under Milk Wood* is a place, not a plot. It is not dramatic, but it contains dozens of mini-dramas briefly described or remembered during the one ordinary sunrise-to-sunset day that frames the narrative. The characters in this play are more than the plot, the setting is more than the characters, and the style is more than the setting. The plot is

simply life itself in all its ordinary extraordinariness (or extraordinary ordinariness).

Yet it is a "play" in the sense of a drama—that is, a narrative—even if it is not "dramatic" in the sense of expressing and eliciting extreme emotional reactions, because that meaning of a "play" (a drama) is one subspecies of the broader meaning of "play"—that is, playing in contrast to working, or in contrast to anything practical and necessary and utilitarian.

Playing is not "rational." Nor is it irrational, unless you call all sports irrational. Is it "irrational" to enjoy the contrived little drama of trying to hit a ball into the seats with a baseball bat or into a hole with a golf club? Many doggedly practical and utilitarian people think so. Those people will not like this play or "get" it at all, except perhaps to laugh at its apparent silliness. But the silliness is serious—as serious as heaven. For heaven itself is play in both senses of the word "play": it is a creative drama, a work of art, and it is also a game, or a dance, to enjoy for its own sake rather than a "job" to work at as a means to some other end. It *is* the end. As C.S. Lewis said, "Joy is the serious business of heaven."

The name "Dylan" means "son of the sea" in Welsh, and that is a very good image for his style. His words come at you like waves: a delightful overplus, unceasing, rich and deep and roundly rolling, golden with alliteration, musically lyrical. Poetry cannot be translated nearly as well as prose because every language *sounds* different, even if the meanings are not different; and this is especially true of Thomas' poetry, which depends not on mental but musical acrobatics.

And this is not just stylistic but substantive: Thomas sees life as music. (The Welsh have the best singing voices in the world, and they have always loved choral singing.) "Life as music" is perhaps one way to translate the implicit theme of *Under Milk Wood*. Just as the implicit theme of the movie *Babette's Feast* is that life

5

is a feast, the theme of *Under Milk Wood* is that life is a feast of sound. Because this play depends so much on its musical sounds, translating it into another language would be almost as difficult as rewriting a Chopin nocturne for a marching band.

The play is not designed for the theater of a stage but for the theater of the mind as informed by the ear. Although it was written as a radio drama, it could be made into a movie—and probably spoiled by no longer requiring much activity from the visual imagination, unless it were largely impressionistic. TV and movies have rendered our imaginations passive, and they are eroding not only radio, which demands our active visual imagination, but also reading, which demands also the audible imagination. That is why a movie made from a great book almost always lets us down: it substitutes the director's visual imagination for our own. Lesson: always read the book before the movie, not after.

If you read rather than hear this play, it should ideally be read aloud rather than silently. The words on the page are only a code for the play itself, like sheet music for a performance on a musical instrument. The instrument in this case is the human voice. (Primitive societies like the Aboriginal Australians always prefer orality to writing: it is so much more *alive*.) The effect of this play in your soul depends on your ear as much as on your brain. In most movies, the music is "background music" to the events; here, it is almost the reverse. For Thomas' poetry is as close to music as words can get. One thinks of Edgar Allan Poe (e.g., "The Raven") or G.K. Chesterton ("Lepanto") or Gerard Manley Hopkins ("The Windhover," "Pied Beauty," "God's Grandeur") for comparison.

Since appreciation of this work depends on your ear, please move heaven and earth to find and listen to Richard Burton's rendition of it. Then, whenever you read it again (and you will, for poetry demands rereading, far more than prose does), you will remember those sounds, that music, like a bird identifying

other birds by their call. It is like a bird identifying the first creature it sees when it hatches as its mother and as the touchstone for all subsequent meetings with other creatures. (Remember the heartbreaking and hilarious children's picture book *Are You My Mother?*) We act like that too. Having fallen in love with Beethoven through listening to Toscanini's conducting of all nine of his symphonies, I cannot help judging all other interpretations of Beethoven by that standard. This principle of "primitive patterning" applies to music more than to any of the other arts because music is the least cerebral and abstract, and the most intuitive and mystical; at the same time, it is the most physical.

Thomas finished this play only one month before he died. He drank himself to death. He was as eccentric as the characters in this play. As a boy, Thomas described himself as "small, thin, indecisively active, quick to get dirty, curly." His education ended with grammar school. Imagine how university would have corrupted his art!

I chose this play to illustrate the best in the pagan or pre-Christian or not-quite-Christian attitude toward life as a whole, even though that historical association is something of a stretch. But you could view it not so much historically as personally, as a version of what Kierkegaard called the "aesthetic" or pre-ethical and pre-religious stage on life's way, though Thomas' version of that is significantly more joyful and less tragic than that of the melancholy Dane. The presence of God here is almost totally anonymous, except for the kindly and sweet Reverend Eli Jenkins, whose concluding poem is as close to Thomas' religious philosophy as anything else he wrote.

All of the characters in Llareggub are eccentrics. In fact, if, either in this play or in real life, there were one character that was *not* eccentric, that would be the most eccentric eccentricity of all. Eccentricity is the norm; individuality is the supreme universal; being somehow "off-center from the standard" is in fact

the center and the standard—unless and until, like most of the rest of the world, Llareggub becomes "educated"—that is, mechanized, urbanized, technologized, socialized, tamed, domesticated, globalized, and mass produced. The point of Thomas' eccentric characters is "to hold the mirror up to nature," for we are all potential eccentrics, if only suppressed eccentrics; that is why we can identify with them. (The same principle holds true for most of the characters in the novels of both Dostoevsky and Dickens.)

That is also why one of the most popular BBC comedy series for almost two decades was *Doc Martin*, set in the fictional Cornish village of Portwenn, almost all of whose inhabitants are only a small step less off-center than those of Dylan Thomas' Llareggub, and whose ongoing theme was the fittingly unfitting relationship and marriage between Louisa, the most normal and complete character in the village, who is both homely and beautiful and thus the center and the norm, and the title protagonist, the most eccentric personality of all, a curmudgeonly doctor with zero social skills.

Since most readers of this book will be unfamiliar with *Under Milk Wood*, in order to seduce them to buy, read, and hear it, I will not analyze it but just quote a few random passages. The first introduces the protagonist, which is the town itself:

> It is spring, moonless night in the small town, starless and bible-black, the cobblestreets . . . limping down to the sloe-black, slow, black, crowblack, fishingboatbobbing sea.
>
> . . . . . . . . . . . . . . . . . .
>
> You can hear the dew falling, and the hushed town breathing . . . the folded town fast, and slow, asleep. And you alone can hear the invisible starfall. . . .
>
> . . . . . . . . . . . . . . . . . .

Listen. It is night moving in the streets.

The play alternates between voiceover and characters, the first of whom is

> Captain Cat, the retired blind sea-captain, asleep in his bunk in the seashelled, ship-in-bottled, shipshape best cabin of Schooner House [dreaming] of never such seas as any that swamped the decks of his S.S. Kidwelly bellying over the bed-clothes and jellyfish-slippery sucking him down salt deep into the Davy dark.

He dreamingly interacts with the dead (much as the dead Emily in the third act of *Our Town* interacts with the living). Captain Cat sings:

> Johnnie Crack and Flossie Snail
> Kept their baby in a milking pail
> Flossie Snail and Johnnie Crack
> One would pull it out and one would put it back

> O it's my turn now said Flossie Snail
> To take the baby from the milking pail
> And it's my turn now said Johnnie Crack
> To smack it on the head and put it back

> Johnnie Crack and Flossie Snail
> Kept their baby in a milking pail
> One would put it back and one would pull it out
> And all it had to drink was ale and stout
> For Johnnie Crack and Flossie Snail
> Always used to say that stout and ale
> Was *good* for a baby in a milking pail.

The characters don't need to do much in this drama. Their being is their doing. For instance:

> Mr. Utah Watkins counts, all night, the wife-faced sheep as they leap the fences on the hill, smiling and knitting and bleating just like Mrs. Utah Watkins.

. . . . . . . . . . . . . . . . . .

> Now, in her iceberg-white, holily laundered crinoline nightgown, under virtuous polar sheets, in her spruced and scoured dust-defying bedroom in the trig and trim Bay View, a house for paying guests, at the top of the town, Mrs. Ogmore-Pritchard, widow, twice, of Mr. Ogmore, linoleum, retired, and Mr. Pritchard, failed bookmaker. . . . "I must put my pyjamas in the drawer marked pyjamas. . . . And dust the parlour and spray the canary. . . ." "And before you let the sun in, mind it wipes its shoes."

. . . . . . . . . . . . . . . . . .

> "Who's that talking by the pump? Mrs. Floyd and Boyo, talking flatfish. What can you talk about flatfish? . . . There goes Mrs. Twenty-Three, important, the sun gets up and goes down in her dewlap; when she shuts her eyes, it's night."

The philosophy of life of the citizens of Llareggub is perfectly and paradoxically summarized in the character Polly Garter's masterpiece of Welsh and Irish logic: "Oh, isn't life a terrible thing, thank God?" The author directed that these words be accompanied by a

"single long high chord on strings." A sign. A musical version of "author's message."

That is the central theological point, the God-point, so to speak. That line is the only one in the play that mentions God by name. But it is not the only time God is on stage. God is not dead in Llareggub; he is just off-center. *And loved*, however anonymously and implicitly. That's the point, the "thank God": the cosmic gratitude. It is concrete, though unfocused. It is Molly Bloom's "Yes, yes, yes, yes, yes" in Joyce's *Ulysses*. True, hers is a yes to unfocused sex, but it is also a yes to life itself, which is the earth on which the cathedrals are built, and an essential aspect of the psychological foundation of all religion. It is that yes to life, that groundwork beneath the faith, as large and encompassing as the planet, that is dying in our hearts and therefore in our world today. The very sense of the numinous, the wonder, "the idea of the holy," of the holiness of life itself, however poor and "unsuccessful," is dying in the human heart, as we shall see in plays like *Godot*, *Equus*, and *The Sunset Limited*.

From a theological point of view, Llareggub is more pagan than Christian, and it is very far from utopian or perfect. But this life is *loved*, and that is what matters first and most. In the words of the preacher-poet Rev. Eli Jenkins,

> A tiny dingle is Milk Wood
> By Golden Grove 'neath Grongar,
> But let me choose and oh! I should
> Love all my life and longer
>
> To stroll among our trees and stray
> In Goosegog Lane, on Donkey Down,
> And hear the Dewi sing all day,
> And never, never leave the town.

The religion of Llareggub is not a creed but a prayer. It is expressed, with a striking simplicity and an extraordinary ordinariness, in the words of Rev. Jenkins' homemade prayer. The prayer is a poem, and thus a song; and that is significant. It is not just a question of style but substance. It is lovers who sing. It could only have been love that first invented music. This love of life in Dylan Thomas is only pagan, with a very thin Christian veneer, and far from the fullness of Catholicism; but it is much, much further from the emptiness of post-pagan, post-Christian secularism. It prays. The first thing is not what it prays, or what it fails to pray, but the fact that it prays:

> Every morning when I wake,
> Dear Lord, a little prayer I make,
> O please to keep Thy lovely eye
> On all poor creatures born to die
>
> And every evening at sun-down
> I ask a blessing on the town,
> For whether we last the night or no
> I'm sure is always touch-and-go.
>
> We are not wholly bad or good
> Who live our lives under Milk Wood
> And Thou, I know, wilt be the first
> To see our best side, not our worst.
>
> O let us see another day!
> Bless us all this night, I pray,
> And to the sun we all will bow
> And say, good-bye—but just for now!

The sense of gratitude and the sense of contingency, and therefore preciousness, go together. They are instinctive in human nature and therefore in all cultures whose lives are still surrounded and determined by God's nature rather than man's ideology and technology. In other words, all cultures except one: the one to whom this poem is addressed as a kind of pre-evangelical missionary message.

The most instructive conflict in this drama is not any of the many conflicts within and between the characters, or between them and nature or life or the nature of things, but between this pagan naturalism, in which the persons and their lives fit into the landscape, and the alien, artificial, external, utilitarian unnaturalism of the modern world, represented by an outsider's guidebook to Llareggub, very much as it is also represented by the two critical and dismissive out-of-towners in *Our Town*.

> Less than five hundred souls inhabit the three quaint streets and the few narrow by-lanes and scattered farmsteads that constitute this small, decaying watering-place which may, indeed, be called a "backwater of life." . . . Though there is little to attract the hillclimber, the healthseeker, the sportsman, or the weekending motorist, the contemplative may, if sufficiently attracted to spare it some leisurely hours, find . . . in its several curious customs, and in the conversation of its local "characters," some of that picturesque sense of the past so frequently lacking in towns and villages which have kept more abreast of the times.

Tragically, we only appreciate persons, places, and things when they die.

And that is one of the things that *Our Town* shows us.

# 2

## CHRISTIAN

# *Our Town*

### BY THORNTON WILDER

The philosophy or world-and-life-view of *Our Town* is in continuity with that of *Under Milk Wood* because Christianity is in continuity with paganism, its fulfillment as well as its transcendence. *Waiting for Godot*, in contrast, is in discontinuity with both.

It is in continuity with paganism because it reflects God's natural revelation and "natural law" and its affirmation of natural life. It is a correction to paganism because it reveals the true God who created us in his image rather than the false gods we created in our image. It is the transcendence of paganism because it is supernatural rather than natural. The typically post-Christian play *Waiting for Godot*, in contrast, is in discontinuity with both Christianity and paganism. When Christians complain that "the world is going back to paganism," they confuse a progress with a regress. A fertile field without crops is a regress compared to that field *with* crops, but it is a progress compared to a field whose fertility is dead.

One of the obvious differences between *Under Milk Wood* and *Our Town* is that no one dies in *Under Milk Wood*. In *Under Milk Wood* the living speak of the dead, but in *Our Town* the dead

also speak of the living. The point of view in *Under Milk Wood* is wholly natural, but the point of view in *Our Town* becomes supernatural in act 3. In *Under Milk Wood* life after death is pictured only in a dreaming; in *Our Town* it is more real than this life. In *Under Milk Wood* nature casts only a thin and shadowy light on the supernatural, but in *Our Town* the supernatural casts a shatteringly bright light on the natural.

*Our Town* is (1) a radically misunderstood classic; (2) a "concrete universal," like a myth; (3) a paradoxical inversion of death and life; (4) a deeply religious work; and (5) a torture and threat to its left-wing secular critics.

### (1)

I will let the playwright Donald Margulies make the first point, from his introduction to this play:

> If you think you're already familiar with *Our Town*, chances are you read it long ago, in sixth or seventh grade . . . when you were too young to appreciate how enriching it might be. . . . You sneered at the domestic activities of the citizenry of Grover's Corners, New Hampshire, and rolled your eyes at the quaint-seeming romance between George Gibbs and Emily Webb. You dismissed *Our Town* as a corny relic of Americana and relegated Thornton Wilder to the kitsch bin along with Norman Rockwell and Frank Capra.

> You may have come around on Capra (*It's A Wonderful Life* actually owes a great deal to *Our Town*) . . . but Wilder is another story. In your mind he remains the eternal schoolmaster preaching old-fashioned values to a modern public that knows far more than he does. . . . "[In this play] nothing happens." "It's dated." "Simplistic." "Sentimental."

Margulies then tells us how he shared this common reaction and these four criticisms as a teenager but, when he saw the play as an adult, "was so mesmerized by its subversive power . . . so shattered by its third act, that I couldn't believe it was the same play. . . . [It] had changed very little. *I* was the one who had changed. . . . *Our Town* is anything but dated, it is timeless; it *is* simple, but also profound; it is full of genuine sentiment, which is not the same as its being sentimental; and, as far as its being uneventful, well, the event of the play is huge: it's life itself."

Wilder wrote it as a reaction *against* exactly those four faults in most other plays promoted by the theatrical establishment of his day—and ours. He wrote that he had "ceased to believe in the stories . . . presented there. . . . It was evasive. . . . I found the word for it: it aimed to be *soothing*."

But most establishment theater is cynical and negative and even nihilistic. Isn't that the opposite of "soothing"? Not at all. Cynicism is often soothing because the life it portrays is not our life, the life of ordinary people. It is *escapist*. That is exactly the enemy, the villain, in *Our Town*: escapism. Emily's complaint to her mother is the same as Wilder's complaint about the theater of his day (and ours, a century later): "Oh, Mama, you never tell us the truth about anything." In contrast, *Our Town* is like Oedipus in *Oedipus the King*: it demands to see the truth even if seeing it is unendurable, as it is to Emily in the end. It was so unendurable to Oedipus that he blinded himself. The word "see" is the key word in both plays, and it is repeated dozens of times in both.

In *Oedipus the King*, the blind prophet Tiresias sees while the sighted Oedipus does not. In a similar irony, in the third act of *Our Town*, it is the dead who see, and the living who do not. In fact, what the dead see is the blindness of the living:

Emily: Live people don't understand, do they?
Mrs. Gibbs: No, dear—not very much.
Emily: They're sort of shut up in little boxes, aren't they?

The point is utterly simple and obvious, yet utterly profound. Adding more words, or more eloquent words, would be like muffling the sound of a bell by piling on layers of snow.

The point is repeated in the very last words of the play, a dialogue between the same two characters, now dead, who see the blindness of the living. Emily has died, but she is now very much more alive, and she is neither in heaven nor hell but in a kind of purgatorial learning and suffering experience (even though the Christianity is more Protestant in flavor than Catholic). The last spoken words are the point of the whole play, the reason it is a tragedy, and the reason it elicits tears:

Emily: Mother Gibbs?
Mrs. Gibbs: Yes, Emily?
Emily: They don't understand, do they?
Mrs. Gibbs: No, dear. They don't understand.

The point is put only a little more elaborately earlier, after Emily is allowed to visit just one ordinary day in her past life without being seen, but not without seeing. The dead Emily addresses her living mother, who cannot see or hear her:

Emily: Oh, Mama, just look at me one minute as though you really saw me. . . . *Let's look at one another.* . . . I can't go on. It goes so fast. We don't have time to look at one another. . . . So all that was going on and we never noticed. Take me back—up the hill—to my grave. But first: Wait! One more look. Good-by, good-by, world. Good-by, Grover's Corners . . . Mama and Papa. Good-by to clocks ticking . . . and Mama's sunflowers. And food and coffee. And new-ironed

dresses and hot baths . . . and sleeping and waking up. Oh,
earth, you're too wonderful for anybody to realize you.
*She looks toward the stage manager and asks abruptly, through
her tears:*
Emily: Do any human beings ever realize life while they live
it?—every, every minute?
Stage Manager: No. *Pause.* The saints and poets, maybe—
they do some.

This is why *Goodnight Moon* is a classic and was probably your
favorite book in the world when you were two: it is *Our Town* for
the very young. For sleep is a natural image of death.

<p style="text-align:center">*</p>

How much is this play loved? Here is the answer: of no other play
can it be truly said that for many years it was being performed
on some stage somewhere in America every single day of the year
except Christmas and Easter.

The proof that any work of art is great is its effect on us. That
is C.S. Lewis' point in *An Experiment in Criticism*: that we can
judge the value of the book by the value of the reading experience
and the response it elicits from us, instead of (or as well as) judg-
ing the value of the reading by the value of the book, as we usually
do. In other words, we can judge a book as great because it causes
a great reading response as its effect in us. We know the cause by
the effect. And the three most precious and profound powers of
any book, the three most difficult and deep delvings that a book
can carve in the soil of our souls are truth, goodness, and beauty.
Such a play as *Our Town* shows us a deep truth (such as the good-
ness [value] and beauty of ordinary life) that we did not see before,
even though it was obvious, and by doing that, it breaks our hearts
with both joy and sorrow. (Tears often manifest both!)

Truth, goodness, and beauty all break us, melt us, mold us, and fill us. Regarding the first and most necessary of those three criteria, truth, Wilder wrote: "The response we make when we 'believe' a work of the imagination is that of saying: 'This is the way things are. I have always known it without being fully aware that I knew it.'"

Regarding the second, goodness or value, here is how Wilder identified the purpose of his play: The play is "an attempt to find a value above all price for the smallest events in our daily life." Against almost impossible odds, he succeeded.

Regarding the third criterion, C.S. Lewis said that the sincerest and most precious praise we can give to any artist is that "you break my heart." For no human heart can be whole unless it has been broken. This happens in those mysterious places in the heart where joy and sorrow meet. (It is exceedingly strange that both of these opposing things produce the very same effect: tears. It is not strange that our body overflows when our soul overflows, but it is strange that the same salty, watery overflow comes from opposite causes, great sorrow and great joy.)

Here is one account of the effect *Our Town* had on its first audience: "After a short, stunned silence, broken by audible sniffles in the house, the audience offered an ovation." Here is another: "Audience swept by laughter often; astonishment; and lots of tears; long applause at the end by an audience that did not move from its seats." Here is the effect of its premiere on the hard-hearted Hollywood elite, in Wilder's eyewitness words: "Friday night both Sam Goldwyn and Bea Lillie were seen to be weeping. Honest!"

The literally breathless silence, the astonishment, the audience not moving—I have seen this at only one other play: a performance of C.S. Lewis' *The Great Divorce*. I have seen it after only three movies: *The Prisoner* (with Alec Guinness), *The Passion of the Christ*, and *Dead Man Walking*. All three audiences sat stunned

and stuck to their seats at the end. No popcorn. They were imprisoned by their passion, and their legs were too weak to walk.

### (2)

The events of our lives seem small. They are particular, limited, imperfect, changing, and mortal. "The meaning of life" is not a finite object that we can possess, or even other people like ourselves, however precious they are and however much we love them. Universal truth and goodness and beauty are abstract and timeless, while concrete realities are particular and limited. We need both, but how can we have both at once?

Philosophy and theology give us the abstract universals: truth and goodness and beauty—but they are not concrete particulars. History—that is, both our own life's history individually and human history collectively—gives us concrete, particular things and persons and events, but they are not universal. But great works of art like *Our Town* somehow give us both at once. That is what a great myth does: it incarnates a universal in a particular. A myth is like the Incarnation in that way.

"Myth" does not mean "fantasy, fiction, or fallacy." It means "sacred story." Myths are archetypal. They are *concrete universals*. Three of them are the subjects of the three acts of this play, as the Stage Manager says at the beginning of the second act: "The First Act was called the Daily Life. This act is called Love and Marriage. There's another act coming after this: I reckon you can guess what that's about."

The Stage Manager is not simply a wise old hayseed or country bumpkin. He is a prophet, or an angel, or the voice of God, the divine point of view concretized in an offstage character. He himself is like a myth, incarnating abstract eternal and universal truth in a concrete human narrative form.

Paradoxically, the more particular and individual and unique a story is, the more universal it can be, for what is most universal among us is our individuality and uniqueness.

Myths are narrative archetypes. Archetypes are real. They are universals that give each of their individual instances concrete reality. "Man," or "human nature," makes every individual differently human. Stereotypes, often confused with archetypes, are actually the extreme opposite: fake universals, mentally produced concepts, mere classes of things, that abstract from and eliminate differences, producing Xeroxed copies (e.g., racism: "They're all the same").

Wilder explains how the theater pulls off this paradoxical feat of showing truths that are both concrete and universal at once: "The theater longs to represent the symbols [that is, archetypes] of [particular, real] things, not the things themselves." Notice that he said "symbols," not "concepts": they are Platonic Ideas, not human ideas. He also did not call them "allegories," for they are not puzzles to solve but realities to contemplate.

The theater possesses this magic power, which rises above literalism and "realism":

> All the lies it tells—the lie that that young lady is Caesar's wife; the lie that people can go through life talking in blank verse; the lie that that man just killed that man—all those lies enhance the one truth that is there—the truth that dictated the story, the myth. . . . When the [typically modern "realistic"] theater pretends to give the real thing in canvas and wood and metal it loses something of the realer thing [the archetype] which is its true business. Ibsen and Chekhov carried realism as far as it could go, and it took all their genius to do it. Now the [movie] camera is carrying it on and is in great . . . peril of falling short of literature.

*Under Milk Wood, Our Town*, and *Waiting for Godot* all fit this pattern. They are archetypal, not stereotypical.

It's a tricky point, this thing about archetypes. The modern mind almost inevitably reduces archetypes to stereotypes, Ideas to ideas, concrete universals to abstract universals, or sets, or class concepts. But Plato didn't. He ended all of his greatest dialogues (the *Republic*, the *Phaedo*, the *Gorgias*) not with abstract concepts and arguments but with myths, sacred stories, theatrical narratives. And in the *Phaedo*, Socrates himself becomes mythical and archetypal. His death, at the end of the *Phaedo*, shows us the immortality of the soul far more convincingly than any of his arguments, for when the idea of death and the idea of Socrates thus meet in the theater of the reader's soul, Socrates changes the meaning of death; death does not change the meaning of Socrates.

Perhaps we can see the point I am trying to make about archetypes if we radically stretch our imagination and imagine a very strange plot to a story. In this very strange story, Platonic Ideas, archetypes, are being incarnated, each one being drawn into a concrete particular. Or, to put the same point backward, imagine concrete particular things becoming their archetypes, their concrete material particularity totally drawn into their perfect, universal Platonic Forms. A lion becomes Leoninity itself, or Leoninity takes possession of one concrete lion. (Actually, that is literally the plot of Charles Williams' novel *The Place of the Lion*, the book that fascinated C.S. Lewis and sealed their lifelong friendship.)

Such "incarnation" is what actually happened in the greatest story ever told, the myth that became fact. Myth, in this sense, is the essence of Christianity; for the two natures of myth are the two natures of Christ, who is the concrete, temporal, historical incarnation of eternal universal goodness, truth, and beauty, so much so that he could say, "I am the way, and the truth, and the life" (John 14:6). Nothing is more concrete than "I," and nothing is more universal than truth, goodness, and beauty.

## (3)

One of the causes of the greatness of this play is what it does to the two largest finite realities we ever meet: life and death.

We habitually see death from the viewpoint of the living, but *Our Town* lets us see life from the viewpoint of the dead. And that makes a total, global difference, a difference to literally everything. It reframes everything. The frame and the picture exchange places.

Death is present from the very beginning, when "*a rooster crows*" and the Stage Manager says: "The morning star always gets wonderful bright the minute before it has to go,—doesn't it?"

Donald Margulies writes: "The simultaneity of life and death, past, present, and future pervades *Our Town*. As soon as we are introduced to Doc and Mrs. Gibbs, the Stage Manager informs us of their deaths. Minutes into the play and already the long shadow of death is cast, ironizing all that follows."

The irony is total: as soon as we are born, we begin to die. The very same ironic fact that gives *Our Town* its greatness and grandeur is at the heart of the nihilism, the darkness and hopelessness, of *Waiting for Godot*: the fact that "they give birth astride of a grave."

Here, in *Our Town*, life is stronger than death. Why?

Because *love* is stronger than death.

And that is the light, the *truth*, that is stronger than death.

There are in fact three things in *Our Town* that are stronger than death: love, light, and life. They were the three favorite words St. John the Evangelist used for God. They are the three things God is by his very essence: "the way, and the truth, and the life"—love, the self-giving grace which is goodness, the "way" of life; light, the seeing of which is truth; and the joy of life itself, which is beauty.

Even the vague faith preached by the Stage Manager, only a step or two up from the poem of the Rev. Eli Jenkins in *Under*

*Milk Wood*, is strong enough to conquer death and thus transform its meaning, as he implies at the beginning of act three:

> Now there are some things we all know, but we don't take'm out and look at'm very often. We all know that *something* is eternal. And it ain't houses and it ain't names, and it ain't earth, and it ain't even the stars. . . . Everybody knows in their bones that *something* is eternal, and that something has to do with human beings. All the greatest people ever lived have been telling us that for five thousand years and yet you'd be surprised how people are always losing hold of it. There's something way down deep that's eternal about every human being.

And that irony, that liveliness of death that conquers the deathliness of life, that yin-yang interpenetration of life and death, makes the very awfulness of life wonderful. When Mrs. Soames, one of the dead, says, "My, wasn't life awful—and wonderful," she echoes almost word for word the verdict of Rosie Probert in *Under Milk Wood*: "Oh, isn't life a terrible thing, thank God?" Life conquers everything, even logic!

### (4)

The First Cause of this wonder, this conquest, is the real protagonist of the play: both the play *Our Town* and the play of life itself. He is identified in act 2, the act about love and marriage, by the Stage Manager, who also plays the part of the preacher during the wedding of Emily and George (just as Dylan Thomas' "First Voice" and "the Rev. Eli Jenkins" are also the same voice): "The real hero of this scene isn't on the stage at all, and you know who that is." That is the key line in the play. That is "God on stage." And we all know that; we all know who that is; we just forget it

or suppress it or deny it. It's *there* to be suppressed or denied. We are not born atheists; we have to suppress the light.

That is the very same thing Tolkien said about *The Lord of the Rings* in one of his letters: that the real protagonist is omnipresent but anonymous. After all, why is Sauron the villain, not the hero? Because he is *not* the Lord of the Rings. And we all know Who is. Tolkien's title itself is deliberately ironic.

There are three ways this "character" can be on stage: by need, by presence, or by absence. His place, his throne, can be ready and prepared for him; or he can come and sit on that throne and make all things new, even death itself; or he can be exiled from that throne and leave it empty. Those are the ultimate meanings of the three stages of our history: the pre-Christian, the Christian, and the post-Christian.

The power of *Our Town* derives from its transcendent perspective; and this comes out in a most off-center way, from an address on an envelope, on "that letter Jane Crofut got from her minister when she was sick. He wrote Jane a letter and on the envelope the address was like this: It said: Jane Crofut; The Crofut Farm; Grover's Corners; Sutton County; New Hampshire; United States of America . . . Continent of North America; Western Hemisphere; the Earth; the Solar System; the Universe; the Mind of God— that's what it said on the envelope. . . . And the postman brought it just the same."

That letter, that envelope, and that address are "addressed" to us. The letter is this play itself, and its human author is only the secondary author of it. But our postmen no longer deliver such envelopes.

The concept of "perspective" is key here. *Our Town* is not a human perspective about God but a divine perspective about man. *Our Town* is not "about" God, in that God is not Wilder's *object*, sitting out there in the front yard and observed through the windows of the house Wilder lives in. God lives *inside* Wilder's

house, in his soul, in his eyes, in his perspective. The same is true of Tolkien in *The Lord of the Rings*.

The human heart's innate demand for eternity is made visible and concrete in Emily's demand of George before they marry:

> George: I love you, Emily. I need you.
> Emily: Well, if you love me, help me. All I want is someone to love me.
> George: I will, Emily. Emily, I'll try.
> Emily: And I mean for *ever*. Do you hear? For ever and ever.

The presence of eternity also makes the past present. As the Stage Manager / preacher continues, "And don't forget all the other witnesses at this wedding,—the ancestors. Millions of them. Most of them set out to live two-by-two, also. Millions of them. Well, that's all my sermon. 'Twan't very long, anyway."

The same could be said of Wilder's simple "sermon." It isn't "preachy" even though it is preached, because it is not an alien color spilled from the outside onto a self-contained picture but the very life and essence of the picture as a whole. It is not a light shining on the picture but the light that lives within it and emanates from it. The presence of God in *Our Town* is inside-out, not outside-in. And we sense that. That's why we love this play: in it we meet our God.

<p style="text-align:center">(5)</p>

Even those who hate the play sense that, and that is the deepest reason they hate it. As we appreciate life most sharply by death, sight by blindness, love by lovelessness, hope by despair, beauty by ugliness, and joy by sorrow, we appreciate the appreciation of *Our Town* most sharply through those who do not appreciate it.

Within the play itself this contrary point of view is expressed by the two snobbish visitors and critics of Grover's Corners. (Compare

the outsider's guidebook description of Llareggub in *Under Milk Wood*.) The "Belligerent Man at Back of Auditorium" complains: "Is there no one in town aware of social injustice and industrial inequality?" And the "Lady in a Box" asks: "Oh, Mr. Webb? Mr. Webb, is there any culture or love of beauty in Grover's Corners?" And Mr. Webb answers, "Well, ma'am, there ain't much—not in the sense you mean. . . . But maybe this is the place to tell you that we've got a lot of pleasures of a kind here: we like the sun comin' up over the mountain in the morning, and we all notice a good deal about the birds. We pay a lot of attention to them." Ironically, the trivial and the profound are reversed here.

When *Our Town* was first performed, it divided its audience almost as sharply as Christ divided his. The clever and cynical humorist Robert Benchley called it "so much ersatz." The left-wing paper *The New Masses* called it "an exasperating play, hideous in its basic idea." In other words, it was bourgeois (Marx's "spit word"), middle class, common, and nonrevolutionary. Our soldiers who saw a USO production in postwar Europe loved it, but the Russian authorities in East Berlin censored it as "too democratic."

Eleanor Roosevelt wrote that this play had "depressed her beyond words": "On one plane *Our Town* is a very pessimistic piece. But on a higher plane it isn't. . . . If you hang the planets and the years high up above the play, you can get the Reconciliation but if you don't it's crushing." What she meant by "the planets and the years" was the metaphysical perspective, the address on Jane Crofut's letter. It's God's perspective, of course, and if you no longer believe in God, this play is not just neutral and boring but threatening and even terrifying. As we shall see in the next play, *Waiting for Godot*.

# 3

## POST-CHRISTIAN

# *Waiting for Godot*

### BY SAMUEL BECKETT

This is a play about God because it is a play about the presence of God's absence.

In *Our Town*, God is present "on stage"—in fact omnipresent, but anonymously. In *Waiting for Godot*, God is absent, and not anonymously. The author obviously meant to indicate the center of his play by his chosen title, in no less than four ways.

First of all, the word "God" is obviously and deliberately present in the name "Godot."

Second, we notice the word "go," which is the one thing the two protagonists never do.

And third, speaking of "do," that word is also in the name "Godot," and Vladimir and Estragon never do anything that matters, that makes a difference (e.g., hang themselves). There is no place for them to go and nothing to do, except wait—for Godot.

Which is the fourth point: they wait forever, and Godot never comes, and his "prophet" assures them that Godot will come "tomorrow," and as we know from a great ten-year-old female philosopher with red hair (and also from Macbeth's most

famous speech), tomorrow is "always a day away." Thus, the very first line of the play is

> Nothing to be done.

The point is repeated in the play's last line:

> Vladimir: Well? Shall we go?
> Estragon: Yes, let's go.
> *They do not move.*

The structure of the play is thus a closed loop, a "no exit." Compare the book of Ecclesiastes, which also goes nowhere because it both begins and ends with the same words: "Vanity of vanities . . . all is vanity" (Eccles. 1:2, 12:8).

The two pervasive and generic differences between Ecclesiastes and *Waiting for Godot* are that Ecclesiastes is a sermon while *Waiting for Godot* is a play, and, unlike Ecclesiastes, *Waiting for Godot* is not simply a tragedy but "a tragicomedy." The protagonists are clowns. It reminds us of Shakespeare's clowns digging Ophelia's grave in *Hamlet*.

<p style="text-align:center">*</p>

*Waiting for Godot* is a play without a plot. In fact, the plot of the play gives us the point of the play, for the plot is that there is no plot; the point and plot of the play is that there is no point or plot to life.

Since it has no plot, or narrative, or chronology, I cannot organize my analysis of it narratively and dynamically but only statically, by dividing it into abstract aspects or topics.

This is a drama about the lack of drama. There is no narrative action that makes a difference, that brings about a real change.

There is only one change, one hint of hope and progress: the tiny, teasing hint of four or five new leaves on the one dead tree in act 2.

Is this "play" truly a play then? Let's look at the two meanings of the word "play." This is indeed a "play." In fact, it is full of play. It is not only *playful* but funny, even hilariously funny, in a mordant kind of way. But it is not a "play" in the sense of *events*, at least for Vladimir and Estragon. Only Lucky and Pozzo come from offstage and move offstage. They probably are meant to represent human history, which is symbolized as essentially the history of oppression, since Lucky is Pozzo's slave. But the two protagonists, Vladimir and Estragon, "go" nowhere and "do" nothing because they are waiting for Godot, who himself goes nowhere and does nothing because, like the giant invisible rabbit in the old Jimmy Stewart movie *Harvey*, he does not exist. (Beckett is of course an atheist.) You first have to exist in order to go anywhere or do anything!

The effect cannot exceed the cause. Because Godot does not exist, in Beckett's atheist universe, Vladimir and Estragon themselves barely exist. In fact, one of its profoundest lines, a summary of all human history, is this: "We always find something, eh Didi, to give us the impression we exist?" All their absurd contortions, of both the mind with its words and the body language that incarnates and reveals the mind, are ultimately efforts at *being*. The deepest longing in us is our ontological thirst. All our loves and hopes and desires are for being, for without being, truth and goodness and beauty are attributes of nothing, are not real.

This play is (indirectly) about the ontological thirst and (directly) about the nonexistence of the water that can quench it; it is about the longing for being and the tragic nonfulfillment of that longing. And this is not its defect but its greatness: it can teach believers more about that longing than most of our hopeful and optimistic religious narratives can do, just as death can reveal the importance and value of the living more poignantly than life can.

I suspect this "ontological thirst" goes a long way to explain the madness of human history, with all its violence. For instance, murder and rape are not only two of the most horrible but also two of the most dramatic and literally "exciting" deeds (*excitare*, to call forth) in our individual lives and in our collective history and in our stories—why? Because we desperately want to prove to ourselves that we are not ghosts but real. Forcibly destroying life or forcibly creating it are two things ghosts cannot do.

The single point of this play can be perfectly summarized in another of Beckett's plays, in which there is not only no action but also no actors and no words! As the curtain goes up (after a wait), the audience sees a stage littered with garbage. They wait for someone to enter or speak and for something to happen. They wait in vain. After this second wait, the curtain falls. And that is all.

That is one step beyond even the nihilism in the soul of Macbeth, who is on his way to hell and sees all of human life as "full of sound and fury, / *signifying nothing.*" It is even beyond the nihilism of MacLeish in his poem "The End of the World," where nothingness takes the place of God (see chapter 9). What is the meaning of life? What does life signify? Nothing! William Faulkner, in *The Sound and the Fury*, tells the same story, the story of damnation, not from the outside, as Shakespeare does when he views Macbeth's fall into nihilism from the perspective of a meaningful Christian worldview, but from inside, from Macbeth's point of view. Shakespeare *frames* Macbeth's "sound and fury, signifying nothing" by a Christian frame; Faulkner removes the frame. Beckett takes Faulkner's nihilism one step further: in *Waiting for Godot* there is not even any sound or fury, as in *Macbeth* and *The Sound and the Fury*; there is just nothingness. And a lot of it! As Estragon says, "There's no lack of void." As Vladimir says, "This is becoming really insignificant." Significantly insignificant. Really unreal. The real presence of the absence of Being.

The London *Times* missed the point of this play as totally as it is possible for a person to miss the point of a play when it described it as "one of the most noble and moving plays of our generation, a threnody of hope." But its whole point is precisely the deconstruction of all nobility, all hierarchy of values, as well as of all human movement and activity ("go" and "do")—and thus all hope. When I first read that review, I thought it was a satire, but I soon realized that the author of the review had succeeded in making satire impossible by erasing the distinction between satire and reality. He would probably take seriously and literally the happy-face pop psychology of "I'm okay, you're okay" and "Look for the silver lining" that Christ preaches from his cross to the two dying thieves in Monty Python's satirical *Life of Brian*. Beckett called *Waiting for Godot* "a tragicomedy," but the *Times'* interpretation misses both its tragedy and its (satiric) comedy. As Thoreau said: "Read not the *Times*. Read the eternities."

### The Play as a Mirror: Our Reactions to It

Which brings us to the revealing point of our surprisingly diverse reactions to this play. Whenever I teach it, I find my students divide into four clearly distinct groups. (In that way, this play is like Christ, for Christ too divided those who met him into clearly distinct groups, like a bright mirror.)

The first group, like the London *Times* reviewer, felt deep admiration and compassion for Vladimir and Estragon. This group included both believers and unbelievers.

A second group, composed almost entirely of unbelievers, thought it a hilarious and successful satire on religion.

A third group, composed almost entirely of believers, thought it a hilarious and successful satire on atheism.

A fourth group thought the whole thing was neither tragic (like the first group) nor comic (like both the second and third

groups) but nonsensical, empty, shallow, stupid, silly, and worthless. This group too included both believers and unbelievers.

I think the two groups who are the closest to each other and also to the play itself and the sensibilities of its author are the second and the third, even though they were the most divided from each other in what they believed; for both groups instinctively felt it to be hilarious. I think both these groups understood the play best because they both understood the subtitle, "a tragicomedy," while most in both the first and fourth groups did not.

These four reactions lead me to suspect that perhaps our conscious answers to poll questions about religious beliefs are less probing and revealing of our deepest human divides than are our instinctive reactions to a play like this. I have long suspected that a sense of humor tells more about a person's relationship with reality, and thus implicitly with God's mind, than almost anything else.

### The Setting, the Props

The setting of this play is also, like the characters, almost nonexistent. It is as minimalist as that of *Our Town*, and for the same reason: both plays are mythic, not "realistic." They are about universals, about Everything, about life itself, and therefore about everybody, including you. That's signified by Pozzo's question to Estragon, "What is your name?" and Estragon's reply, "Adam."

There are only three descriptions of the setting for this play: "*A country road. A tree. Evening.*" The road is the place, or space; the tree is the matter; and evening is the time. These are the three constants in the physical universe. These three props—the road, the tree, and evening—can also symbolize, respectively, culture, nature, and death: three universal constants in human life.

"A road" (which is man-made, and thus culture) naturally symbolizes hope, teleology, purpose, destination, and meaning. But this road leads nowhere, and the protagonists do not move on it.

"A tree" naturally symbolizes all of nature and all of human life as part of nature, and this tree is dead. But at the beginning of act 2, "*The tree has four or five leaves.*" This is the only real event, or change, that happens in the entire play. Is it a signifier of hope, or is it just random and meaningless, or, even worse, is it just a cruel trick, the worm on the fishing hook? In the whole of the play there is no answer to that question, unless the not-coming of Godot is itself the answer.

"Evening" naturally symbolizes death, or the coming of death, or the death of coming, the death of hope for Godot's coming. "They give birth astride of a grave, the light gleams an instant, then it's night once more." "Down in the hole . . . the grave digger puts on the forceps. . . . In an instant all will vanish and we'll be alone once more, in the midst of nothingness!"

## The Theme, the Point

Beckett's main theme is not ethical but metaphysical, ontological. It's not that Vladimir and Estragon have taken the wrong road. There are no right roads. It's not their fault; it's their fate. It's not that they are cowardly or lazy; it's not that they can and ought to "go" and "do." It's that "there *is* nothing to *be* done." The play is about what *is*. This is a play about Being, about its lack. "There's no lack of void." Gabriel Marcel perspicaciously observes that the fundamental distinction is not between "the one and the many" but between "the full and the empty."

Its philosophy is the philosophy of Ecclesiastes: "Vanity of vanities, says the Teacher; all is vanity" (Eccles. 12:8). All is in vain, all "going" and "doing." (Thus, the nickname "Gogo" is satirical.) There *is* no good, no goal, no end, no purpose, and

therefore no progress and no hope for progress, because if there is no goal to measure it, progress is logically impossible. There is in this play no difference between time and eternity: "Time has stopped." It is a dark inverse of the identity of alpha and omega, the beginning and the end, in God and in heaven. It is the non-difference between our future and our past, between act 1 and act 2. That is why there are two acts; to show that there are *not* two acts, that nothing changes. It is the worm Ouroboros, swallowing its own tail. God alone can endure and live in timeless eternity; our souls need time to breathe as our bodies need air.

Beckett is teaching the ontological point of Sartre's philosophy when he says, through Estragon, that "everything oozes." Marcel explains the image:

> To understand and sympathise with Sartre's basic experience I need only recall the disgusting feeling of coming on a "gooey" lump in a *purée*. "Gooeyness" is indeed the key word, but it is, for Sartre, gooeyness on an enormous scale. . . . For him, the whole of life is, if not actually gooey, at least tending towards gooeyness. . . . It is surely in this absence of contours that the principle of *La Nausée* [Sartre's novel] resides. . . . It is that of a man who, on waking up one morning, discovers himself to be, not, as in Kafka's story, an ant, but a whole ant-heap.

There are no natures, no definitions, no essences, no *logos*. This is total deconstructionism.

Marcel's alternative to this Sartrian nausea and nihilism is that there is being, and that being means intrinsic value and value means being; that what-is and what-ought-to-be are not two unrelated realms; that being entails value and value entails purpose and purpose entails hope. Thus, hope is ontological. It is about being.

## Hope

Hope is fundamentally not psychological but ontological. It is not an expression of subjective desire or feeling but of objective truth. It is a truth-claim, a prophecy. Marcel says: "Hope consists in asserting that there is at the heart of being, beyond all data, beyond all inventories and all calculations, a mysterious principle . . . which cannot but will that which I will if what I will deserves to be willed and is, in fact, willed with the whole of my being. . . . I do not wish: I assert; such is the prophetic tone of true hope."

So is there hope in Beckett's world?

In one sense, yes, for he deliberately inserted one obvious symbol of it into the play, one tiny change in the plot: in act 2, there are a few leaves on the tree. And the tree is not a random symbol but a significant one. In Christianity, the tree of the cross is the tree of life that conquers the evil of the tree of the fall into both spiritual and physical death. The tree is the sign or symbol of Godot for whom they wait:

> Estragon: Let's go.
> Vladimir: We can't.
> Estragon: Why not?
> Vladimir: We're waiting for Godot.
> Estragon (*despairingly*): Ah! (*Pause.*) You're sure it was here?
> Vladimir: What?
> Estragon: That we were to wait.
> Vladimir: He said by the tree.

But the reason there cannot be any true hope in Beckett's world(view) is that there is no hierarchy of values, no better or worse, even among miseries:

> Estragon: (*He raises what remains of the carrot by the stub of leaf,*
> *twirls it before his eyes.*) Funny, the more you eat the worse it gets.
> Vladimir: With me it's just the opposite.
> Estragon: In other words?
> Vladimir: I get used to the muck as I go along.
> Estragon: (*after prolonged reflection*). Is that the opposite?

There is also no hierarchy of time, no progress. The end is no different from the beginning. Nothingness has the last word: "*They do not move.*"

> Estragon: I can't go on like this.
> Vladimir: That's what you think.

That's why Pozzo is terrified by this prospect:

> Vladimir: Time has stopped.
> Pozzo: (*cuddling his watch to his ear*). Don't you believe it,
> Sir, don't you believe it. (*He puts his watch back in his pocket.*)
> Whatever you like, but not that.

Hell is timeless. So is heaven. Unlike us, both God and the devil are immortal. Hell is eternal, and so is heaven, but heaven includes all time while hell excludes it. In hell, tomorrow is no different from today, as today is no different from yesterday. In heaven, "when we've been there ten thousand years, bright

shining as the sun, we've no less days to sing God's praise than when we'd first begun."

And both heaven and hell begin here and now, in this world. Vladimir and Estragon are living in hell, like Macbeth, and the only "good news" of the boy who seems to be Godot's servant and prophet is that "Mr. Godot told me to tell you he won't come this evening but surely tomorrow." In heaven, tomorrow is part of today; in hell, "tomorrow is always a day away."

## The Question of Suicide

Wouldn't suicide be a kind of hope, like a declaration of bankruptcy? As Vladimir says, "Your only hope left is to disappear." No, because that choice is no different, no better or worse, no more meaningful and hopeful, than any other. As in Sartre's *Nausea*: "I thought vaguely of doing away with myself, to do away with at least one of these superfluous existences. But my death—my corpse, my blood poured out on this gravel, among these plants, in this smiling garden—would have been superfluous as well. I was superfluous to all eternity."

Thus, suicide is reduced to a triviality:

Vladimir: What do we do now?
Estragon: Wait.
Vladimir: Yes, but while waiting.
Estragon: What about hanging ourselves?
Vladimir: Hmm. It'd give us an erection.

But, after a futile calculation about the technology of hanging, they decide: "Don't let's do anything. It's safer." That was Beckett's own choice, too—not to commit suicide—though apparently for a different reason: you can't write a great play if you're dead. So the very act of writing a play about meaninglessness refutes the

philosophy of meaninglessness, in the real world of deeds even if not in the dream world of philosophy or the theater of words.

## Sin and Repentance

One of the reasons for absence of hope is the absence of the possibility of repentance and forgiveness, since there is no God and thus no concept of sin. Like everything else, it is dissolved into vagueness:

Estragon: What exactly did we ask him [Godot] for?
Vladimir: Were you not there?
Estragon: I can't have been listening.
Vladimir: Oh . . . Nothing very definite.
Estragon: A kind of prayer.
Vladimir: Precisely.
Estragon: A vague supplication.
Vladimir: Exactly.
Estragon: And what did he reply?
Vladimir: That he'd see.

Exactly the maddeningly vague promise parents give to their small children when they don't want to simply say yes or no.

In Beckett's world, Christianity would be not merely false but impossible because it demands repentance, and repentance would be impossible:

Estragon: Where do we come in?
Vladimir: Come in?
Estragon: Take your time.
Vladimir: Come in? On our hands and knees.
Estragon: As bad as that?
Vladimir: Your Worship wishes to assert his prerogatives?

Estragon: We've no rights any more? . . . We've lost our rights?
Vladimir: We got rid of them.

The issue of the connection between hope and repentance arises very early with the mention of the two thieves crucified with Christ:

Vladimir: One of the thieves was saved. (*Pause.*) It's a reasonable percentage. (*Pause.*) Gogo.
Estragon: What?
Vladimir: Suppose we repented.
Estragon: Repented what?
Vladimir: Oh . . . (*He reflects.*) We wouldn't have to go into the details.
Estragon: Our being born?

But repentance, and thus hope of salvation, *depends on* "the details." "Our being born" is not a "detail." One cannot repent one's being born. One wonders whether Beckett is simply misunderstanding Christianity here or understanding it very well indeed, and rejecting it as a "package deal," through his two protagonists.

## The Motives for Atheism

Why is it a "package deal"? Because the alternative to nihilism depends on hope, and hope depends on forgiveness, and forgiveness presupposes repentance, and repentance presupposes sin. But if there is no God, there is no sin, for sin means infidelity to God. It is a circle but not a circular argument, because it is not an argument. Christianity is a marriage proposal from God, and like every authentic marriage proposal it is a "package deal," a "take all of me." It all stands or falls together.

And therefore, the real motives and causes for both belief and unbelief in the religious "package" are not parts of the package

but parts of the recipient of it. And these motives are more pri-mordial and mysterious than deductive or inductive reasoning. They are what Pascal calls reasons of the heart first of all. For "the heart has its reasons, which the reason does not know." The heart has not just feelings but "reasons," but its "reasons" are intuitive and holistic. Apologetics may validly deduce the rest of the reli-gious "package" from any one part of it, but that is not how the heart works. Analysis may deduce the rest of a painted portrait from one part of it, as paleontologists deduce the whole dinosaur from one of its bones; but that is not how the human artist's mind worked when he designed the picture, nor is that how the divine artist's mind worked when he designed the dinosaur—or the man. Nor is that how the spectator's soul works when he "accepts" the work of art, receives it and understands it. Understanding human beings and human life is more like art than like science.

### Humanism as Hope?

However, there is in *Waiting for Godot* some kind of positive and actually achieved hope: togetherness in the muck. On the very first page, Vladimir says: "I'm glad to see you back. I thought you were gone forever. . . . Together again at last! We'll have to celebrate this."

It is as it is in *J.B.* and Stephen Crane's allegory "The Open Boat." If Godot cannot come to us, we can at least come to each other.

And self-forgetful love, in however tattered a form, remains a possibility and a meaningful contrast to its two alternatives:

Vladimir: (*Joyous.*) There you are again . . . (*Indifferent.*) There we are again . . . (*Gloomy.*) There I am again.

There remains here one meaningful value hierarchy, with the self-forgetfulness of "you" at the top, as "joyous"; and the self-addicted "I" at the bottom, as "gloomy"; and the collective "we" in the middle, as "indifferent." Even when the first great commandment is thought impossible, the "second is like it" (Matt. 22:39), and that one remains doable.

A theological aside from "outside": when we do love our neighbor with genuinely selfless love, we are obeying one of God's two great commandments and thus willing what God wills. This is why there is genuine hope for the salvation of atheists. There is also genuine concern, since the other half of this "two-in-one package deal" is missing. Christ's answer to the question "Will those who are saved be few?" was neither "yes" nor "no" but "Strive to enter through the narrow door" (Luke 13:24).

## Cultural Nihilism

There may be this halfway house of hope for individuals in this play, but there is none indicated for our society, culture, or civilization. There are at least three striking symbols of this:

1. The relationship between Pozzo (a play on *pazzo*, the Italian word for "nuts" or "insane") and "Lucky" (an obvious irony) is the master-slave relationship, the oppression which, for Marx, pervades all human history. What Lucky carries in his bag is only sand.
2. The contents of Vladimir's pockets are "bursting with miscellaneous rubbish," which is pretty obviously Beckett's symbol for all of culture and civilization, which is not only "rubbish" but, even worse, "miscellaneous," lacking in *logos*.
3. Lucky's famous one-sentence "speech" of more than seven hundred words is all of culture in a blender—or in the small intestine and destined for the sewer.

## Epistemological Nihilism

And this brings us to the play's take on reason.

In Lucky's "speech" (the quotation marks are deliberate), the sublime (e.g., "Essy-in-Possy," a satire on the metaphysics of existence [*esse*] and essence [potential or *posse*]) and the ridiculous (e.g., quoting the authorities "Fartov and Belcher") are blended into one. The same lack of hierarchy and lack of discrimination (the two most despised words in modern culture!) is applied to Christianity. Everything high is reduced to something low. When the Bible is mentioned, it is reduced in Estragon's mind to a pale color for a dead sea:

> Vladimir: Did you ever read the Bible?
> Estragon: The Bible . . . (*He reflects.*) I must have taken a look at it.
> Vladimir: Do you remember the Gospels?
> Estragon: I remember the maps of the Holy Land. Coloured they were. Very pretty. The Dead Sea was pale blue. The very look of it made me thirsty. That's where we'll go, I used to say, that's where we'll go for our honeymoon."

The "argument" against believing the Bible is deliberately (I hope) trivial and fallacious:

> Vladimir: How is it that of the four Evangelists only one speaks of a thief being saved. . . . Of the other three, two don't mention any thieves at all and the third one says that both of them abused him. . . . But one of the four says that one of the two was saved.
> Estragon: Well? They don't agree and that's all there is to it.
> Vladimir: But all four were there. [*Sic!*] And only one speaks of a thief being saved. Why believe him rather than the others?

43

Estragon: Who believes him?

Vladimir: Everybody. It's the only version they know. [*Sic!*]

Estragon: People are bloody ignorant apes. [No *sic!*]

The burlesque horseplay about the protagonists' hats makes visible the invisible and conceptual verbal horseplay about their heads. (The same horseplay surrounds their boots, symbols of "go" and "do.") Their brains are reduced to entertainment machines. Pozzo commands Lucky to "Think!" and he produces his verbal diarrhea.

Vladimir: He thinks?

Pozzo: Certainly. Aloud. . . . Well, would you like him to think something for us?

Estragon: I'd rather he dance, it'd be more fun.

This implies that thinking is *less* "fun," and therefore threatening, so that our chatter is there to protect us from it:

Estragon: In the meantime let us try and converse calmly, since we are incapable of keeping silent.

Vladimir: You're right, we're inexhaustible.

Estragon: It's so we won't think.

### The Reasons for Atheism

There is no *argument* for atheism here. Religion, which means literally a "yoke" or "binding relationship" to God, is seen as simply and literally unthinkable:

Estragon: I'm asking you if we're tied.

Vladimir: Tied?

Estragon: Ti-ed.

Vladimir: How do you mean tied?

Estragon: Down.
Vladimir: But to whom? By whom?
Estragon: To your man.
Vladimir: To Godot? Tied to Godot! What an idea! No question of it.

Why not? Because to Beckett, being "tied" means being tied "down," not up as with all the saints and mystics.

Thus, this "dream" of Christianity is rejected because it is seen as threatening, not liberating:

Estragon: I had a dream.
Vladimir: Don't tell me!
Estragon: I dreamt that—
Vladimir: DON'T TELL ME!

It may seem puzzling at first, but it is very significant that when they think Godot is turning up they are not comforted but terrified. To judge by their postures, this salvation would be itself a "fall":

Vladimir: Listen! (*They listen, grotesquely rigid.*)
Estragon: I hear nothing.
Vladimir: Hsst! (*They listen. Estragon loses his balance, almost falls. He clutches the arm of Vladimir, who totters. They listen, huddled together.*) Nor I. (*Sighs of relief. They relax and separate.*)
Estragon: You gave me a fright.
Vladimir: I thought it was he.
Estragon: Who?
Vladimir: Godot.

When their greatest hope itself is their greatest fear, hopelessness is complete. It is as if the sun became a black hole.

And yet Beckett cannot help being obsessed, or "tied," to Christianity:

Vladimir: But you can't go barefoot!
Estragon: Christ did.
Vladimir: Christ! What has Christ got to do with it. You're
not going to compare yourself to Christ!
Estragon: All my life I've compared myself to him.

Nietzsche called Christianity "the synthesis of all errors," and yet he signed his last letters, from his insane asylum, "The crucified one."

Beckett does not ignore God. He cannot (or will not) free himself from his obsession with God. He is tied (religiously) to his not being tied (religiously). The absence of God's presence in *Waiting for Godot* is really the presence of his absence; and that is a real presence! If you want to see what difference God makes to everything (and to Everything), this is one of the most helpful books you can ever read.

# Three Dramas
# About Religion

# (Relationship with God)

# 4

## PRE-CHRISTIAN

# *Prometheus Bound*

### BY AESCHYLUS

This is the first and oldest of all great plays.

Its greatness does not depend on plot and action, for there is none; or on dramatic interaction between protagonists, for there is little; or on character, for all the characters are one-dimensional, as befits mythology.

Its greatness, its height, depends on its theme and on its style, its rhetoric, which is proportionate to the high theme. The theme is man's relationship to the gods, and to Fate, which rules over all, men and gods alike. (The same theme of the absoluteness of Fate is present in all Greek dramas, most notably in *Oedipus the King*, as we shall see later.)

What is the difference between pagan and Christian religion? It is the difference between "the relationship of men to the gods" and "the relationship of man to God." God creates man, but men create gods. In pagan polytheism, men invent gods in their own image—or rather in their own image*s*, for men are always divided and in conflict. But if the one God created man in his image, then our divisions and conflicts with each other and with God are not part of that image, not part of the One—even when,

49

as in Christianity, the One is three persons, since those persons are in perfect and complete unity in mind and will and even in substance, or essence, or being. The imagined conflict among the Greek gods in pagan polytheism is the effect and image of the real conflict between man and God; and even though in paganism we do find piety or the fear of God, which is the beginning of wisdom, it never matures into wisdom, love, hope, and trust, except in Socrates, at least to an extent—an extent that is about halfway between paganism and Christianity.

The background of this play is far more important and dramatic than the play itself. Zeus, the far-from-wise, bad-tempered tyrant, has recently become the autocratic ruler of all the gods by cunning and force—in fact, by parricide against his father, Kronos (which is the Greek word for cosmic Time). He declared himself the enemy of mankind and resolved to exterminate the human race out of jealousy and fear that they would rival the gods. Prometheus, one of the Titans, opposed Zeus' plans, both because he despised Zeus and because he pitied mankind. He stole fire from the gods and gave this gift to men, thus founding all the arts of human civilization.

Zeus, in his fury, punished Prometheus by having him chained to a rock, unable to die, escape, or sleep, to be tortured daily by having his liver eaten by birds and then regrown for more torture the next day. As Zeus claimed to rule forever, he sentenced Prometheus to suffer thus forever; but both claims are prophetically declared to be false by Prometheus, who predicts his own eventual release and Zeus' eventual overthrow.

So with the exception of Prometheus (and a very few of the other gods, such as Io), the gods are mankind's enemies, not their friends, according to the Greeks' collective myth. Obviously, a radically different god is on stage here than in the Christian story. Or, for that matter, in the post-Christian story, where man becomes his own god.

This picture is not the whole of the pagan worldview; and our first play, *Under Milk Wood*, paints a more benign picture of paganism, which was its relationship to nature and human nature, even at its weirdest and wildest, and omits the worst side of paganism, which was its religion full of wicked and untrustworthy gods. In *Under Milk Wood*, religion was a thin layer of Christian icing on the pagan cosmological cake that had long lost the poisonous ingredients of its threatening gods. That thin Christian icing did not include the new, less-than-comfortable aspect of sin, the Christian relationship of man to himself as a sinner, since without a strong sense of the new Christian *marriage* to God, there is no strong sense of the *divorce* from God.

The backstory to *Prometheus Bound* is the long and evolving metanarrative of Greek mythology. The play is a festooning of a small segment of the myths—as if someone decorated one of many trees in a forest with ornaments. Although "myth" means "sacred *story*," myths in their original forms are not dramas, plays, or novels. They were told orally long before they were written down by poets like Hesiod, and used as the background for epics, like those of Homer. The myths themselves are not realistic fictions, and they have little or no concrete detail or psychological subtlety. Nor, at the opposite extreme, are they abstract allegories, as they were later interpreted to be by the philosopher-influenced Greek thinkers who had ceased to take them seriously and literally; for they are not, like allegories, codes or puzzles to be solved by cleverness, nor do they have one and only one correct interpretation such that once you find that, you are finished with them. They are like stones thrown into the pond of human consciousness, making many ripples on the surface and many changes in the dark underwater depths.

Later writers influenced by the old myths sometimes transcend this dualism between abstract allegory and concrete realism, between universal truths and concrete facts, and write

archetypal myths that are also realistic—that is, both psychologically subtle in their characters and detailedly naturalistic in their settings (e.g., Tolkien's *The Lord of the Rings* and Lewis' *Till We Have Faces*). Homer and Virgil stand somewhere between these two points. But in the myths themselves, these two realistic elements (of character and setting) are spare or simply absent.

And this is not because the myths are mere *stereotypes*, which are *less* than empirically observed reality, but because they are *archetypes*, which are *more*. The distinction is so crucial that it bears repeating. Archetypes are not like undeveloped infants but like pregnant women. Stereotypes are constructed by society; archetypes construct society. Stereotypes are subnatural; archetypes are supernatural.

The story, the dramatic events, in *Prometheus Bound* is not in the play itself but in the mythic events that have preceded it and that are prophesied to follow it. So this "play" is like a still photograph of a crucial stage in the moving picture or long story of the gods' relationships to men and to each other that is the story of pagan religion. (Religion is a story because the word means literally a "binding relationship"—from the Latin *religare*—and relationships are stories because they change when at least one of their parties change, as mankind always does, and pagan gods also do, even if the true God does not.)

In writing this play, the author's religious or theological problem is obvious: What is the nature of the divine power and its relationship to mankind? The nature of the divine power is the "theological" or "thinking about God" question; the relationship to mankind is the "religious" or relationship question. And Aeschylus' answer to that question is not original. But he has another problem, as a playwright, that does demand originality and creativity: how to make drama out of a situation that is changeless and unable to change because the protagonist is literally chained to a rock. The rock, like the Greek myth, cannot

be moved by mere men (that's the "theology"); and the rebel god who is chained to that rock, Prometheus, also cannot be moved from it by either men or any of the lesser gods (at least for now) because Zeus, who has supreme power, has decreed these chains. Only the defeat of Zeus can cause the liberation and further adventures of Prometheus.

Aeschylus' solution to this dramatic problem of the lack of drama is threefold.

First, the dramatic changes of past and future are referred to in the present staging. They are all offstage, either in the past (Zeus' rebellion against his father) or in the future (Zeus' prophesied removal from power by his own son's rebellion).

Second, three secondary characters are brought onstage to dialogue with Prometheus: Oceanus, who, like Fate, is impersonal and neutral; Io, who has also suffered from Zeus' tyranny and who sympathizes with Prometheus, and in punishment is transformed by Zeus into a cow; and Hermes, the "lackey" of Zeus, who seems to prevail against Prometheus.

But the audience knows that Hermes will not prevail, for the audience are the very ones who have received Prometheus' stolen fire from heaven, since they are now participating in one of its greatest flames—namely, the art of drama! Thus, the audience knows that Zeus' will to destroy mankind will not succeed, and mankind will survive and thrive—because of Prometheus.

Thus, ironically, although Greek drama was supposed to assume and foster piety to the gods, *Prometheus Bound* fosters the opposite: Zeus is the villain, and Prometheus the rebel is the hero. The drama is in the ironic contrast between appearance and reality.

At the beginning of the play there are also two other characters, but they are merely allegorical: Power (Kratos) and Force (Bia), who in Zeus' name and in obedience to Fate have captured Prometheus and are carrying him to his rock, far from

civilization, where "no human voice will reach thee here, nor any form of man be seen."

Third, the inner turmoil and desire that boils forth from Prometheus' lips is itself dramatic, both because of its high style and because of its profoundly philosophical question of the relation between power and goodness, might and right, will and law, which is the fundamental question of all political philosophy, and which will be the central issue in the most famous of Plato's dialogues, the *Republic*.

Zeus himself is a rebel, an upstart, and a parricide. In Greek paganism, gods change even more suddenly and unpredictably than men. The Chorus announces that "new helmsmen guide in the heavens, and Zeus unlawfully rules with new laws."

The only law above Zeus is not justice or charity but Fate. Law (morality) and power have no necessary or natural relation to each other, and in the ontological hierarchy of Greek paganism, right (law) is subject to might (power), and both are subject to Fate. Only later is the hierarchy reversed, so that natural moral law is placed above power and force, and a "wisdom" that is not mere cleverness (like Ulysses') but moral reason, a "natural moral law," is placed above will and willpower, especially with Socrates, Plato, and Aristotle.

But in the myth, it will not be a moral law (*logos*) of divine justice (*dike*) that brings Zeus down, but his own foolish pride (*hybris*), as Prometheus predicts:

> Prometheus: His pride shall be humbled, I think; his hardness made soft, and his wrath shall bow to the blows of adversity. . . .
> He shall himself despoil by his own folly. . . .
> Io: His bride shall drag him from the throne?
> Prometheus: A son she shall bear, mightier than his father. . . .
> Then at last the curse of his father Kronos shall be fulfilled to the uttermost.

The alternative to brute force here is not justice (law) or charity (love) but simply cleverness and guile. Prometheus says, in speaking of Zeus' forthcoming downfall, "Not by might or brutal force should victory come, but by guile alone."

There is no appeal to anything or anyone beyond Fate, and Fate has no face. Fate, or Necessity, rather than a moral law of justice, is the only justification for the pagan exaltation of humility over pride. As Oceanus says to Prometheus, "Thou hast not learned humility, nor to yield to evils. . . . Kick not against the pricks, for there rules in heaven an austere monarch who is responsible to none." It is ambiguous, from the context, perhaps deliberately, whether that ruler is meant to be identified with Zeus or Fate.

But Fate is not a character in the play, even in the sense that Zeus is. Fate, like the true God, is usually invisible and anonymous, yet omnipresent and omnipotent. In Christianity, the omnipresent and omnipotent God comes on stage and has *more* of a human personality than anyone else, and he does the most dramatic thing ever done. But not here. Fate is faceless and inexorable:

Chorus: Who then holds the helm of Necessity?
Prometheus: The Fates triform and the unforgetting Furies [their instruments].
Chorus: And Zeus, is he less in power than these?
Prometheus: He may not avoid what is destined.

The sin for which Prometheus is being punished is love—love of mankind. The contrast with Christianity is almost painfully obvious, and if the reader did not know the date of the play, he might suspect its author to be a Christian and the play to be an allegorical satire on paganism. In Christianity, "God so loved the world [mankind] that he gave his only Son, so that everyone who believes in him may not perish but may have eternal life" (John 3:16). In Greek paganism, Zeus so *hated* the world of man that

he punished his servant Prometheus for doing what Jesus did in giving mankind a higher life. In Christianity, God is love, and lovable, and the love of God and man *overcomes* sin; in paganism, the true god is Fate, and the one who claims to be the true god is an unlovable tyrant full of hate and jealousy, and in the mind of this god the love of man *is* sin, and Prometheus is punished for it. "See now the profit of thy human charity," scolds Hephaestus. One of these two gods is upside down.

One strange and ironic *similarity* to Christianity is that for both religions it is true of the hero, as Prometheus says, that "mankind I helped, but could not help myself." When Christ was crucified, the Jews said to him, "If you are the Son of God, come down from the cross," and when he refused, they scolded, "He saved others; he cannot save himself" (Matt. 27:40–42). This was true in a profounder sense than they meant it: it was precisely because he was saving others that he could not save himself.

Another ironic foreshadowing of Christianity is in the advice of Hermes, who, like Caiaphas in John 11:47–52, spoke a prophetic truth-to-come that he did not fully understand, when he said to Prometheus: "Neither look for any respite from this agony, unless some god shall appear as a voluntary successor to thy toils, and of his own free will goeth down to sunless Hades and the dark depths of Tartarus."

Prometheus has hope of defeating Zeus, but neither he nor anyone else, even Zeus, has any hope of defeating impersonal Fate, which rules both gods and men with an iron hand. The only relationship we can have to this god, the only thing we can do with Fate, is to suffer it. Even Prometheus must admit that "the will of Destiny we would endure . . . knowing still how vain to take up arms against Necessity." The ultimate reality here is not a divine person but an impersonal Force. This pagan point of view is essentially the same as that of modern atheism and materialism.

It is a pity that most Christians today know and care very little about history in general and about Judaism and paganism in particular, because those are the two historical religious traditions that cast a remarkably clearer light on Christianity: Judaism, by providential preparation and prophecy, and paganism, by contrast.

# 5

## CHRISTIAN

# A Man for All Seasons

### BY ROBERT BOLT

Plato's verdict on Socrates, in the last words of the *Phaedo*, was that he was "of all the men in the world the most just, the most reasonable, the most virtuous." And Samuel Johnson said of St. Thomas More that "he was the person of the greatest virtue these islands ever produced." A saint like More is an example and "test case" of the difference that a personal relationship with God (i.e., "religion") makes to a man's life.

This play was made into a movie that won the Academy Award for Best Picture in 1966. It is my candidate for the most perfect movie ever made. Certainly, it is the best one ever made about a saint. (I do not count *The Passion of the Christ* as a movie, for it is not something to "watch"; it is a bloody liturgy to be caught up in. It abolishes distance.)

Rarely are movies that are made from classic plays or novels as good as the original. The BBC version of Dickens' *A Tale of Two Cities* and Martin Scorsese's version of Endo's *Silence* are two notable exceptions, largely because they were faithful to the books. Even rarer are movies that are even better than the books

or plays they were based on. Besides *A Man for All Seasons*, *Jaws* and *The Exorcist* are the only two that come to mind, and neither of those two books was great, though the movies were. More than one movie was made of the two classic plays *Waiting for Godot* and *Our Town*, but none were as effective as the plays they were based on. But the movie of *A Man for All Seasons* was.

Part of the reason was how perfectly Paul Scofield fit the part. Another reason was its perfect use of music, costumes, and scenery, especially the water symbolism. Another part was getting rid of the artificial and intrusive commentator "The Common Man," who, like the Stage Manager in *Our Town*, performed the function of the Greek chorus but who, unlike the chorus and the Stage Manager, seemed superfluous rather than a natural fit.

### The Point of the Play

The central point of the play is More the man, not God, or even More's religion, his relationship with God. Robert Bolt, the author, was an agnostic. Yet his play is profoundly respectful and understanding of More's religion (and perhaps envious). We see very clearly the difference More's faith makes not just to his life and actions and destiny but to his character, his very essence. Bolt sees this very essence of More as the central thing lacking in modern man:

> We no longer have, as past societies have had, any picture
> of individual Man (Stoic Philosopher, Christian Religious,
> Rational Gentleman) by which to recognize ourselves and
> against which to measure ourselves; we are anything. But if
> anything, then nothing. . . . And the individual who tries to
> plot his position with reference to our society finds no fixed
> points, but only the vaunted absence of them, "freedom" and
> "opportunity": freedom for what, opportunity to do what, is

nowhere indicated. . . . It is with us as it is with our cities—
an accelerating flight to the periphery, leaving a center which
is empty when the hours of business are over.

In contrast, More clearly "knew where he began and left off,
what area of himself he could yield to the encroachments of his
enemies. . . . Since he was a clever man and a great lawyer he was
able to retire from those areas in wonderfully good order, but
at length he was asked to retreat from that final area where he
located his self. And there this supple, humorous, unassuming
and sophisticated person set like metal . . . and could no more be
budged than a cliff."

The play opens with More comfortably ensconced in the
good graces of King Henry VIII, who has made him his Chan-
cellor. But Henry had not been able to father a male heir, di-
vorced his first, legal wife, and broke with the Roman Catholic
Church when the pope would not (or rather could not) grant him
a divorce. More stood alone in not signing an oath supporting
Henry's break with the Church, and as a consequence he lost
everything: not only his chancellorship and comfortable income
but eventually his life. He stood like a rock amid the changing
tides and destructive waves of his time. Bolt's play looks at this
conflict not from history's outside but from More's inside, from
the heart of his soul—that is, his will and his reason.

From his prison cell in the Tower of London, More explains to
his daughter Meg why he must accept martyrdom and cannot, like
all the others, use mental reservation and take a lying oath of fealty
to his king in support of his break with the Church, and thus with
Christ: "When a man takes an oath, Meg, he's holding his own self
in his own hands. Like water. (*He cups his hands*) And if he opens
his fingers *then*—he needn't hope to find himself again."

More has an absolute, a center, an "infinite passion," as
Kierkegaard put it. (This passion is also the center of our next
play, *Equus*, in a post-Christian form in two characters: in an

acted-out way in the protagonist and in a pagan dreamed-of way in his psychiatrist.)

Bolt says this apparent fanaticism (modernity's most serious and severe insult) is "something which I feel the need to explain [to modern man]. . . . More was a very orthodox Catholic and for him an oath was something perfectly specific; it was an invitation to God . . . to act as a witness and to judge; the consequence of perjury was damnation, for More another perfectly specific concept."

That is why More says, sincerely, to his betrayer Richard Rich, "In good faith, Rich, I am sorrier for your perjury than my peril." And when he learns that Rich did this simply for the sake of being appointed Attorney-General for Wales, he says, "(*Looking up into Rich's face, with pain and amusement*) For Wales? Why, Richard, it profits a man nothing to give his soul for the whole world. . . . But for Wales!"

He is assuming here the truth of Mark 8:36, the single most practical sentence any man ever uttered, a sentence that presupposed that a man knew that he *had* a soul, an identity, an essence, a castle keep that could not be yielded, an inner absolute. Modern man, in contrast, is, in the words of Carl Jung's title, "in search of a soul."

Bolt says, to his modern audience, "But though few of us have anything in ourselves like an immortal soul which we regard as absolutely inviolable, yet most of us still feel something which we should prefer, on the whole, not to violate [notice the weak "weasel words"] . . . (the marriage vow, for example)." Alas, Bolt wrote this at a time that now seems as remote as Camelot.

### The Need for Religion

Thus, this play, though about More the man, is also about God, for as even the agnostic Bolt admits, "It may be that a clear sense

of the self can *only* crystallize around something transcendental, in which case our prospects look poor." When "God is dead," his image soon dies as well. The point of Bolt's play is a prophecy, a terrifying warning about nothing less than what C.S. Lewis called "the abolition of man."

This is also the point of More's conversation with Norfolk, who compromises and cannot understand why More does not:

> Norfolk: Oh, that's immutable, is it? The one fixed point in a world of changing friendships is that Thomas More will not give in!
> More: (*Urgent to explain*) To me it *has* to be, for that's myself! Affection goes as deep in me as you think, but only God is love right through, Howard; and *that's* my *self.* . . . I will not give in because I oppose it—I do—not my pride, nor my spleen, nor any other of my appetites, but *I* do—*I!* (*More goes up to him and feels him up and down like an animal . . .*) Is there no single sinew in the midst of this that serves no appetite of Norfolk's but is just Norfolk?" . . .
> Norfolk: But damn it, Thomas, look at those names. . . . You know those men! Can't you do what I did, and come with us, for fellowship?
> More: (*Moved*) And when we stand before God, and you are sent to Paradise for doing according to your conscience, and I am damned for not doing according to mine, will you come with me, for fellowship?

Matthew, More's pragmatic steward, foresees quite early in the play that this will be More's downfall: "My master Thomas More would give anything to anyone. . . . There must be something that he wants to keep." There is indeed. It is his soul. To put the same point in terms that seem to be its opposite but are in fact

its cause, More has already given his soul to Christ; that is why he must keep it.

Thus, he says to Cromwell, after Rich's perjury and his own verdict of death, "What you have hunted me for is not my actions, but the thoughts of my heart. It is a long road you have opened. For first men will disclaim their hearts and presently they will have no hearts."

Cromwell, like all tyrants, demands More's soul and conscience, not just his body and his service. He is like the woman in the Bob Dylan song "Don't Think Twice, It's All Right": "I give her my heart but she wanted my soul."

### Conscience

If the soul is the heart of the self, and the spirit (the relationship to God) is the heart of the soul, then the conscience is the heart of the spirit. Bolt misleadingly calls this "your private conscience," which sounds perilously subjective. It is certainly true that each individual has, and is responsible for the work of, his or her own unique and irreplaceable conscience; but it is also true that conscience can have no absolute authority if its object is only oneself rather than God, for in that case the one who binds and the one who is bound are the same person. Conscience is a prophet, and prophets get their authority from God. If there is no God, then prophets can no more have divine authority than the king's servant can have royal authority when the king has been removed.

Cardinal Wolsey argues with More that the welfare and peace of the state and the avoidance of dynastic civil war is more important than his "own, private, conscience," and therefore it is More's public duty to approve King Henry's divorce and break with Rome so that he can remarry and hopefully have a legitimate heir. And More's reply is "Well . . . I believe, when statesmen forsake their own private conscience for the sake of their public

duties . . . they lead their country by a short route to chaos." That sounds like a merely utilitarian response to Wolsey's tempting utilitarian argument (which appealed to the very same principle as the argument of Caiaphas the high priest, the one that ensured the crucifixion of Christ [John 11:47–50]). But it is not. More is not agreeing with Wolsey that the *summum bonum* or final end is the welfare of the state and arguing only that fidelity to conscience is a more effective means to that end than compromise. He is warning Wolsey that if moral conscience is not enthroned as an absolute, then even the relatively great but secondary end of the welfare of the state will also collapse. When first things are put second and second things first, second things fall and fail as well as first things.

Conscience is indeed "private" in the sense that each individual has one, but it is not "private" in the sense of being a power to invent our own moral values. It is our fallible human understanding of objective moral truth and the will of God. Nor is it "private" in the sense of withdrawn from public and political duties and obligations.

Unfortunately (and this is the only weak point in this marvelous play), when Bolt has More give his strongest argument from conscience, the argument from the divine authority of the Church and thus of Christ himself, he has More explicitly separate and distinguish the personal, subjective dimension from the objective truth: "The Apostolic Succession of the Pope is— . . . Why, it's a theory, yes; you can't see it, can't touch it; it's a theory. . . . But what matters to me is not whether it's true or not but that I believe it to be true, or rather, not that I *believe* it, but that *I* believe it." Which is exactly and totally and precisely the thing More himself would *not* say and did not say! It is the very same heresy that Henry expected More to adopt: "No opposition, I say! No opposition! Your conscience is your own affair, but you are my Chancellor."

More explicitly rejects Henry's morality in his confrontation with Cromwell, when he says, "In matters of conscience, the loyal subject is more bounden to be loyal to his conscience than to any other thing." But More's reason was not that his conscience is *his*, or, surely, that it is "private," but that it is God's mouthpiece and that it is public as well as private because moral good and evil are public as well as private.

Bolt, unlike More, would probably defend pro-abortion "Catholic" politicians today who use this "privacy" defense: "I'm personally opposed, but . . ." That's a very big but. Pontius Pilate believed Christ was innocent, *but* he had a big "but": "I'm personally opposed to murdering the innocent, *but* . . ." I suggest invoking St. Thomas More as the heavenly patron for a "Pontius Pilate Big But Award," also known as a "Millstone of the Month Award" (Luke 17:2).

I fear Bolt would not have written the last line of *Judgment at Nuremberg*, in which the American prosecutor says to Janning, the German lawyer who compromised his conscience to go along with his Führer and who then defended himself by saying "I never knew it would come to that" (namely, the Holocaust): "Herr Janning, it came to that the first time you sentenced a man to death you knew to be innocent."

For "just as you did it to one of the least of these who are members of my family, you did it to me" (Matt. 25:40). If you believe that your Lord said that to you about your sins, and if you do not find it intolerably terrifying, your conscience is asleep in private dreams.

### More's Religion

More was a simple man. His relationship with God, though mysterious and even mystical on God's side, was wonderfully simple on his side, as is evident from the evening prayer he and his family say: "Dear Lord, give us rest tonight, or if we must be wakeful,

cheerful. Careful only for our soul's salvation." As T.S. Eliot put it, "Teach us to care and not to care." Or as Mother Teresa put it, "God did not put us in this world to be successful, only to be faithful." Or as Christ himself put it, to Martha, "There is need of only one thing" (Luke 10:42). Liberating simplicity!

Bolt says he used *water* in the play (and it was used even more powerfully in the movie) to symbolize this religious dimension: "As a figure for the superhuman context I took the largest, most alien, least formulated thing I know, the sea and water. The references to ships, rivers, currents, tides, navigation, and so on, are all used for this purpose. Society by contrast figures as dry land."

There are only two philosophies of life. For supernaturalism, the land is an island—small and surrounded by the sea, the mystery, symbolizing the one who created us in his own image. For naturalism, the sea is a pond surrounded by the land, which symbolizes the ones who created God in their own image. The river, which takes More repeatedly between his home and family and the King's lackeys and eventually the Tower and martyrdom, is as clear a symbol of divine providence as the road in *The Lord of the Rings*.

The two aspects of every human life, the two dimensions that are inescapably religious, are death and love. The play culminates in More's death, and his last words to his beloved daughter Meg are: "Trouble not thyself. Death comes for us all; even at our birth—*(He holds her head and looks down at it for a moment in recollection)*—even at our birth, death does but stand aside a little."

The line is strikingly similar to the one in *Waiting for Godot*: "They give birth astride of a grave." Yet there it is the striking image of hopelessness and meaninglessness, while here it is the striking image of hope, of teleology. In one way, More is the same as Vladimir and Estragon: he is "waiting for Godot." The difference is that here there is a season, in this "man for all seasons," when Godot actually comes for him. Time leads to

eternity. And even Bolt the agnostic at least hopes that is true, while Beckett the atheist does not. Time is a river in this play; it is a desert in the other.

It is in confronting death that love plays its trump card and reveals its priority. When Meg argues, very reasonably, that More need not die, and says, "But in reason! Haven't you done as much as God can reasonably want?" More replies, "Well . . . finally . . . it isn't a matter of reason: finally it's a matter of love."

# 6

# *Equus*

### BY PETER SHAFFER

Here is another play by an agnostic that profoundly understands and respects religion as such.

Peter Shaffer heard about a striking news item at a dinner party—a boy was on trial for appalling cruelty to a horse, having jabbed the horse's eyes out—and the playwright constructed a backstory to this factual event that transcended the factual by being not only imaginative but also archetypal.

The horses in the play are not realistic or sub-realistic but super-realistic—that is, archetypes: not horses but "horsedom" or "horseness." The stage directions specify that the horses are actors wearing "tough masks made of alternating bands of silver wire and leather. . . . Any literalism which could suggest the cosy familiarity of a domestic animal—or worse, a pantomime horse—should be avoided. . . . Great care must also be taken that the masks are put on before the audience with very precise timing—the actors watching each other, so that the masking has an exact and ceremonial effect." It is a *liturgy*.

Shaffer directs that "references are made in the text to The Equus Noise. I have in mind a Choric effect . . . composed of

humming, thumping, and stamping—though never of neighing or whinnying. This Noise heralds . . . the presence of Equus the God." Neighing or whinnying would image real horses, but real horses image this god.

This device is meant to help the audience to see through the eyes of Alan Strang, the exceedingly strange boy who worships this god Equus. It is assumed that they will begin by seeing through the eyes of the psychologist, Martin Dysart, whose task it is to free Alan from his destructive obsession. The play's essential conflict is not between two forces within Alan ("illness" vs. "cure") or even between Alan and Dysart (though that is the conflict the "treatment" begins with) but between these two points of view that coexist in conflict within Dysart. Similarly, the primary conflict and drama of the book of Job is not so much between two forces within Job or within God as it is between Job's and God's points of view. The same contrast obtains in *Oedipus the King* between the divine and human points of view. However, there is no divine point of view in *Equus*, neither Alan's nor Dysart's nor a third that transcends both.

So the play is not theological (about God), but it is religious (about the relationship between man and God). Since neither God nor the gods are characters in this play, as they are in Job and *Oedipus*, there is no "vertical" drama between the divine and human points of view. But it is essential to rightly identify the locus of the primary drama and the central protagonist, who is *not* the "strange" boy but the non-strange, predictable, competent, and familiar psychologist. Alan Strang is clearly obsessive-compulsive, thus lacking in free choice, which is essential to drama. But Martin Dysart experiences a far more dramatic and agonizing conflict and choice, and we are expected to "identify with" his dilemma.

Unfortunately, most audiences will fail to do this, and will misunderstand the whole point of the play. When I taught it to a class of mostly Catholics at Boston College, only one out of

nineteen students saw the point or felt the conflict at all. The other eighteen had no empathy for Alan, but only sympathy, and could not understand why Dysart had any qualms or reservations about doing his job and being a "shrink" by shrinking Alan's soul and freeing him from his obviously destructive religion.

Yes, it was destructive, but it was religion. It was worship. It was passion. It was the only "infinite passion" in Alan's life. Apparently eighteen out of nineteen "Catholics" in my class had never experienced this passion *or even its absence*, as Dysart (and apparently Shaffer) did.

Dysart freed Alan from his suffering, but also from his worship; and there was no third alternative, no compromise, no way out of the dilemma, because worship and suffering (though not worship and obsessive-compulsive or violent behavior) necessarily go together in this life. For the very essence of worship is the suffering of the loss of our very ego-self, the self that claims control and centrality and thus claims the sacred name of God himself, "I Am." We must let God be "I" and consent to be his "thou." We cannot "attain" God; we can only "suffer" him. He is not the object of (and thus relative to) our religious experience; we are the object of, and thus relative to, his religious experience. Something like that seems to be the point of all the mystics.

If we are so typically modern as to see suffering as the supreme evil, then *Brave New World* is our supreme good, a world whose impressive argument is that "everybody's happy now." And that is the story of modern man in a nutshell, who is moving ever closer to this new world in which there is, ironically, no need for bravery or courage or heroism because of the spectacular success of our technology in relieving most of our obvious inner and outer pains, but not our inner emptiness.

It is significant that Alan chose horses (or rather The Horse, "Equus") as his God-substitute, for *equus* (the Latin word for "horse") begins with the syllable "ek," and so does "ecstasy" in English and

"ek-stasis" in Greek, which mean "standing-outside-yourself," transcending yourself, identifying no longer with yourself but with the Other, the Absolute Other, God. In Christianity, this includes also identifying with the relative other, other people, for God's sake, as his children and our siblings. Unlike Equus, this is not an idol but the true God.

When Alan first experienced the wonder and power and holiness of horses as a child on the beach when a stranger let him ride his stallion, the words Alan spoke in the horse's ear were religious and even mystical words: "Bear me away!" Christ's last words before his death were the equivalent of those words: "Father, into your hands I commend my spirit" (Luke 23:46).

But, you object, horses are not gods, and Alan's worship of them is idolatry. Indeed. But, as G.K. Chesterton says, there is something even worse than idolatry, and that is far more common in our modern world than that idolatry. It is the worship of the self, and its centrality and its happiness: "That Jones shall worship the god within him turns out ultimately to mean that Jones shall worship Jones. Let Jones worship the sun or moon, anything rather than the Inner Light; let Jones worship cats or crocodiles, if he can find any in his street, but not the god within."

The most spiritually obscene song I have ever heard, when my kids were young, was the theme song of a TV show for small, innocent children! The show was called *The Most Important Person*, and the opening song began with the words: "The most important person in the whole wide world is—you!"

I suspect most pop psychologists grew up listening to *The Most Important Person*.

The play both begins and ends with Dysart's dissatisfaction with this soulless soul and his fascination with Alan's strange alternative.

Its beginning is quite mystical: "With one particular horse, called Nugget, he embraces. The animal digs its sweaty brow into

71

his cheek, and they stand in the dark for an hour—like a necking couple. And of all nonsensical things—I keep thinking about the *horse!* Not the boy: the horse, and what it may be trying to do. I keep seeing that huge head kissing him with its chained mouth. Nudging through the metal some desire absolutely irrelevant to filling its belly or propagating its own kind. What desire could that be? Not to stay a horse any longer? Not to remain reined up for ever in those particular genetic strings? . . . The thing is, I'm desperate. You see, I'm wearing that horse's head myself. . . . I can't see it, because my educated, average head is being held at the wrong angle."

And the play's last words are: "There is now, in my mouth, this sharp chain. And it never comes out." In a sense Dysart, like Christ, takes away Alan's suffering by internalizing it himself. At the same time, he commits the crime Alan committed against the horses he blinded, only Dysart commits it against the deepest eyes of his patients: "I stand in the dark with a pick in my hand, striking at heads!"

Most of the movement of the drama in this play is inward. As Dysart puts together the clues and understands Alan more and more (and that seems to be a progress), he also understands his own role as a "shrink" more and more, and that appalls him and seems to be a regress. For instance, "I had this very explicit dream. In it I'm a chief priest [note the irony] in Homeric Greece. I'm wearing a wide gold mask, all noble and bearded, like the so-called Mask of Agamemnon found at Mycenae. I'm . . . holding a sharp knife. . . . The sacrifice is a herd of children. . . . And then, of course—the damn mask begins to slip." Dysart's respectable, "realistic" mask (psychologist, helper), designed to reveal the souls of his patients and penetrate their escapes, actually conceals his own soul from himself, while Alan's iconic mask of the horse-god Equus, though imaginary and functioning as escapist, actually reveals his deeper self.

72

When Dysart's mask falls, his real identity is revealed. The contrast to the holy word "Equus" is the slang but revealing word "shrink." As Dysart says in the end, "Passion, you see, can be destroyed by a doctor. It cannot be created. . . . You won't gallop any more, Alan. Horses will be quite safe. . . . You will, however, be without pain."

What has Alan been robbed of? Holiness. Worship. The very word *equus* was holy to Alan:

> Dora [Alan's mother]: . . . the Latin word for horse. Alan was
> fascinated by that word, I know. I suppose because he'd never
> come across one with two U's together before.
> Alan: (*Savouring it.*) Equus!

Later, dreaming, Alan waxes mystical about the word that suggests ecstasy and cries: "Ek! . . . Ek! . . . Ek! . . . (*Cries of* Ek! *on tape fill the theatre, from all around.*)"

Alan tells Dysart about his mother reading to him about "the white horse in Revelation. 'He that sat upon him was called Faithful and True. His eyes were as flames of fire, and he had a name written that no man knew but himself' . . . Even the words made me feel . . ."

Alan's father, Frank, a Marxist atheist, is a sexual voyeur, and reduces religion to sex: "All that stuff to me is just bad sex." And when Alan catches his father in a porno theater, he describes it this way: "All round me they were all looking. All the men—staring up like they were in church." Frank is almost right, but has it exactly backward: religion is not a substitute for sex; sex is a substitute for religion. Pornography is a crudely idolatrous version of the beatific vision. And the physical experience of "standing-outside-yourself" (ek-stasis) that is sexual orgasm is in fact a holy physical icon of the self-forgetful love that is our primary commandment and our primary joy because it is the very essence of the life of the Holy

Trinity. Sex can also be an unholy idol instead of a holy icon, pointing not beyond the self to its true *summum bonum* but back into the self, like a snake swallowing its own tail. "Equus" is for Alan something of both: a holy icon and an unholy idol. It is both constructive and destructive.

Alan's god is clearly a substitute for the true one. Over his bed was a photo of a horse that was "most extraordinary. It comes out all eyes . . . staring straight at you." His mother tells Dysart that "it took the place of another kind of picture altogether . . . a reproduction of Our Lord on his way to Calvary. Alan found it in Reeds Art Shop, and fell absolutely in love with it. . . . Christ was loaded down with chains, and the centurions were really laying on the stripes. . . . [Frank] tore it off the boy's wall and threw it in the dustbin. Alan went quite hysterical. He cried for days without stopping. . . . He recovered when he was given the photograph of the horse in its place. . . . He hung it in exactly the same position."

Alan constructs a liturgy, which he chants. It includes these words: "And he said, 'Behold—I give you Equus, my only begotten son!'"

Dysart: You ask him a question. "Does the chain hurt?"
Alan: Yes.
Dysart: Do you ask him aloud?
Alan: No.
Dysart: And what does the horse say back?
Alan: "Yes."
Dysart: Then what do you say?
Alan: "I'll take it out for you."
Dysart: And he says?
Alan: "It never comes out. They have me in chains."
Dysart: Like Jesus?
Alan: Yes!

Dysart: Only his name isn't Jesus, is it?

Alan: No.

Dysart: What is it?

Alan: No one knows but him and me.

(Alan is referencing Rev. 2:17: "And I will give a white stone, and on the white stone is written a new name that no one knows except the one who receives it.")

Dysart: Why is Equus in chains?

Alan: For the sins of the world.

Dysart: What does he say to you?

Alan: "I see you." "I will save you."

Dysart: How [will Equus save you]?

Alan: "Bear you away. Two shall be one."

Dysart: Horse and rider shall be one beast?

(Alan had been fascinated when told that the Aztecs thought the invading Spanish conquistadors and their horses were a single animal, like the centaur. This is another shadow or idol of the profound truth of "theosis," that we are destined to be so one with God that we participate in his very nature: 2 Pet. 1:4.)

The problem is that Alan demanded the impossible: that Equus say to him, "And my chinkle-chankle [mouth chain] shall be in thy hand." But the ego cannot both yield and hold the reins. The individuality of the "white stone" (Rev. 2:17) is perverted from being a grace and a gift into being an entitlement and a power: "Only I can ride him. . . . Equus, my Godslave!" Even the agnostic Shaffer understands that worship and power, ecstasy and control, are mutually exclusive.

What is also mutually incompatible for Alan is his god seeing him and saving him. Seeing is not beatific but torturous when his beloved horse Nugget sees Alan naked with Jill. Equus is "a jealous God." (After all, there can be only one *summum bonum*.) And he

has no mercy. This provokes Alan's Nietzschean violence against the unendurable eyes of his god, similar to Oedipus' human violence against his own eyes. I call it Nietzschean because Nietzsche said quite candidly that it was unendurable to have God seeing everything in him, even his dark side and his dwarfish soul. He also wrote: "I will now disprove the existence of all gods. If there were gods, how could I bear not to be a god? *Consequently* there are no gods."

When Dysart asks Alan what Equus said to him at that point of crisis, Alan's answer is: "Mine! . . . You're mine! . . . I am yours and you are mine! . . . Then I see his eyes. They are rolling! . . . 'I see you. I see you. Always! Everywhere! Forever!' . . . Eyes! . . . White eyes—never closed! Eyes like flames—coming—coming!"

The divine truth that blesses and blisses the saints as light (see Psalm 139) tortures the damned as fire. What makes the absolute and eternal difference, the difference between that light being our salvation or our damnation, is not God's existence or his omnipotence and justice but his love and mercy: the difference between Equus and Jesus.

This is neither a Christian nor a pre-Christian but a post-Christian drama. Unlike God and like Nietzsche, it is haunted by the God who, as Nietzsche observed, has not only died but has been killed under our hands. (Nietzsche the atheist did not believe that that had happened literally and physically, in Jerusalem, but he did know that it had happened spiritually in our souls.)

Although Dysart and Alan are spiritual antagonists in a battle that Dysart "wins," both of them are citizens of this "brave new world" in which there is no place for bravery because there is no place for either suffering the loss of self-control in self-sacrifice, or suffering the loss of self-control in worship. The "rough beast" that "slouches toward Bethlehem to be born" nowadays, in the culture that used to be called Christendom, is neither Christ nor Equus— and it will not answer the prayer to "bear me away."

# Three Dramas About Suffering

# 7

# *Oedipus the King*

## BY SOPHOCLES

This is the classic tragedy, perhaps the greatest and most perfect ever written.

"Tragedy" is almost another word for "suffering." Tragedies end with suffering, while "comedies" end with happiness. But just as "comedy" does not mean jokes, "tragedy" does not mean accidental sufferings, like an auto accident, but suffering that is fated, destined, predestined to be brought about precisely through the protagonist's free choices. Thus, tragedies combine the notions of suffering, choices, and fate, or destiny. The destiny comes from the author of the story; the free choices come from the protagonist of the story. Every story has these two dimensions: the immanent one (the freely choosing characters in the story, the creations of the author) and the transcendent one (the predestinating author).

The source of the protagonist's tragic fate is usually a "tragic fault" in the protagonist. The commonest tragic fault, especially in classical tragedy, is *hybris*, or pride, which means not just vanity and selfishness but attempting to exceed the limits of human nature.

We have not learned this wisdom yet. Well-meaning parents tell their children, "You can be whatever you want to be." It is a

comforting and deceptive lie. We cannot be God. As Creon tells Oedipus in the end, "Crave not to be master in all things." "I am the master of my fate" cannot be truly said by any creature. Oedipus the King did not write the play *Oedipus the King*.

Oedipus is a hero—in fact, a "culture hero"—because he pursues a fundamental value of his culture to a heroic extent, an extent that involves great sacrifice and great suffering. That fundamental value, in ancient Greek culture, which is manifested especially with Socrates, is truth, or, more specifically, wisdom. This play is about the *cost* of the heroic "will to truth," the value Nietzsche questioned for the first time and called "the most dangerous question." It is. The deliberate refusal of the will to truth is probably the unforgivable sin. Without truth, everything is a lie, a darkness.

Oedipus is also a hero because as a good king he works for the welfare of his people, not for himself. This is why Oedipus demands to find the cause of, and thus the cure for, the plague from which his people are suffering. And this unselfish dedication to his people requires him to seek the truth passionately and adamantly; and when he finds that he himself is the one who offended the gods by committing the two universally acknowledged sins of killing his father and marrying his mother, even though he did both unwittingly, he is the one whose sufferings and exile cause the plague to cease. In this way, he is a kind of Christ figure, a scapegoat, a savior; in his other heroism (his will to truth), he is a Socrates figure. Thus, he foreshadows the two most influential heroes in Western civilization.

Every different culture focuses on or specializes in a somewhat different fundamental value; thus, each culture has a different culture hero. Job is a culture hero of faith for Jewish culture. Beowulf is a culture hero of both Norse warrior power and courage and Christian service and self-sacrifice because of the conflux of those two cultures in that epic. Abraham Lincoln and Martin

Luther King are culture heroes of freedom, which is the special value of a democratic culture.

Oedipus shares all five of these features typical of a culture hero:

1. His tragic suffering, in the end, is extreme.
2. His tragic moral fault is the unwisdom of pride, which is one source of his suffering.
3. On the other hand, his moral virtue, his altruism and concern to end the plague for his people, is another source of his suffering.
4. Still another source is the moral virtue of his heroic "will to truth."
5. His fate, which includes all four of these elements, and which works by his free choices, is the ultimate and all-encompassing source of his suffering.

All the tragedies in this play, even the ones Oedipus brought upon himself unwittingly, are (as the Second Messenger says) "ills wrought not unwittingly, but of purpose"—but the purpose was not that of the characters in the play but of the dark Fate that was the play's ultimate author. The Chorus says to Oedipus, "Thine is a fate that warns me . . . to call no earthly creature blest." The last line of the play, the "wisdom" preached by the Chorus, is: "Therefore, while our eyes wait to see the destined final day, we must call no one happy who is of mortal race, until he hath crossed life's border free from pain."

The chorus, in Greek tragedy, represents common mankind: common both in the sense of being generic and universal and in the sense of being ordinary and not heroic.

In stark contrast with this pagan "tragic sense of life" and its absolute of "Moria," the faceless Fate that is the arbiter of the lives of both men and gods, for Christianity the real author of

the real human play is not a force but a person, and is not only omniscient and omnipotent but also omnibenevolent; and "all things work together for good for those who love God, who are called according to his purpose" (Rom. 8:28). For pagans, the day of comedy leads in the end to the night of tragedy; for Christians, the night leads to the day. As Fulton Sheen says, there are two philosophies of life: one says, First the feast, then the fast; the other says, First the fast, then the feast.

A famous and prominent dimension of this play is its pervasive irony, which is the contrast or opposition between appearance and reality, or between expectation and result; and this exists in two dimensions. There is the obvious irony that each of Oedipus' choices, which seem to be for his liberation and vindication, are in fact for his doom and misery. There is also, more profoundly, the irony that these very free choices are his fate. The two forces that move every story ever told—namely, free choice and destiny, or fate, which seem to contradict each other—are here not only intertwined but identified! As C.S. Lewis says, in his essay "On Stories," "We have just had set before our imagination something that has always baffled the intellect: we have *seen* how destiny and free will can be combined; even how free will is the *modus operandi* of destiny."

An oracle warned Laius, Oedipus' father, that his son would kill him. When the son was born, he was exposed to die by his parents, but he was rescued and reared by Polybus and Merope, the king and queen of Corinth, so that Oedipus believed they were his parents. When Oedipus slew Laius in a "road rage" fight, he did not know either his own or Laius' identity. When he came to the city of Thebes, he solved the riddle of the sphinx and was made king. He married Jocasta, recently widowed, not knowing she was his mother. Years later, a plague was destroying the population of Thebes, and the people pleaded with their king Oedipus to find and execute the sinner responsible for the plague. The

action of the play centers around Oedipus' attempts to play detective and thus save his people and become a hero.

As in the book of Job, the dramatic irony and conflict is not merely horizontal, between Oedipus and the truth about his past, but also vertical, between Oedipus' human ignorance of his identity and the reader's God-like knowledge of it. The irony is also both exterior (in Oedipus' conflict with Laius, Jocasta, Creon, Tiresias, and the plague) and interior (in Oedipus' conflict with himself, his good with his fault, his knowledge with his ignorance). Oedipus is wise (he solved the riddle of the sphinx and has been a wise ruler up to now) and also unwise (he tries to master his fate). His "will to truth" is also both wise and foolish, both noble and fatal. As in *Hamlet*, everything here has a "dark side." Nothing in this play is what it seems to be. Human existence itself is seen as ironic.

Irony—the contrast between appearance and reality—is in fact the origin of both philosophy and science. Animals do not make that distinction, and therefore do not wonder. Wonder, according to Socrates, Plato, and Aristotle, is the origin of philosophy, and also of all the sciences (which historically emerged from it as children emerge from families and set up on their own). Animals live by appearances and are satisfied; we refuse to do so and create tragedies. That misery is our glory. Even the utilitarian John Stuart Mill, who taught that happiness is the only intrinsic good, said that "it is better to be a human being dissatisfied than a pig satisfied; better to be Socrates dissatisfied than a fool satisfied."

Although the play's philosophy is pagan, Christianity builds on this philosophy, not against it. Christianity surrounds the true perceptions of paganism with a larger frame, especially the frame of suffering as not merely tragic and fated but redemptive—which is perhaps the greatest irony of all, the irony of "*Good* Friday." Christ, unlike Buddha, did not come to deliver us from suffering but to deliver us from sin *by means of* suffering.

It is supremely significant that Oedipus' suffering, at the end, is ocular: he cannot endure the truth that he so passionately sought, and he gouges out his eyes to blind himself. Tiresias, the blind prophet who sees, wisely warns Oedipus, the wise king who does not see; but Oedipus is blind to all warnings, cautions, and practicalities.

And this is also ironic and double-sided for another reason, in the end, because his unendurable sufferings at the end of this play are only half the story. In Sophocles' sequel, *Oedipus at Colonus*, the gods are so impressed by his heroism that they take him up to heaven to be forever among the superhuman beings he foolishly yet nobly aspired to be like. The Second Messenger says, in the end, "The anguish is more than man may bear"—and so Oedipus the man was made a god. Oedipus is thus almost a reverse image of Christ, who is God made man.

# 8

CHRISTIAN

# *Shadowlands*

BY WILLIAM NICHOLSON

This was the play that was made into the *Shadowlands* movie, with Anthony Hopkins playing C.S. Lewis. It is not perfect (especially the ambiguous ending), but it is a masterpiece, and a three-handkerchief movie for everyone except Stoics.

Lewis is my candidate for the most brilliant and effective Christian apologist of modern times, and he is a very good selection to exemplify the Christian response to suffering, especially the very worst suffering of helplessly seeing someone whom we deeply and totally love gradually sink into death. Lewis chronicled the psychological roller coaster of his own response to his wife's death in *A Grief Observed*, with almost unendurable honesty, and the play is faithful to that record.

Suffering is central to both Christianity and Buddhism, in almost totally opposite ways. Buddhism is essentially a way of salvation *from* suffering. Christianity is a way of salvation *by* suffering on the part of the God who is *agape* love and by our incorporation into him and his work. As Lewis said so eloquently in *The Four Loves*, in love

there is no safe investment. To love at all is to be vulnerable. Love anything, and your heart will certainly be wrung and possibly be broken. If you want to make sure of keeping it intact, you must give your heart to no one, not even to an animal. Wrap it carefully round with hobbies and little luxuries; avoid all entanglements; lock it up safe in the casket or coffin of your selfishness. But in that casket—safe, dark, motionless, airless—it will change. It will not be broken; it will become unbreakable, impenetrable, irredeemable. The alternative to tragedy, or at least to the risk of tragedy, is damnation. The only place outside heaven where you can be perfectly safe from all the dangers and perturbations of love is hell.

The play begins *before* Lewis fell in love, married, lost, and grieved; and the personal contrast between the "safe," comfortable bachelor Lewis and the "broken," married, and bereaved Lewis is the narrative plot line of the play. The psychological contrast is stark; yet there is no *theological* contrast between the belief about suffering that Lewis expounded in the early, opening scene where he is lecturing on the problem and the later belief with which he emerged from his fiery furnace. His person was shattered, but his belief was not. He confesses in *A Grief Observed* that he discovered that his faith was "a house of cards," but he says that the fall of that house meant not that his faith in God was false but that his faith in his own faith was false; what fell was not *what* he believed but that he really believed it.

That theology of suffering is summarized in the first scene, where Lewis is lecturing. His first sentence is "Good evening. The subject of my talk tonight is love, pain, and suffering." This "subject" is about to become very subjective, and deeper than even the profoundest lecture.

The agonizing philosophical and theological question is "the problem of evil," which is the strongest argument for atheism: "If

God loves us, why does he allow us to suffer so much?" Lewis puts the argument as strongly as any atheist ever has in *The Problem of Pain*: "If God were good, he would wish to make his creatures perfectly happy, and if God were almighty he would be able to do what he wished. But the creatures are not happy. Therefore God lacks either goodness, or power, or both."

And his sharp and surprising answer in *Shadowlands* is that

God doesn't necessarily want us to be happy. He wants us to be lovable. . . .

God creates us free, free to be selfish, but he adds a mechanism that will penetrate our selfishness . . . and that mechanism is called suffering. . . . Pain is God's megaphone to rouse a deaf world. . . . Because the dream from which we must be awakened is the dream that all is well.

Now that is the most dangerous illusion of them all. . . .

God loves us, so he makes us the gift of suffering. Through suffering, we release our hold on the toys of this world, and know our true good lies in another world. . . .

For believe me, this world that seems to us so substantial is no more than the shadowlands. Real life has not begun yet.

If that theology of heaven is not objectively true, if this world is not in fact a "shadowlands" of the next, if Christianity is only a psychology and a morality for this world, then Lewis' answer to the problem of pain completely fails. Each of Christ's Beatitudes (Matthew 5) are explicitly predicated on the reality of the next life.

The story is not one of subjective feeling defeating objective reasoning. In fact, it is Lewis' tough-mindedness and reason that

save him from despair. As Lewis wrote in *A Grief Observed*, "But is it credible that such extremities of torture should be necessary for us? Well, take your choice. The tortures occur. If they are unnecessary, then there is no God or a bad one. If there is a good God, then these tortures are necessary. . . . Either way, we're for it." The logic is like a diamond: totally hard to the touch and totally light to the eye.

But not soft to the touch. Unlike the sense of sight, the sense of touch is soft and full of pain nerves. Lewis, like Job, is about to suffer God's love in the sculptor's shop of life, where his faith is to be tested like steel in the blacksmith's fire.

The validity of Lewis' apologetics is based on the truth of his metaphysics, his ontology. That is indicated by the title of this play. If this world is not indeed "shadowlands," then Lewis is pitiful and deluded, and the trustable Christian God is a myth or, worse, (as Lewis put it in his darkest doubts in *A Grief Observed*) a "cosmic sadist."

The fact that the issue in this play is not just psychological but ontological is symbolized in the play (though not the movie) by an oversized wardrobe that dominates the set, and into which Joy's son Douglas enters at moments of critical faith and hope. This prop is meant to reflect the central image in Lewis' first and best-known Narnia book, *The Lion, the Witch, and the Wardrobe*. The magic wardrobe is a place of transition, like an airlock connecting two worlds, this world and Narnia, just as death is the airlock connecting earth and heaven. The subjective or personal connector of these two worlds is Love, and as Lewis discovers in this play, Love is the door that leads from safety to suffering in this world. Lewis discovers by experience what he believed by faith, that Love is stronger than death. The airlock or door is Christ. He is the "wardrobe" by which we enter the next world. And the door by which we enter that wardrobe is threefold: it is faith and hope and love (which, like the three persons of the

Trinity, are ultimately one reality, that one reality that we can see in the eyes of a baby looking up at its mother's eyes).

Joy Davidman was an American poet who divorced her former husband, her former religion (atheism), and her former philosophy (communism)—the latter two partly through Lewis' writings. Her letter suggesting they meet is deliberately but ironically non-intimate: "She suggests tea, in a hotel. . . . Tea is safe. A hotel is safe." Lewis feels a spiritual attraction and respect for her, but "it's only tea. An hour or so of polite conversation. Then we go home, and everything goes on just the way it always has." Riiiiiight! That's what the baby thinks at the entrance to the birth canal. Or what Lucy thinks when she hides in the wardrobe.

Lewis' first step into the wardrobe is to decide to marry Joy "civilly," on paper, for purely philanthropic reasons, so that she (now newly divorced) can legally stay in England with her two sons (who are condensed into one in the play). Lewis does not know it, but he is reenacting the choice made by Digory, the protagonist in his own Narnia chronicle *The Magician's Nephew*, to ring a magical bell that will awaken a sleeping witch. On the bell is the warning "Make your choice, adventurous stranger: strike the bell, and bide the danger." In the narrative of *Shadowlands*, Joy's son Douglas imagines himself ringing the bell and entering the other world. The stage directions say: "*DOUGLAS rings the BELL. The LIGHTS change. The screen rises. The door of the giant wardrobe slowly opens to reveal a magical infinite space beyond. . . . DOUGLAS walks toward the opening wardrobe door, as if hypnotized. LEWIS watches. DOUGLAS enters the magic world, and the great door closes behind him.*" What happened to Digory in Lewis' story and to Douglas in his imagination is about to happen to Lewis himself. But this witch turns out to be good, or providentially used for good, even though one of her names is Suffering, because her other name is Joy.

Joy is even more adamantly honest than Lewis. Early on, she asked him, "Jack, have you ever been really hurt?" He replies, "I have been really hurt, you know. The first time is always the worst. That was when my mother died." "And you went somewhere secret to cry?" "I went somewhere secret. I didn't cry." Both of those reactions are about to change.

At first the paper marriage seems to be as nonthreateningly thin as the paper itself. The conversation between the two bachelor brothers is charmingly comic to us (though not to Lewis):

> Lewis: Oh, Warnie. There is something you should know.
> Warnie: What's that, Jack?
> Lewis: I've agreed to marry her.
> Warnie: You have?
> Lewis: Yes. Seemed like the right thing to do.
> Warnie: You astound me. No, I mean—
> Lewis: It's alright, Warnie. Nothing's going to change. I'm not really going to marry Joy.
> Warnie: You're not?
> Lewis: What I have agreed to do is extend my British citizenship to her, so that she can go on living in England.
> Warnie: By marrying her.
> Lewis: Only technically.
> Warnie: You're marrying Joy technically?
> Lewis: . . . It is nothing more than a bureaucratic formality.
> See you at tea.

And then she came down with cancer. And Lewis found himself falling deeply in love with her by listening to what he called in his lecture "God's megaphone." When Lewis is honest enough to tell

her, in hospital, that "they expect you to die," Joy responds, with equal honesty, "You seem different. You look at me properly now."

Ironically, this listening to God *seemed* to bear the same threatening relation to his faith that Joy's cancer bore to her body. He says: "I find it hard to believe that God loves her. If you love someone, you don't want them to suffer. You can't bear it. You want to take their suffering onto yourself. If even I feel like that, why doesn't God?"

The answer of the Christian faith, of course, is that he does! When Jesus' friend Lazarus died, "Jesus wept" (John 11:35 NABRE). (Christians who suffer find this shortest verse in the Bible the most comforting.) But Lewis goes on to question whether this applies to the present: "Not just once in history, on the cross, but again and again? Today. Now."

And then comes the hope of childbirth that makes the labor pains acceptable if not endurable: "It's at times like this that we have to remind ourselves of the very core of the Christian faith. There are other worlds than this. This world, that seems so real, is no more than a shadow of the life to come." We need not just faith and love but also hope.

If that ontology, that objective reality, that divine object of faith and hope and love and trust, is an illusion, then the whole of the faith is an illusion.

Lewis, who has now added love to his faith and hope, wants to really marry her, before God. The scene with his priest is played with an amazing synthesis of Stoicism and passion by Anthony Hopkins:

Harrington: Well, she's your friend, of course, but she's not
. . . well, family.
Lewis: Not my wife?
Harrington: (*Gives a nervous laugh at such a prospect*) No. Of course not.

Lewis: Of course not. Impossible. Unthinkable.

Harrington: I only meant—

Lewis: How could Joy be my wife? I'd have to love her, wouldn't I? I'd have to care more for her than for anyone else in this world. I'd have to be suffering the torments of the damned at the prospect of losing her.

Harrington: *(Awed by Lewis's passionate outburst.)* I'm sorry, Jack. I didn't know.

Lewis: Nor did I, Harry. *(Suddenly, his manner changes. He becomes calm, almost businesslike.)* I'm going to marry her, Harry. I've made up my mind. I want you to marry us properly, Harry, before God.

The decision is Lewis' wardrobe door not only to love and to suffering but also to honesty:

Lewis: I'm going to marry you, Joy. I'm going to marry you before God and the world.

Joy: You don't have to, Jack.

Lewis: I want to. It's what I want.

Joy: Make an honest woman of me.

Lewis: Not you, Joy. I'm the one who hasn't been honest.

Look what it takes to make me see sense.

Later, during her miraculous but temporary remission, they have a conversation that Lewis referred to in *A Grief Observed*. (That book and the play marvelously reinforce and explain each other, by the way.)

Joy: What will you do when I die?

Lewis: I don't know.

Joy: I want to be with you then, Jack. The only way I can do that is to talk to you about it now. . . . What I'm trying to say is that pain, then, is part of this happiness, now. That's

the deal. . . . Only shadows, Jack. That's what you're always saying. Real life hasn't begun yet. You'd just better be right.

Lewis anticipates his lack of faith in his own faith (which is a good thing!) when he says, "When it gets close, you find out whether you believe or not." In *A Grief Observed*, he writes:

> You never know how much you really believe anything until its truth or falsehood becomes a matter of life and death to you. It is easy to say you believe a rope to be strong and sound as long as you are merely using it to cord a box. But suppose you had to hang by that rope over a precipice. . . . Apparently the faith—I thought it faith—which enables me to pray for the other dead has seemed strong only because I have never really cared, not desperately, whether they existed or not. Yet I thought I did. . . . I thought I trusted the rope until it mattered to me whether it would bear me. Now it matters, and I find I didn't.

Thus, after Joy's death, Lewis has this conversation:

> Riley: Are you alright, Jack?
> Lewis: No.
> Harrington: Thank God for your faith, Jack. Where would you be without it? . . . What I mean to say, Jack, is that it's only faith that makes any sense of times like this.
> Lewis: . . . No, I'm sorry, Harry, but it won't do. This is a mess, and that's all there is to it. . . .
> Harrington: This is your grief talking.
> Lewis: What was talking before? My complacency? . . . I'm sorry, Harry. You're a good man. I don't mean to distress you. But the fact is, I've come up against a bit of experience recently. Experience is a brutal teacher, but you learn fast.

As he writes in *A Grief Observed*, "Talk to me about the truth of religion and I'll listen gladly. Talk to me about the duty of religion and I'll listen submissively. But don't come talking to me about the consolations of religion or I shall suspect that you don't understand."

The most memorable and powerful scene in the play (and in the movie) takes place near the end, with Lewis, having been moved through the wardrobe of the experience that is "a brutal teacher," now transferring his emotional openness and rawness to Joy's son Douglas in a wordless profundity of shared tears.

To get him there, Warnie has to remind him: "Your grief is your business. Maybe you feel life is a mess. Maybe it is. But he's only a child."

> Lewis: What am I supposed to do about it?
> Warnie: Talk to him.
> Lewis: I don't know what to say to him. [That in itself is new wisdom for Lewis.]
> Warnie: Just talk to him. [What's said is not as important as what's done: being there.]

Douglas asks, "Do you believe in heaven?" Lewis says, "Yes." That is an important word, a simple confession. Douglas confesses, "I don't believe in heaven." Lewis replies (uncharacteristically out of character), "That's okay." The real Lewis would not have said that without adding something like "Because heaven believes in you" or "That's okay for now; I didn't believe when I lost my mother either."

But then Lewis does something else uncharacteristic and out of character, but this time a healing thing: the two weep together. It is the most memorable and powerful scene in the book. The stage directions say: "Lewis wraps his arms around the boy, and at last his own tears break through, in heartbreaking sobs, unloosing

the grief of a lifetime. His emotion releases the tears that have been waiting in the boy."

Lewis confessed to Joy that when his own mother died, when he was about the same age as Douglas, "I went somewhere secret. I didn't cry." Now Lewis undoes these two mistakes. And that was almost as important as his undoing his intellectual mistake, his former unbelief, by becoming the most effective Christian apologist of modern times. The sculptor in the sky has been hammering out a masterpiece. Lewis' heart as well as his head is now whole because it is broken.

Lest we think Nicholson the playwright is misinterpreting Lewis as losing his faith in the end, he gives Lewis these last words, the very last words in the play, directed to his dead wife, reaffirming first the psychology and then the ontology of Christianity: "The pain, now, is part of the happiness, then. That's the deal. Only shadows, Joy." Joy is literally the last word, the word beyond the shadows.

The movie, in contrast, added a gratuitous and misleading final scene of Lewis wandering off alone into the distance, as if absence had the last word. No. The subjective experience did not contradict or refute the objective theology. The point of the play is that presence trumped absence, not vice versa; that love is stronger than death because love is not just human but divine.

# 9

## POST-CHRISTIAN

# *J.B.*

### BY ARCHIBALD MACLEISH

Of the five dimensions of any narrative—plot, character, setting, theme, and style—the most important dimension of this play, in one sense, is its setting, because the setting is the whole world, but a world that has discarded God and therefore one in which human suffering is no longer redeemable. The stage directions at the beginning tell us this, in fairly obvious symbolism: "The scene throughout is a corner [earth] inside an enormous circus tent [the universe] where a side show of some kind [human life] has been set up. . . . Clothes that have the look of vestments of many churches and times have been left about at one side and the other of the stage."

One could also say that the most important dimension of this play is the character, the protagonist, J.B. (Job), as Everyman. Like most individuals in most cultures, J.B. is a religious believer; and like *all* individuals, he suffers, but spectacularly more than most men do. He is also more pious than most men are, so that the relation between piety and reward seems not only unjust but

spectacularly unjust. This makes the conflict between his faith and his suffering superheated, so to speak.

And if the God J.B. believes in, as distinct from the pagan gods, is supposed to be just, then his life is a strong argument for atheism, for he gets the opposite of what justice demands. In fact, he seems better than God; it seems that he is the hero and God, if there is a God, is the villain—in fact, as C.S. Lewis dares to call him for a moment in *A Grief Observed*, "the cosmic sadist." The argument for atheism is summarized succinctly by Nickles, the actor in the play within the play who plays Satan: "If God is God, he is not good; / If God is good, he is not God." Power (God's middle name: "Almighty God") and justice seem to contradict each other in the world God created and in the script the divine author writes.

Two things that will not exist in heaven are doubt and faith—and for the same reason: when there is sight, there is no room for either doubt or faith. When we see God as he is, we will fall so totally in love with his goodness and beauty that there will be no possibility of temptation to either sin or doubt.

But here, faith is necessary in a world where there is so much data on the devil's side. It is also true that faith is *possible* only in such a world, as distinct from heaven, where there is *no* data on the devil's side.

Most atheists' concept of God is closer to that of Zeus than that of a saint with a sense of humor. If you don't *like* the person you think God is, you're not going to *want* to believe in him or, certainly, trust or love him. I think that perhaps the line in this play that is the key to MacLeish's atheism is the line from Mr. Zuss, the actor who plays God (Zeus): "God never laughs! In the whole Bible!"

First of all, that is not true in either the Old Testament or the New. In the Psalms, "He who sits in the heavens laughs" (Ps. 2:4)—at the "fools [who] say in their hearts, 'There is no God'"

(Ps. 53:1). More decisively, in the New Testament, the supreme revelation of God's goodness is also the greatest joke ever told, the one God played on the devil on the Friday Christians dare to call "Good." Mel Gibson got the joke. In his movie *The Passion of the Christ*, when Christ redeemed us from the devil by the supreme *injustice* of the Crucifixion, we hear a horrible groan come from the depths of the earth, or beneath it, at the moment of Christ's death. It is the devil, who has been tricked out of his prey—not by justice alone but by self-emptying love. MacLeish has it exactly backward: in the Bible, which is God's play, God laughs, but the devil does not; in MacLeish's play, Nickles (the devil) laughs, but God does not.

And if anyone wonders why the four Gospels never tell us about the laughter of God incarnate, they should read the last paragraph of G.K. Chesterton's masterpiece *Orthodoxy*. No, I won't quote it; I want you to buy it.

*J.B.* could be called a satire on God, but it is not funny, like *Waiting for Godot* or Voltaire's *Candide*. It is not just an updating but a radically deconstructive reinterpretation of the all-time classic drama about suffering, the book of Job, from the post-Christian viewpoint of an atheist and a nihilist.

Not all atheists are nihilists, or "nothing-ists." MacLeish is. Here is his metaphysics in a nutshell, or rather a sonnet. His poem, titled "The End of the World," is a parody of Christian eschatology. It begins, like *J.B.*, with the image of the world as a circus:

> Quite unexpectedly, as Vasserot
> The armless ambidextrian was lighting
> A match between his great and second toe
> And Ralph the lion was engaged in biting
> The neck of Madame Sossman while the drum
> Pointed, and Teeny was about to cough

In waltz-time swinging Jocko by the thumb—
Quite unexpectedly, the top blew off:

And there, there overhead, there, there, hung over
Those thousands of white faces, those dazed eyes,
There in the starless dark the poise, the hover,
There with vast wings across the cancelled skies,
There in the sudden blackness the black pall
Of nothing, nothing, nothing—nothing at all.

The last word is "nothing." That's the devil's favorite word. Karl Marx's favorite quotation, from Mephistopheles in Goethe's *Faust*, is "Everything that exists deserves to perish." That's the devil's philosophy and ultimate goal.

Bertrand Russell taught essentially the same worldview, with equal eloquence but with a more bitter and satirical bite, in *A Free Man's Worship*:

> To Dr. Faustus in his study Mephistopheles told the history of the Creation, saying:
>
> "The endless praises of the choirs of angels had begun to grow wearisome; for, after all, did he not deserve their praise? Had he not given them endless joy? Would it not be more amusing to obtain undeserved praise, to be worshipped by beings whom he tortured? He smiled inwardly, and resolved that the great drama should be performed.
>
> "For countless ages the hot nebula whirled aimlessly through space. At length it began to take shape, the central mass threw off planets, the planets cooled, boiling seas and burning mountains heaved and tossed, from black masses of cloud hot sheets of rain deluged the barely solid crust. And now the first germ of life grew in the depths of the ocean, and developed rapidly in the fructifying warmth into vast forest trees, huge ferns springing from the damp mould, sea

monsters breeding, fighting, devouring, and passing away. And from the monsters, as the play unfolded itself, Man was born, with the power of thought, the knowledge of good and evil, and the cruel thirst for worship. And Man saw that all is passing in this mad, monstrous world, that all is struggling to snatch, at any cost, a few brief moments of life before Death's inexorable decree. And Man said: 'There is a hidden purpose, could we but fathom it, and the purpose is good; for we must reverence something, and in the visible world there is nothing worthy of reverence.' And Man stood aside from the struggle, resolving that God intended harmony to come out of chaos by human efforts. And when he followed the instincts which God had transmitted to him from his ancestry of beasts of prey, he called it Sin, and asked God to forgive him. But he doubted whether he could be justly forgiven, until he invented a divine Plan by which God's wrath was to have been appeased. And seeing the present was bad, he made it yet worse, that thereby the future might be better. And he gave God thanks for the strength that enabled him to forgo even the joys that were possible. And God smiled; and when he saw that Man had become perfect in renunciation and worship, he sent another sun through the sky, which crashed into Man's sun; and all returned again to nebula.

"'Yes,' he murmured, 'It was a good play; I will have it performed again.'"

Such, in outline, but even more purposeless, more void of meaning, is the world which Science presents for our belief. Amid such a world, if anywhere, our ideals henceforward must find a home. That Man is the product of causes which had no prevision of the end they were achieving; that his origin, his growth, his hopes and fears, his loves and his beliefs, are but the outcome of accidental collocations of atoms; that no fire, no heroism, no intensity of thought and feeling, can preserve

an individual life beyond the grave; that all the labours of the ages, all the devotion, all the inspiration, all the noonday brightness of human genius, are destined to extinction in the vast death of the solar system, and that the whole temple of Man's achievement must inevitably be buried beneath the debris of a universe in ruins—all these things, while not quite beyond dispute, are yet so nearly certain, that no philosophy which rejects them can hope to stand. Only with the scaffolding of these truths, only on the firm foundation of unyielding despair, can the soul's habitation henceforth be safely built.

MacLeish is not only an atheist and a nihilist but also a deconstructionist. That label, and its inventor, Jacques Derrida, appeared later (*J.B.* was published back in 1958); but the essence of deconstructionism is already present in MacLeish. This is the attack on "logocentrism," on the *logos* or truth that John's Gospel identified as both "God" and "with God" and that became a man in Jesus. Truth is usually defined as the correspondence between what you think or say and what is, and technically, deconstructionism is the denial of the distinction that makes truth possible—namely, the distinction between "text" (what you say or write) and "world" (what is, what you say or write about). This is nicely summarized in MacLeish's most famous line, in *Ars Poetica*:

> A poem should be palpable and mute
> As a globed fruit,
> . . . . . . . . . . . . . . . . . .
> A poem should not mean
> But be.

What does this mean? That words are neither true nor false because they are not *about* things in the world; they *are* things in the world. This is the philosophy of the man who Nietzsche declared

the only admirable figure in the whole New Testament, Pontius Pilate, with his cynical question "What is truth?"

Truth really means "what is," and Pilate is saying: "What is 'what is'"?

There are three possibilities here about *logos*, or words, or text, or truth.

(1) The medieval Christian mind saw even *things* as *words*, as signs, as significant, as God's language. Therefore, they "looked-along" things as well as "looking-at" them (to use a crucial distinction from C.S. Lewis), as we (but not animals) do with words.

(2) The modern scientific mind sees things only as things, not signs, and words as labels for things.

(3) Deconstructionism takes the process one more step: even words are not words, not intentional, not signs of things; they are simply things, "palpable and mute."

What does human suffering look like from such a perspective?

The answer of *J.B.* is the exact opposite from the answer of Job. The narrative, the plot, is same *factually*, but with the opposite meaning and interpretation. Job's sufferings do not *mean* God's mysterious love. They do not mean anything. They are a poem that does not mean but be.

So either the author of Job or the author of *J.B.* is standing on his head.

The events of the plot are not the central feature of *J.B.*, for they are only an updated version of the events in Job. Instead of Sabeans stealing Job's camels and a hurricane collapsing Job's children's feasting house, we have rape, accidents, drugs, murder, war, and the effects of a nuclear holocaust as the causes of Job's sufferings. And J.B., like Job, retains his faith, trust, and gratitude to God, even though his sufferings are not justly deserved. MacLeish satirizes this piety through the words of Nickles, who is playing the devil:

Justice!
No wonder he laughs. It's ridiculous. All of it.
God has killed his sons, his daughters,
Stolen his camels, oxen, sheep,
Everything he has and left him
Sick and stricken on a dung heap—
Not even the consciousness of crime to comfort him—
The rags of reasons.

Later, Nickles sings:

I heard upon his dry dung heap
That man cry out who cannot sleep:
"If God is God He is not good,
If God is good He is not God;
Take the even, take the odd,
I would not sleep here if I could."

Nickles is here trashing not only God but also God's world and man. J.B. affirms both. For MacLeish, J.B. is only half right. He is wrong to believe in God but right to believe in man, and life, and human love, in the end, even though all of it is not only unjust but meaningless. That's *something* positive, and it's what Ivan Karamazov begins with in his great dialogue with Alyosha, but it's not enough. Our thirst for meaning cannot be ignored any more than our thirst for life. Replacing justice with love as both the meaning of life and the nature of God I think would be a good beginning of an answer to MacLeish, and the end of the play seems to give some grounds for moving toward that answer.

The events are retold as a play within a play, a dialogue between two actors, Mr. Zuss and Nickles, who play the parts of God and Satan. Actually, the biblical book is also a play within a play, but in reverse: in Job, we are in God's play; in *J.B.*, God is in ours. What distinguishes *J.B.* from Job is the reversal of the

perspective on the events in the narrative, a reversal that athe-ism demands. If God did not create us in his image, we created him in ours.

The events are played out by two has-been circus performers "acting out" the play. Mr. Zuss plays God. His name is meant to suggest the arrogant and ill-tempered god Zeus. Nickles, who is both more moral and wiser than Zeus, plays Satan. His name suggests "Old Nick," an English nickname for the devil, derived from Niccolò, the first name of Machiavelli, who was said to be the son of the devil.

These two, like God and Satan in the biblical account, argue about Job: Will he keep faith with God or not? ("Faith" here, as in the Bible, means not just intellectual belief but also personal fidelity.) But the deeper drama in *J.B.* is not about Job. We al-ready know how that drama ends: Job will keep faith. The drama is not in the old story, which MacLeish reframes, but is in the new frame itself. In the old story inside the new frame, Zuss wins and Nickles loses, since Job keeps faith, as Zuss predicts, and does not abandon it, as Nickles predicts; but from the larger context of the frame itself, Zuss (God) loses, even though J.B. wins. In the end, it is not the will of God but the will of man that triumphs; not divine love but human love, despite cosmic and/or divine injus-tice, randomness, and meaningless.

In Job, there is also a reversal of viewpoint—not outside of the story but within it. From Job's point of view, the drama seems to be about God, who seems to be put on trial by the injustice of Job's sufferings; but the drama is really about Job, who is be-ing tried by God rather than vice versa. The "vertical" conflict between these two viewpoints is the real drama in Job. And this conflict between the two viewpoints, the human and the divine, is a deeper drama than either the conflict on the divine level be-tween God and Satan or the conflict on the human level between doubt and faith in Job.

MacLeish preserves this doubleness of viewpoint but reverses it. In Job, "God on trial" is the appearance and "Job on trial" is the reality; in *J.B.*, it is the opposite: it is really God who is being tried, and who does *not* emerge innocent. We are his judges; he is not ours.

It is even more complex than that, for there are not just two but *three* viewpoints, or frames, like three enclosing circles. In Job, God is the ultimate frame, and God uses Satan, and the sufferings Satan brings to Job, as the middle frame or means to Job's eventual wisdom and joy in the end. So Job is surrounded by Satan, and Satan is surrounded by God; and both God and Job win while Satan loses. In *J.B.*, all of this is reversed. Job, not God, is the ultimate standard and point of view for judgment, and both God and Satan are "surrounded" or framed by Job (for there is no real God or devil to be outside the human frame, according to atheism), and Satan's point of view is wider and truer than God's.

This superiority of Satan to God is symbolized by Zuss' all-white God-mask having closed eyes while Satan's (Nickles') dark mask has open eyes, for "Satan sees." Nickles (Satan) has the two divine attributes of truth and love, and Zuss (God) does not. For Satan understands and cares about Job's sufferings while Zuss (God) does not. This is, of course, for the theist, the exact opposite of reality. In this total reversal of the truth, it is like Sartre's famous line that summarizes *No Exit*: "Hell is other people." And it may illumine the Christian alternative better, by contrast, than most Christian writings, as death illumines the value of life, and the bitterness of suffering makes joy sweeter. (This does not *justify* death or suffering, but it is true nevertheless.)

And in this upside-down drama, the winners and losers shift positions as well as the three frames or circles shifting positions. In *J.B.*, it is Job who wins, God (Zuss) who loses, and Satan (Nickles) who half wins and half loses: he loses in his conflict with Zuss about J.B., who does not apostatize, but he wins in his

conflict with God (Zuss), since he "identifies" and empathizes with Job, not with God.

The reader cannot help empathizing with Nickles' empathy rather than Zuss' lack of it. In *J.B.*, Satan is more moral than God. Zuss is indignant at the idea that Job would dare to demand justice. Nickles, on the other hand, like Dostoevsky's sympathetic atheist Ivan Karamazov, takes justice seriously enough to use it as the presupposition for his argument against God: "If God is God, He is not good. / If God is good, He is not God." The demand for goodness is right. We worship God for his goodness, not his power. If there were two Gods, one good but weak and the other evil but powerful (as in Norse mythology, where the gods are defeated in the end by the demons, the frost giants), we should worship the good one, not the powerful one.

The cynic may question whether we actually do that or the opposite. After all, in our vocabulary, "Good God!" is a swear word while "Almighty" is almost God's first name.

But in *J.B.*, "good" means most centrally and primarily justice, not love, and evil means injustice, not sin, or separation from the God who is infinite love. (The two ideas of God as perfect love and sin as separation from God imply and make meaningful each other, as do marriage and divorce.) By the standards of commonsense human justice, most of us are fairly good people, and would seem to need no radical suffering to become wholly acceptable on a human level. But by the standards of divine love, we are all radically defective, far from the total self-giving love that God is. Only a proud fool demands justice at the Last Judgment, and even Muslims and Jews know to ask for mercy, not justice, from God.

That does not explain the "problem of evil," by the way, for it does not appear that anyone needs such horrors as the Holocaust to be transformed into saints. Nor does suffering always do that. In fact, great suffering seems to destroy more often than build

up human goodness and happiness. The only adequate answer to the "problem of evil" is unavailable to our reason in this life. Faith alone can leap the gap between the ambiguous data and the theistic hypothesis. But, of course, that is exactly what the theistic hypothesis entails: that God's wisdom is unattainably superior to ours. If we *could* explain why Job is chosen to suffer so horribly, we would be as wise as God.

Thus, the culmination and "point" of Job is not God justly restoring Job's worldly fortunes, but Job's foretaste of heaven, his vision of God face to face: "I had heard of you by the hearing of the ear, but now my eye sees you; therefore I despise myself, and repent in dust and ashes" (Job 42:5–6). What Job repents of is not some hidden sin but his foolish demand for justice: "I have uttered what I did not understand, things too wonderful for me, which I did not know" (Job 42:3). That "wonderful thing" that he did not know was God's love and wisdom, not his power, and Christ; the ultimate proof and the incarnation of that love is Christ and his cross.

What Job repented of was his assuming the point of view of the author, not the author's character. After all, his name is "I AM," and our "I" is only "in the image of God," not God. Job had put God in the dock, demanding of God: "Hear, and I will speak; I will question you, and you declare to me" (Job 42:4). That is what *God* must say to *us*, not what we must say to him.

Therefore, our sufferings, as Viktor Frankl realized in Auschwitz and describes in *Man's Search for Meaning*, are God asking us, "What is the meaning of your life?" rather than us asking God, "What is the meaning of life?" And that question includes the question "What is the meaning of this suffering?" We, not God, must give the answer to that question. And our answer is not just our words, as if God were taking a poll, but our choice, our life, as if God were proposing marriage to our souls. For he is.

What would I say to MacLeish if I met him? I know of no abstract argument that can persuade anyone to thus change his point of view, his "frame," as Job did in the book of Job but not in *J.B.* That changed point of view comes essentially from the free choice of the will, the will to believe and trust. It does not come merely from the mind and its reasoning, however strong those reasons are. As Pascal and all the saints knew, "the heart has its reasons that the reason does not know." The "heart," in biblical rather than modern terminology, is not just *feeling* but *seeing*.

It is love (which is the work of the heart and the will) that sees, and therefore trusts: love "bears all things, believes all things, hopes all things, endures all things" (1 Cor. 13:7). Nothing else does. There is no substitute for love. Faith and love always go together. Job is a hero of love, not just of faith. But, then, so is J.B., though it is only human love in the end.

I cannot help but sympathize with MacLeish's *motive* for atheism and even his inability to empathize with J.B.'s piety and fidelity to God, both when his life was too comfortable and when it was too horrible (though that seems to be a "damned if you do and damned if you don't" catch-22). Nickles complains, sarcastically, that J.B.

> wouldn't understand if twenty
> Thousand suffocating creatures
> Shrieked and tore their tongues out at him
> Choking in a bombed-out town. He'd be
> Thankful!

And Mr. Zuss replies (but "stiffly"),

> I think he understands it
> Perfectly! I think that great
> Yea-saying to the world was wonderful—

That wounded and deliberate Amen—
That—affirmation

Nickles retorts,

> I think it stinks!
> One daughter raped and murdered by an idiot,
> Another crushed by stones, a son
> Destroyed by some fool officer's stupidity,
> Two children smeared across a road
> At midnight by a drunken child—
> And all with God's consent! . . .
> And he blesses God! . . .
> It isn't decent!
> It isn't moral even! It's disgusting!
> His weeping wife in her despair
> And he beside her on his trembling ham-bones
> Praising God! . . . It's nauseating!"

And when Mr. Zuss quotes the line T.S. Eliot identified as the greatest line in all of poetry, Dante's "His will: our peace," Nickles replies, this time clearly mistakenly,

> Will was never peace, no matter
> Whose will, whose peace.
> Will is rule: surrender is surrender.

Eliot's claim is verifiable in experience. When we surrender our will to God's, understanding that God is not the tyranny of power but the free offer of love, we infallibly find happiness. When we live "the pursuit of happiness" on our own terms, and pray "my will be done," we infallibly fail at the end to find even our own happiness. That is the fundamental paradox taught in some form

by every religion. The only reason religion survives is that that paradox actually works.

MacLeish, like Nickles and like Ivan Karamazov, is not just an atheist but a rebel, and not for scientific or intellectual reasons but for a very moral reason: because he wants justice. That's one of the steps in the heart's road toward God. Another more crucial one is human love, which triumphs over meaninglessness and hopelessness in the end of this play even without God. Thus, MacLeish is in love with two of the things that God is.

But he is not, like that other great literary atheist Camus, in love with sanctity. Camus, like his protagonist Dr. Rieux in *The Plague*, wants to be a saint and agonizes over the dilemma that "the meaning of life is to be a saint, but you can't be a saint without God." MacLeish does not admire sanctity and martyrdom, of body or will. When Zuss says, "His suffering will praise," Nickles replies, simply, "It will not." So it's yes to justice and to human love, but no to God and to Christianity and its redemptive suffering, and above all no to "surrender," to the "islam" that is the heart of all religion. It is understandable, but it is tragic because it refuses the deepest hope, peace, and joy.

MacLeish here is rejecting the central claim of Christianity, that God is love. When he has Nickles reject Zuss'

cold complacence . . .
Horrible as a star above
A burning, murdered, broken city!

he is right about the city (Hiroshima) but wrong about the star. The star has a face: it points to Bethlehem, to Christ, who is God's love incarnated.

MacLeish cannot empathize with J.B. when he says,

God is there too, in the desperation.
I do not know why God should strike
But God is what is stricken also

—which seems to refer to Christ. Christ transforms God's justice from something rational and predictable to something mysterious and dramatic and paradoxical: its manifestation is Crucifixion as well as Resurrection.

It is this strange justice that makes plays possible. If there were no tragedies, there could be no plays, and thus no comedies. If there were no losing, there could be no winning. Yogi Berra was right: "If the world were perfect, it wouldn't be."

That strange "justice" even includes sin and guilt. MacLeish understands that Bildad is wrong when he says: "At the end there will be justice!—Justice for All! Justice for everyone! On the way—it doesn't matter. . . . Guilt is a sociological accident." And J.B. refutes this with: "Guilt matters. Guilt must always matter. Unless guilt matters the whole world is meaningless." As George MacDonald says, "In my blame lies my hope." And when Eliphaz says, "There is no guilt, my man. We are all victims of our guilt, not guilty," J.B. responds ("violently"), "I'd rather suffer every unspeakable suffering God sends, knowing it was I that suffered, I that earned the need to suffer, I that acted, I that chose, than wash my hands with yours in that defiling innocence." This is nobly and deeply religious—and J.B. is MacLeish's hero! So this is hardly simple atheism.

The three "comforters" that come to J.B. to "justify the ways of God to Job" are a priest, a Freudian psychiatrist, and a Marxist. They only add to J.B.'s sufferings by removing his guilt, which is his only hope, for what J.B. wants most of all is a God who is just, and if Job is guilty, then God is just. Why, then, does the priest not help him? For two reasons: first, because he is a Calvinist, who identifies man's whole being, not just his actions, with sin, and second, because the priest brings only words, and only

words of blame, not the Good News. He does not perform the essential task of a priest, to bring the Real Presence of Christ in word (truth), deed (love), and sacrament. Instead, he says, "Why should God reply to *you* / From the blue depths of his eternity?" The Freudian adds "Blind depths of His Unconsciousness," and the Marxist adds "Blank depths of His Necessity." The God of the priest (who is, to MacLeish, the Church) is thus the same as that of the other two and the exact opposite of Christ, who *does* reply to us, but not with words on paper but with the Word on wood, on the cross.

At the end, Nickles admits that Zuss has won the bet about Job—he does not apostasize. But there is one more scene to play. Nickles says Job will have the guts to turn down God's gifts when he restores them, and he counsels Job to kill himself to avoid future sufferings. But Job refuses, and he is saved—not by God but by his wife, who returns with a flowering forsythia branch that survived the nuclear blast that surrounds them. (That flower functions as a tiny hope, like the few leaves on the dead tree in Beckett's *Waiting for Godot*.) Not God, but Job and his wife have the last word, which is human love. She says to J.B., "You wanted justice and there was none— / Only love."

The words are profoundly true. As W.H. Auden said so sagely and succinctly, "We must love one another or die." But for Mac-Leish, love is only human, not divine. And that is not enough. If Ultimate Reality is neither justice nor love but only a faceless "Distant Voice," then our lives in the long run cannot correspond to reality, for the voice of reality says to us, like Rhett Butler to Scarlett O'Hara, "Frankly, my dear, I don't give a damn."

It is that metaphysics, that disconnect between us and reality, that is the ultimate source of modern man's ridiculous denial of the objective reality of values, design, teleology, purpose, and even the essential natures of things (i.e., nominalism), including the reality of our gender and the humanity of unborn human children.

No other, less metaphysical error could be profound enough to justify such insanity. Ethics is always grounded in metaphysics, whether consciously or not. Thus, when "God is dead," man is dead too, for man is his image. As Cardinal Sarah sagely said, it's "God or nothing." J.B. says the same thing: "God is God or we are nothing." For J.B., God is God; for MacLeish, we are nothing.

Perhaps this is unfair. Perhaps there is a case for not labeling MacLeish an atheist, because there is also this unnamed "Distant Voice" that seems to belong to the true God, but it does not speak or give love. Nor does it have the last word. The "Distant Voice" seems to be only the God of Ecclesiastes, who does not change the meaning of life, which is still "vanity of vanities." It is the god of *Star Wars*, with a "dark side" as well as a light, for it is a Force rather than a person who can love, or even be nasty, like Zuss— and also like Zeus in *Prometheus Bound*. In paganism, there are at least gods to fight with. Thus, even pagan idolatry is more hopeful than post-Christian nihilism. As Chesterton said, paganism is like a virgin, Christianity is like a married woman, and modernity is like a divorcée. A divorcée does not return to being a virgin.

Whether there is a God or not is not the most difficult question. The Bible raises it only once, when the Psalmist says, "Fools say in their hearts, 'There is no God'" (Ps. 53:1). The most difficult question, which the Bible answers (continually and increasingly, through "progressive revelation" and "the development of doctrine") definitively in Christ, is about the *nature* and *motives* (will) of God. The difference between a God who is not love and a God who is, is much greater than the difference between the God who is not love and no God at all.

That is clear from the two greatest and most total atheists of all time, Nietzsche and Sartre, both of whom candidly admit that the nonnegotiable reason for their atheism is God's loveless eye, which sees their own dark side. Thus for them, the two deepest demands of the human heart, love and truth, contradict each other. This is

especially clear in Sartre's *No Exit*. None of the characters can be loved in all their unlovable faults, except by fantasizing, by blinding the eye to the real nature of the one loved. If you have eyes, like Nickles, you cannot love. Truth blocks love. Just as God, for Sartre, could not possibly be the union of being-in-itself (object-ness, thingness) and being-for-itself (subjectness, conscious and free personhood), God could not possibly be the union of truth and love, objectivity and subjectivity.

Fulton Sheen said two surprising, even shocking, things about atheists. The first was that he never met one—that is, he never met someone who understood who God really is, who un-derstood the real God, infinite goodness and love and beauty, and still denied him. The God that atheists deny is the deniable god—that is, an idol or a misunderstanding. The second thing was that the motive for being an atheist is always more funda-mentally moral than rational, always a matter of willing more than thinking. Not "My philosophy is right, not yours," but "My will be done, not Yours"—or, much better, but still a matter of morality, the demand for justice.

But even if this is true, we must not use this admission by both Nietzsche and Sartre (about their personal motivation for their atheism) as a weapon to scapegoat the atheist, for we all act like atheists time and again. We believers also resist that divine eye every time we sin against truth, against the light, against what God is; every time we "close down" against the light and run away from the face of God, that face that was Job's heaven and total satisfaction in the end, even before he got any of his "stuff" back. That is the crucial verse in Job that MacLeish does not compre-hend, and he does not comprehend it because he does not know Jesus Christ, who *is* the face of God.

# Three Dramas
# About Death

# 10

## *Hamlet*

BY WILLIAM SHAKESPEARE

I begin with a dogma: *Hamlet* is the greatest play ever written.

Most of humanity agrees with me here (or, rather, I agree with humanity); for to be great is to be lovable; and what we love and cherish, we remember and make familiar; and there are more quotations in Bartlett's *Familiar Quotations* from *Hamlet* than from any other play ever written—in fact, from any other *book* ever written, except the Bible.

*Hamlet* is universal in its appeal first of all because it is universal in its central theme, which, I will argue, is not Hamlet's character or procrastination or melancholy, but death. The stage is turned into a graveyard: ten of its eleven main characters are dead at the end!

It is great also for its style or speech, its eminently quotable eloquence, both tragic and comic and many levels in between. But the style ministers to the theme, not the theme to the style.

In the third place, its appeal is universal also because it is both pagan and Christian, like *Beowulf,* though more typically pagan than Christian. Post-Christian nihilists identify with it too.

For death and darkness and uncertainty pervade every thing and character in the play.

We shall see each of these three main points continually as we follow the play, but I begin with the first point, the central theme, because if we get that wrong, everything else will be out of focus. And the best way I can do this is to point to C.S. Lewis' masterful and persuasive essay "Hamlet: the Prince or the Poem?," which leaves thousands of *Hamlet* critics biting the dust. The essay is almost twenty pages long, but the most pervasive problem in criticism of the greatest of all plays merits a long refutation.

Lewis divides *Hamlet* critics into three classes. (1) Some say Hamlet's actions and lack of actions have no good motive, especially his procrastination and his feigned madness. (2) Some see Hamlet as a tragic hero who responds as well as he can but fails. (3) And some, like T.S. Eliot, say it is simply a bad play, "most certainly an artistic failure." Lewis' response to that is: "If this is failure, then failure is better than success. We want more of these 'bad' plays. . . . Have we ever known the day or the hour when its enchantment failed?" ("Enchantment" is the greatest virtue and power of the play, yet it is usually neglected by the critics.) Most of the critics, Lewis concludes, have "kept constantly before us the knowledge that in this play there is greatness and mystery. They were never entirely wrong. Their error, on my view, was to put the mystery in the wrong place—in Hamlet's motives rather than in that darkness which enwraps Hamlet and the whole tragedy and all who read or watch it."

Toward the end of the essay, Lewis calls his view "naïve and concrete and archaic": "I am trying to recall attention from the things an intellectual adult notices to the things a child or a peasant notices." Thank you, Lewis, for being the little boy in "The Emperor's New Clothes."

*Hamlet* is indeed what Gabriel Marcel calls a "mystery" rather than a "problem." It is not solved or resolved. The mystery of

death "enwraps" every one of the characters. Hamlet, his father, Claudius, Gertrude, Ophelia, Polonius, Rosencrantz and Guildenstern, and Laertes all die, and Horatio attempts suicide until restrained by Hamlet in the end. When we see this play, we have no place to flee.

Not only is death itself dark, but it shines its dark light into life, changing light into darkness, dividing appearance from reality, knowledge from being. Every one of the characters is not what they seem to be. The play is as ironic as *Oedipus the King*, its only rival for the greatest of all plays. And in both plays, what moves the plot and the doom is the hero's dogged pursuit of truth and light in a foggy world of irony and paradox. Hamlet seems mad but is fatally sane. Ophelia seems sane but goes fatally mad. Claudius and Gertrude seem innocent victims but are really murderers. The gravediggers are at a most tragic work, but they are the greatest of comics. The play within the play ("The Mousetrap") seems to be an artifice, but it is the reality and truth that surrounds and defines Claudius and Gertrude, whose lives outside the play were false. When they see the play, they observe it apparently from outside it but really from inside it.

The ghost seems dead but is really alive, so alive that he is the chief mover of the events. Hamlet's uncle is a murderer, and his "seeming-virtuous queen" is an adulterer and collaborator in the murder of her virtuous husband. Laertes is at first Hamlet's friend, then his enemy and killer, then his reconciled friend. Polonius, like a pop psychologist, seems wise but is really a fool, a pufferfish. Rosencrantz and Guildenstern, Hamlet's old friends, are his attempted murderers. Ophelia, apparently sane, is insane and kills herself. Their love, apparently destined, is doomed. Hamlet, apparently mad, is the one sane man in this insane asylum. He himself is "not himself." No one is what they seem to be. Here in the "shadowlands," almost nothing is except the ghost.

And he is the most ambiguous figure of all: Is he sent from heaven or from hell?

Only Horatio is trustable and predictable. He alone is what he seems, so it is fitting that he alone survives "vertically" to tell this "slanted" story to the world, like Ishmael in *Moby Dick*.

\*

One way this play is more pagan than Christian is that the above description of life is a typically pagan one. Only in Christianity does light conquer darkness by divine revelation and does life conquer death by divine (and human) resurrection. Pagans put their faith and hope and love into everything except Everything, while Christians put theirs in nothing except Everything. Pagans put their gods into the cosmos because they put their hopes there. Jews and Christians do not.

\*

The very first line of the play not only sets the tone but also the theme. Out of the cold, dark night on a castle parapet, one guard asks another, "Who's there?" (That's the question the play asks about every single character!) The other does not answer, but questions in turn, "Nay, answer me. Stand and unfold yourself." But all the "unfoldings" in the play will prove to be deceptive.

Immediately, on the very first page, the ghost enters. Marcellus is afraid to speak to it and asks the brave Horatio, "Question it, Horatio." Horatio asks almost the very same question that began the play, "What art thou?"

That is the primary question for Hamlet too, and the delay in getting the answer is the perfectly valid reason for Hamlet's delay, for the word of a ghost whom no one but Hamlet saw would hardly justify the killing of a king in the eyes of anyone. And

ghosts could easily be deceptive and lead the living astray—to death, and even to hell. Ghosts can come from heaven (these are bright and happy), from purgatory (these are sad and sorrowful), or from hell (these are deceptive and dangerous).

This ghost *seems* authentic. But if so, he is the exception, for nearly everything else in this play is not what it seems. Marcellus asks, "Is it not like the king?" And Horatio answers, "As thou art to thyself." But even this latter likeness to self (which is the law of identity or the law of noncontradiction itself) seems questionable in the world of *Hamlet*. Is any of us simply himself? Rocks cannot help being rocky, dogs doggy, and cats catty, but humans can perform the amazing feat of being inhuman. In fact, being our true selves is not only not guaranteed but is a difficult and even perhaps impossible task!

The only two "authentic" characters in this play besides the ghost are Hamlet and his best friend Horatio, who, like Hamlet, shows that he is the exact opposite of a procrastinator, a coward, or a melancholic who withdraws from action. He confronts the ghost: "I'll cross it, though it blast me." Like Job, he wants truth more than life itself. (Job says, "Though he slay me, yet will I trust in him" [Job 13:15 KJV].) Like Oedipus, Horatio demands to pierce through shadowy and untrustworthy appearances to objective reality, no matter what the cost. But he cannot stop the shadows from shifting. Thus, he addresses the ghost: "Stay, illusion!"

But at the very moment Horatio opens himself to the ghost, the cock crows, announcing the coming dawn; and the coming of the morning light, ironically, makes it impossible for the ghost, who dwells in darkness, to shed the light of truth.

There are many references to Hamlet deliberately dressing in black. It is obviously to mourn his father's death, but there is epistemological significance to the color too. The queen says, "Good Hamlet, cast thy nighted color off. . . . Thou know'st 'tis common; all that lives must die. . . . Why seems it so particular with

thee?" And Hamlet answers, "Seems, madam! Nay, it is; I know not 'seems.'" Hamlet, like Socrates, is a philosopher who questions appearances ("seeming") to find reality (truth). This honesty and devotion to truth is his personal absolute: "I have that within which passeth show." No one else in the play except Horatio can make that statement. The whole of Hamlet's life, and this whole Hamlet-centered play, is now like a ghost, full of shadows.

One of the contrasting characters to Hamlet is Polonius, a fake or inauthentic philosopher. Hamlet addresses him as "fool." Yet most of my students think he is a wise man, an Oprah, a pop psychologist when he says:

> This above all: to thine own self be true
> And it must follow, as the night the day,
> Thou canst not then be false to any man.

That was Hitler's philosophy too, and Satan's.

When the ghost appears again, Hamlet confronts it:

> Be thou a spirit of health or goblin damned,
> Bring with thee airs from heaven or blasts from hell,
> Be thy intents wicked or charitable,
> Thou com'st in such a questionable shape
> That I will speak to thee. I'll call thee "Hamlet."

Hamlet's father is Hamlet's own inner identity, not an external force that confronts and contradicts his own will. A pagan might call him a god or a fetish. A Christian might say he was a prophet sent by God. *Hamlet* has one foot in both of these two religions.

When the ghost gives Hamlet the heaven-sent task to revenge his "foul and most unnatural murder," Shakespeare's audience, like all premodern audiences, both pagan and Christian, would

all assume that "revenge" here is not a vice but a virtue, an essential part of justice. For virtue reveals truth rather than concealing it or forgetting it. Hamlet is tasked to expose what his father calls his brother's

> wicked wit and gifts, that have the power
> So to seduce!—won to his shameful lust
> The will of my most seeming-virtuous queen.

Hamlet must expose this "seeming" to the light.

And he does so with infinite passion, which Shakespeare's audience, unlike modern ones, would see as a virtue, not a vice. When the ghost commands, "Remember me," Hamlet invokes the whole of reality in support:

> O all you host of heaven! O earth! what else?
> And shall I couple hell? O, fie! Hold, hold, my heart;
> And you, my sinews, grow not instant old,
> But bear me stiffly up. Remember thee!
> Ay, thou poor ghost, while memory holds a seat
> In this distracted globe. Remember thee!
> Yea, from the table of my memory
> I'll wipe away all trivial fond records

> . . . . . . . . . . . . . . . . . . .

> It is "Adieu, adieu! Remember me."
> I have sworn 't.

Hamlet has sworn an oath, and in all premodern societies oaths are absolutely sacred. (See Robert Bolt's preface to *A Man For All Seasons*, chapter 5.) Hamlet is no dreary dreamer or passive procrastinator. He is *choleric*, not melancholic; active, not passive,

in spirit. But his moral passion to revenge his father's death in the bodily world depends on his intellectual passion to know: to know, in his own mind, the true identity of the ghost, and thus of the present king and queen.

Finding and exposing this truth is not easy, because truth and reality in this fallen world are complex and deceptive. Truth is so hidden that without the passionate love of it, it will not reveal itself. It is also hidden because "there are more things in heaven and earth, Horatio, than are dreamt of in your philosophy," or in ours. This "moreness" is the ultimate metaphysical basis for mystery, for the discrepancy between appearance and reality. The typically modern mind would tell Horatio that there are *fewer* things in heaven and earth—that is, in objective reality—than in our philosophies, most of which are myths and need to be deconstructed.

When Polonius finds Hamlet in the library and asks, "What do you read, my lord?" Hamlet replies, "Words, words, words." That answer is the essence of deconstructionism: that neither real things nor words are signs of truth and have real "sign-ificance," but that even words are only things, and are used for power, not truth.

Hamlet is feigning madness here in the library while he reads. The essence of madness is to confuse subjective with objective reality, thought with being, words with things, ideas with realities, thoughts with truths, "text" with "world." That is the very distinction deconstructionism denies. That philosophy is almost the definition of insanity. To the insane, words are no longer signs but weapons.

This is especially true when words are value-words, like "evil" and "good" or "murder" and "revenge." When Hamlet tells Rosencrantz that "there is nothing either good or bad, but thinking makes it so," he is deliberately playing the part of a madman. My students don't get that point; they think Hamlet is uttering wise

philosophy here! But if that were so, if there were really nothing good or bad but thinking makes it so, why would Hamlet bother to sacrifice his comfort and risk his life to avenge his father's "foul and most unnatural murder"? All he would have to do is to master his thinking (and he certainly has the brains to do that) and not the real world in which he lives with Claudius and Gertrude.

Hamlet plays also with Polonius by denying the law of identity in his "madness":

> Hamlet: Do you see yonder cloud that's almost in shape of a camel?
> Polonius: By th'mass and 't is like a camel indeed.
> Hamlet: Methinks it is like a weasel.
> Polonius: It is backed like a weasel.
> Hamlet: Or like a whale?
> Polonius: Very like a whale.
> Hamlet: Then I will come to my mother.

That "then" is a *non sequitur* if there ever was one. And it is preceded by a metaphysics of "whatever." If you say it is a whale, it is a whale. If you say it is good, it is good.

Hamlet has a rational motive for his madness. Polonius admits that "though this be madness, yet there is method in 't." Many critics puzzle over what the motive could be, but it should be quite clear and simple: it takes a thief to catch a thief. Hamlet is a detective. Madness is his cover. Just as apparent sanity is the madman's best disguise, so apparent madness is the best disguise of the sane man, especially the detective.

When Hamlet asks Rosencrantz, "What news?" and gets the answer, "None, my lord, but that the world's grown honest," he replies, "Then is doomsday near." For Hamlet, the normal situation of the world is abnormality; to be true to your nature is unnatural; the truth is that we are liars. In other words, Hamlet,

like both pagans and Christians and unlike moderns, believes in original sin.

*Hamlet* is amazingly contemporary. Our crisis, as St. John Paul II clearly saw, is a crisis of anthropology, of human nature, of "know thyself." Hamlet lives this crisis and this irony when he soliloquizes: "What a piece of work is a man! How noble in reason! How infinite in faculties! In form and moving how express and admirable! In action how like an angel! In apprehension how like a god! The beauty of the world! The paragon of animals! And yet, to me, what is this quintessence of dust? Man delights not me—no, nor woman neither."

When the actors arrive, their presence is an additional irony, for their play, their acting, their fiction, reveals fact and truth about the murder, while the life in the castle that surrounds and creates this "artifice" in the theater is full of lies. When Polonius tells Hamlet that he should treat the actors well and "use them according to their desert," Hamlet replies, "God's bodykins, man, much better! Use every man after his desert, and who should 'scape whipping?" Hamlet the "madman" here speaks real wisdom to the purportedly "wise" Polonius, who mouths clichés. Wisdom is the discernment between itself and folly, but Hamlet's apparent folly is true wisdom while Polonius' apparent wisdom is truly folly.

Irony here is pretzel-like.

Before the "Mouse-trap" play is put on, Hamlet implicitly speaks about the goal and purpose of his own creator's (Shakespeare's) vocation, that of the playwright, when he tells the players that their "end, both at the first and now, was and is, to hold, as 'twere, the mirror up to nature; to show virtue her own feature, scorn her own image." In other words, the goal of the theatrical "fakes" is truth. Shakespeare is perhaps slyly warning us that his play may do for us what Hamlet's "Mouse-trap" does for Claudius. For we, too, live in the "shadowlands" of sin,

uncertainty, and false identities—unless, as Hamlet playfully says to Rosencrantz, doomsday has come!

Hamlet's delay (not "procrastination") is wise, not foolish, for

> the spirit that I have seen
> May be the devil; and the devil hath power
> T'assume a pleasing shape [see 2 Cor. 11:14]; yea, and perhaps

. . . . . . . . . . . . . . . . . .

> Abuses me to damn me; I'll have grounds
> More relative [definitive] than this: the play's the thing
> Wherein I'll catch the conscience of the king.

And the trap works:

> Ophelia: The king rises.
> Hamlet: What, frighted with false fire!
> Queen: How fares my lord?
> Polonius: Give o'er the play.
> King: Give me some light. Away! [Note the irony: he asks for light to escape the play's light!]
> Polonius: Lights, lights, lights!

For once, Polonius and Hamlet say the same thing.

Now, Hamlet knows who the ghost is and who Claudius and Gertrude are: "O good Horatio, I'll take the ghost's word for a thousand pound. Didst perceive?"

Then comes the most famous and most philosophical of all soliloquies: "To be or not to be: that is the question." Hamlet had hoped that the ghost had not spoken the truth; now he knows that he did, and that his task is to commit regicide. Who would not sympathize with his reluctance to do that deed? Who would not even sympathize with his temptation to suicide to escape this

terrible responsibility? His choice now, concretized in the most famous first words of the most famous soliloquy in the world, is "to be or not to be." The meanings of this either/or are multiple.

For one thing, the question of "to be or not to be" is both theoretical (reality or illusion?) and practical (life or death?). "To be or not to be" was the question God answered by creation. Suicide is uncreating creation. Uncreating God's creation is the work of the devil; and Hamlet here is being sorely tempted to this because escape seems to be "a consummation devoutly to be wish'd."

And ironically, it is precisely the imprecise and mysterious and unknown that saves him from suicide here: the fact that

> the dread of something after death,
> The undiscovered country from whose bourn
> No traveller returns, puzzles the will
> And makes us rather bear those ills we have
> Than fly to others that we know not of.

"The fear of the LORD is the beginning of wisdom" (Prov. 9:10).

The king arranges for Hamlet to be sent away to England and assassinated by Rosencrantz and Guildenstern because he cannot endure Hamlet's light. He tries to do to Hamlet what Athens did to Socrates and what Jerusalem did to Christ, and for the same reason.

When he sees the king at prayer, alone and defenseless, Hamlet has the opportunity to obey his father's command of just revenge. But, he thinks, that would not be justice, for

> and so 'a goes to heaven;
> And so am I reveng'd. That would be scanned:
> A villain kills my father, and for that,
> I, his sole son, do this same villain send

To heaven.

Oh, this is base and silly, not revenge.

Whether Hamlet's choice to pass by the opportunity to kill Claudius now is good or evil depends on whether one is more pagan or more Christian; and on this, as on many other issues, the play stands clearly in neither camp but halfway between. The ghost's demand for revenge (justice), combined with his impatience and criticism of Hamlet's "almost blunted purpose," suggests that Hamlet should have sent Claudius to heaven at prayer. If so, then the ghost is more Christian than Hamlet is: he wants only revenge (justice) on Claudius, not his eternal damnation. Hamlet has changed his motive from impersonal justice (the right kind of "revenge") to personal vengeance (the wrong kind). Hamlet is "noble," but he is not a saint.

When Hamlet finally confronts his mother in the attempt to bring truth and light into her darkness, the darkness interrupts and triumphs again when Polonius, who was spying, hiding behind the curtain, is killed by Hamlet, who mistakes him for Claudius. (This is another proof that Hamlet is not "procrastinating," by the way.) Hamlet's speech to Gertrude repeats the words "see" and "look" and "eyes." When Hamlet sees his father's ghost and Gertrude does not, she thinks he is mad, even though it is he, rather than she, who sees the full reality.

When Hamlet tells the king that he has killed Polonius, even the humor is dark:

> King: Now, Hamlet, where's Polonius?
> Hamlet: At supper.
> King: At supper! Where?
> Hamlet: Not where he eats, but where 'a is eaten. . . . We fat[ten] all creatures else to fat[ten] us, and we fat[ten] ourselves for maggots. . . . A man may fish with the worm that hath eat[en] of a king, and eat of the fish that hath fed of that

worm. . . .
King: Where is Polonius?
Hamlet: In heaven; send thither to see: if your messenger
find him not there, seek him i' th' other place yourself. But if
indeed you find him not within this month, you shall nose
him as you go up the stairs into the lobby.
King: Go seek him there. (*To some attendants*)
Hamlet: 'A will stay till you come.

Still more darkness and irony is introduced when Hamlet meets a
soldier fighting "to gain a little patch of ground / That hath in it
no profit but the name" but that nevertheless costs "two thousand
souls and twenty thousand ducats." Hamlet muses on the irony:

> I see
> The imminent death of twenty thousand men,
> That for a fantasy and trick of fame
> Go to their graves like beds, fight for a plot
> Whereon the numbers cannot try the cause,
> Which is not tomb enough and continent
> To hide the slain.

And the darkness intrudes again when Ophelia knows of her fa-
ther Polonius' death and sings:

> And will 'a not come again?
> And will 'a not come again?
> No, no, he is dead;
> Go to thy death-bed;
> He never will come again.

But Hamlet's father *has* "come again"!
    The darkness intrudes again when Claudius persuades Laertes
to avenge his sister Ophelia's death by suicide by plotting to

deceive and kill Hamlet with a poison blade. It will succeed four times more than planned: at the end, Hamlet, Laertes, Claudius, and Gertrude are all dead.

But before this concluding scene, there is the dark comic relief of "two Clowns with spades" digging the grave of Hamlet's beloved Ophelia and singing and bantering with very silly puns:

> Hamlet: What man dost thou dig it for?
> First Clown: For no man, sir.
> Hamlet: What woman, then?
> First Clown: For none, neither.
> Hamlet: Who is to be buried in 't?
> First Clown: One that was a woman, sir, but, rest her soul, she's dead.

When the clown mentions Hamlet as "he that is mad, and sent into England," Hamlet asks, "Why was he sent into England?" and the answer is "Why, because 'a was mad: 'a shall recover his wits there; or, if he do not, 't is not great matter there. . . . 'T will not be seen in him there; there all the men are as mad as he." The self-referential joke is a serious reminder that we are laughing and mourning at our own tragicomic madness. And when Hamlet discovers the skull of the dead court jester Yorick, he "sees" the truth of death: "Let me see. *(Takes the skull.)* Alas, poor Yorick! I knew him, Horatio; a fellow of infinite jest." The whole play does what Hamlet does here: it "lets me see" and "takes the skull."

All is teleologically consummated, for "there's a divinity that shapes our ends, / Rough-hew them how we will." For pagans, it is impersonal Fate; for Christians, it is the God of infinite wisdom and love. In the last scene, where Laertes and Hamlet fatally wound each other, king, queen, prince, and friend all share in the mystery of death. Laertes, like the Greek chorus, announces the "lesson": "He is justly serv'd; / It is a poison temper'd by himself."

131

Evil inevitably destroys itself in the end. The spiritual war is won, but at the cost of a terrible physical body count.

Hamlet announces (twice!) to Horatio that "I am dead." Dead men *can* speak, after all, if they have a living prophet, as Hamlet does:

> Horatio, I am dead;
> Thou livest; report me and my cause aright
> To the unsatisfied [i.e., to those who see only injustice, not
> justice, in life's events].

The real protagonist of this play is death itself, which receives its just due from Fortinbras when he comes upon this corpse-laden stage. Fortinbras is a soldier whose very vocation is to deal out death, yet he is appalled at death's triumph. And so are we, who know as well as he that "they give birth astride of a grave," that death is life's one sure guarantee.

> O proud Death,
> What feast is toward in thine eternal cell,
> That thou so many princes at a shot
> So bloodily hast struck?

When we discover this strange play, we feel as Fortinbras felt when he came upon the corpse-strewn stage and spoke those lines. We, too, are appalled. Death seems to be the conqueror. The play's philosophy is more apparently pagan than Christian because it is death and fate that seem to have the last word. There are indeed in Shakespeare's Christian philosophy, as in Hamlet's, "more things in heaven and earth . . . than are dreamt of in your philosophy," but they are not visible on stage.

# 11

## CHRISTIAN

# *The Dream of Gerontius*

### BY JOHN HENRY NEWMAN

Of the fifteen plays I comment on in this book, this one is the shortest. Yet my treatment of it is the longest, and I quote the most from it, because I suspect that for most readers it is the least familiar. (*Hamlet*, since it is the most familiar, is one of the ones from which I quote the least.)

*The Dream of Gerontius* was written as a poem rather than a play, but this poem belongs in a book about plays, even though it was not designed for the stage, for the same reason Dylan Thomas' *Under Milk Wood* does: it is a drama designed for the stage of speech. It is not just to be read silently but to be spoken, or sung, as a lyric, as music. The change in rhythm, rhyme, and tone is part of the cake, not part of the icing. If you can listen to a recording of it, you will feel its power as dramatic theater, so much so that your anticipation of your own death will be deeply altered for the rest of your life. If you can't get a recording of it, make one: create your own auditory theater by speaking all the parts yourself, aloud. For it is poetry, not prose. It is to be sung, even when spoken (again, like *Under Milk Wood*), and parts of it

are literally to be chanted. And you should certainly also listen to the deservedly famous musical version by Edward Elgar.

I think that even if some genius like Terrence Malick ever added fitting visual imagery to the poem, either on a screen or even on a stage (if at all possible, it would require extraordinarily imaginative visual props), it could not be turned into a successful movie because its words could not be relegated to a kind of "background music" for the images, as music is relegated to "background music" for the images in movies. (That is also why *Under Milk Wood* made such a poor movie.) It would probably look as lame as trying to "illustrate" the music of a symphony orchestra with images. If it did work, the only images that would fit the words would have to be impressionistic, suggestive, symbolic, and archetypal, like the horses in *Equus* (see the stage directions there).

Most of the text is poetry, not prose. Poetry is word-music. The difference between prose and poetry is greater than the difference between poetry and music. Poetry is closer to music than to prose. The changes in sound (e.g., from rhyme to blank verse, from long to short lines, from harmony to cacophony) are one with the changes in meaning and feeling. You need to be a musician as well as a philosopher or theologian to get it. But we all are musicians and philosophers and theologians, so we all can get it. These are universally human enterprises.

It is "lyrical," but it is not a lyric poem but a dramatic poem. And it is infinitely dramatic, for infinity is at stake here at the moment of death, the most dramatic moment in every human life: the drama between infinite and eternal life or infinite and eternal death. It provokes what Kierkegaard called "the infinite passion," which is something that he, like so many other astute observers (like Robert Bolt in *A Man for All Seasons* and Peter Shaffer in *Equus*), bemoaned as missing in modern man.

"For what shall it profit a man, if he shall gain the whole world, and lose his own soul?" (Mark 8:36 KJV). A soul without a world (which is what Gerontius experiences in this drama) is at least something. In fact, it is not only "something" but everything, for as even Aristotle noted, "The soul is in a way all things." But a world without a soul to "gain" it, to "have" it, to experience it, is nothing.

Nothing is more immediately important, more difference-making, than how we die. Death is the most important journey we ever make. In fact, it is the only important journey we ever make, for life is the only important journey we make, and death is the last and determinative event in that journey that we call life. It is to life what the conclusion is to an argument.

Dying is active as well as passive. It is something we do as well as something we receive. What difference does it make how we die? Only the difference between everything or nothing; or, rather, between more-than-everything and less-than-nothing. For heaven is infinitely more and better than all worlds, and hell is infinitely less and worse than no worlds at all.

What will happen to me when I die? That is what this drama is about. What will the greatest of all my adventures look like, feel like, sound like? Is there any more interesting question than that? Any more dramatic question? Is there any more mysterious question than the one about what Hamlet calls "the undiscovered country from whose bourn / No traveller returns"? For "no eye has seen, nor ear heard, nor the human heart conceived, what God has prepared for those who love him" (1 Cor. 2:9).

The obvious poem to compare *Gerontius* with as a preview of what we will find after death is, of course, Dante's *Divine Comedy*. But Dante was in one way much more ambitious and in another way much less ambitious than Newman.

Dante gives us a trip through the personalities, details, and levels of hell, purgatory, and heaven; Newman gives us almost none

of those. Dante gives us a moral map of justice, of virtues and vices and their just rewards and punishments. Newman does not, except for what is called the single "fundamental option." Gerontius does not visit or see hell at all; his only purgatory is a part of his heaven (in this Newman is in line with Catholic dogma, especially the revelations of St. Catherine of Genoa); and his final heaven is delayed and not described but only promised at the end. In all these ways, Newman's poem cannot be compared with Dante's in scope.

But in another way Newman is more ambitious, in giving us a likely preview of what we will actually experience after we die as believers, while Dante merely shows us the moral landscape of the afterlife, universally. Dante, like Aquinas in the *Summa theologiae*, is a mapmaker, an observer; Newman, like Augustine in the *Confessions*, is a participant. In other words, Newman's Gerontius is an individual character within Dante's *Comedy*. Dante publishes the atlas of the country of which Gerontius sees a tiny segment.

Newman knew that most of the answer to the question of what we will experience after death must remain a mystery in this life; and that is why he called this drama a "dream." Not a fantasy, but not a divine revelation either, though it is consistent with what the Church has always taught about death and the afterlife.

It is a dream not of Newman's but of Newman's fictional character "Gerontius," which means simply "old man." Newman made him an Everyman, a deliberately unremarkable Catholic, because it is the *agon* or trial of this "proto-agonist" that is remarkable, not because it is peculiar but because it is universal for most believers. Thus, the reader's attention is drawn not to Gerontius but to death itself, and therefore to how the reader also will find it and face it. Lewis Carroll used the same principle with *Alice in Wonderland*, deliberately making Alice an ordinary, unremarkable little girl in an extraordinary, remarkable world. A Wonderkid in Wonderland would be one too many wonders.

Perhaps this is true also of Hamlet, as we have seen; perhaps the obsessive focus of most of the critics on Hamlet's peculiar psychology distracts from the proper focus: the universal theme of death itself, the great unknown that casts a shadow of darkness and ambiguity over all the appearances of life itself, and thus of every character and event in that play.

Death is not sanitized here, or made more comfortable or endurable. Death cannot be simply a transition to another world similar to a graduation or a vacation. The other world is a wholly new world ("See, I am making all things new" [Rev. 21:5]), a whole new mode of being and seeing and feeling that is at least as uprooting, as startling, and as discombobulating as birth.

Perhaps not a wholly new hearing, though. For if "in the beginning was the Word" (John 1:1), then words go all the way up into God. That is perhaps the theological reason why when we die the sense of hearing is the last to go, and why even after heart death and brain death, when all the other senses die, hearing sometimes remains for a little while. We know that from the testimony of millions of "near-death experiences" and "out-of-body experiences." So it is appropriate that this is a heard drama rather than a seen one, in the theater of the mind rather than on a stage or screen. God does not fit on a stage or a screen. (That is the paradox in the title of this book.)

## (1)

"In my end is my beginning," says T.S. Eliot. Thus, from the beginning of the poem we see the deliberate juxtaposition and mutual interpenetration of two themes in Gerontius' end, expressed by the interweaving of lines of verse: what the protagonist passively experiences (dying) and the words of faith and hope that he actively speaks and wills and enacts. The latter are deliberately put into parentheses by Newman to distinguish them. The

two are distinguished in order to be folded into each other like a marbled cake:

Jesu, Maria! I am near to death

. . . . . . . . . . . . . . . . . . . . . . . . .

(Jesu, have mercy! Mary, pray for me!)
'Tis this new feeling, never felt before,
(Be with me, Lord, in my extremity!)
That I am going, that I am no more.
'Tis this strange innermost abandonment,
(Lover of souls! Great God! I look to Thee,)
This emptying out of each constituent
And natural force, by which I come to be.

. . . . . . . . . . . . . . . . . . . . . . . . . . . . .

As though my very being had given way,
As though I was no more a substance now,
And could fall back on nought to be my stay,
(Help, loving Lord! Thou my sole Refuge, Thou),
And turn no whither, but must needs decay
And drop from out the universal frame
Into that shapeless, scopeless, blank abyss,
That utter nothingness, of which I came.

The typically modern mind, for which pain is the greatest evil, will not understand "that sense of ruin, which is worse than pain," as Gerontius says later. It no longer understands that "it is better to be than not to be," even if "to be" is painful. Thus, the modern

mind instinctively embraces euthanasia. We no longer thirst for being, only for pleasure.

Gerontius' experience of death is a reflection or shadow of his and our experience of life, whose drama always has the two-act pattern of the negative and the positive, nonbeing and being, desperation and deliverance, problem and solution, challenge and response, "bad news" and "good news." If there were no "bad news," the "good news" would not be news at all. Thus, the essential structure of human life is the answer to the "problem of evil," to why God allows us to fall: so that he can raise us farther up than if we never fell. It is the Exsultet's "O felix culpa!" and Romans 8:28.

The second worst thing about death is its loneliness. All connections, all umbilical cords, all relationships, which are life's greatest positivities, are removed—except one, the one to God. But this, for a Christian, is the same cord that still connects us to Christ—and, for a Catholic, therefore, to his Church, and to "the communion of saints," whom Gerontius invokes immediately: "So pray for me, my friends, who have not strength to pray." And the "Assistants" promptly invoke Mary, the angels, the choirs of the righteous, Abraham, St. John the Baptist, St. Joseph, St. Peter, St. Paul, St. Andrew, St. John, Apostles, Evangelists, disciples, Holy Innocents, martyrs, confessors, hermits, virgins, and saints of God to do so. Which is done in every Catholic Mass! They are not absent. They are there; they are active; they make a difference. Their names are not just remembered but invoked. They are not just memories of the earthly dead but encounters with the heavenly living.

### (2)

The worst thing about death is not its pain or even its loneliness, but sin, which is its cause (Rom. 6:23). It is the only absolute evil

because it is separation from the only absolute good. Thus, it is the opponent in the only absolute drama, God or not-God, all or nothing. Newman uses short lines and concentrated rhymes to express this concentrated agony, this war, this "agon" at the last concentrated point of the life of Gerontius the proto-agonist. Hear the spiritual fusion, the diamond-like concentration, in the Assistants' (intercessors') lines:

> From Thy frown and Thine ire;
>> From the perils of dying;
>> From any complying
>> With sin, or denying
>> His God, or relying
> On self, at the last;
>> From the nethermost fire;
> From all that is evil;
> From the power of the devil;
> Thy servant deliver
> For once and for ever.

I hope you are not just *reading* this, silently, but *hearing* it, by *speaking* it aloud. It is not sheet music to be looked at but to be performed in the cavernous musical theater of your mouth.

## (3)

The next dramatic event is external rather than internal, though it is what T.S. Eliot calls "the objective correlative" of the inner drama: Gerontius senses a vague but terrifying physical manifestation

of the presence of his spiritual enemies, the evil spirits whose whole will is bent on his soul's eternal destruction:

> A fierce and restless fright begins to fill
> The mansion of my soul. And, worse and worse,
> Some bodily form of ill
> Floats on the wind, with many a loathsome curse
> Tainting the hallowed air, and laughs, and flaps
> Its hideous wings,
> And makes me wild with horror and dismay.
> O Jesu, help! pray for me, Mary, pray!
> Some angel, Jesu! such as came to Thee
> In Thine own agony.

## (4)

And he is answered by the Assistants, who pray, "Rescue him, O Lord, in this his evil hour." And they invoke God's past rescues of his servants, whose power is still present and operative in the very real and difference-making communion of saints: Abraham, Job, Isaac, Lot, Moses, Daniel, Shadrach, Meshach, and Abednego, Susanna, David, Peter and John, and Thecla (to show that the obscure and unremembered are not obscure and unremembered).

This entire narrative is both intensely individual and intensely communal. Never is either dimension missing or in tension with the other. And that is neither oxymoronic nor paradoxical but inevitable.

Also still present and operative is the prayer of the priest at Gerontius' bedside. The two worlds are not cut off from each other, or from real causal interactions; they are only cut off from earthly visibility. For the Church Militant on earth, the Church Suffering in purgatory, and the Church Triumphant in heaven is one Body with one Head. It is one complete person, both human

and divine. Christ and his Body are one, not two, like the "head" of a corporation and his employees. The priest speaks not in his own name but in the name of the Church, and therefore his words have divine authority and not just human hope when he commands, "Go forth upon thy journey, Christian soul!" And he, too, invokes the Trinity, the choirs of angels, and the whole communion of saints: Father, Son, Holy Spirit; angels, archangels, thrones, dominations, princedoms, powers, virtues, cherubim, and seraphim; patriarchs, prophets, apostles, evangelists, martyrs, confessors, monks, hermits, virgins, and saints. They are all *there.* They are what Heidegger calls *Dasein* ("being-there"), not *Seiendes* (entities, objects).

The effect in Gerontius' soul is palpable:

> A strange refreshment; for I feel in me
> An inexpressive lightness, and a sense
> Of freedom, as I were at length myself.

He had previously feared losing himself to nothingness; but this fear is not realized, for the soul is a seed, and from this loss, this falling into the ground and dying, comes the new life (John 12:24).

## (5)

But "with what kind of body do they come?" (1 Cor. 15:35). St. Paul's answer is that there are many different kinds of bodies. And the next event, or discovery, in Gerontius' journey is that he seems to be in an interim body, neither still alive in the mortal one nor immortal in the resurrection one:

> Am I alive or dead? I am not dead
> But in the body still; for I possess

A sort of confidence which clings to me,
That each particular organ holds its place

. . . . . . . . . . . . . . . . . . . . . . . . . . . . . . . . . . .

And yet I cannot to my sense bring home,
By very trial, that I have the power.
'Tis strange; I cannot stir a hand or foot,
I cannot make my fingers or my lips
By mutual pressure witness each to each,
Nor by the eyelid's instantaneous stroke
Assure myself I have a body still.
Nor do I know my very attitude [posture],
Nor if I stand, or lie or sit, or kneel.

So much I know, not knowing how I know,
That the vast universe, where I have dwelt,
Is quitting me, or I am quitting it.

This second body, or semi-body, or "interim body," is not part of the material universe. We know (and Gerontius knows) no more about it than an unborn baby knows about the larger universe outside the womb. But without some kind of body we are not wholly human, and Gerontius has not lost his human nature; therefore, he has some kind of body, which he will in the next few lines call "my subtle being."

### (6)

Another dramatic event now occurs from outside him:

Another marvel; someone has me fast
Within his ample palm; 'tis not a grasp

Such as they use on earth, but all around
Over the surface of my subtle being

. . . . . . . . . . . . . . . . . . . . . . . . . . . .

I am not
Self-moving, but borne forward on my way.
And hark! I hear a singing; yet in sooth
I cannot of that music rightly say
Whether I hear or touch or taste the tones.
Oh what a heart-subduing melody!

The next voice is identified simply as "Angel." It is Gerontius' own personal guardian angel, who sings in short and concentrated lines. (By the way, for angels, the relationship between speech and song, and between prose and poetry, is the reverse of what it is for us. Music is their first and natural language.)

My work is done,
My task is o'er;
And so I come,
Taking it home,
For the crown is won,
Alleluia,
For evermore.

My Father gave
In charge to me
This child of earth
E'en from its birth
To serve and save,
Alleluia,
And saved is he.

This child of clay
　To me was given,
　　To rear and train
　　By sorrow and pain
In the narrow way,
　Alleluia,
　From earth to heaven.

. . . . . . . . . . . . . . . . .

O Lord, how wonderful in depth and height,
　But most in man, how wonderful Thou art!

The Angel praises God for the very thing that provoked the demons' rebellion, namely, God's love of man.

## (7)

The Angel also reveals the scary and seldom-admitted fact of the spiritual warfare that each of us has been through and that has been fought throughout life by not just one spirit but two:

And, coiled around his heart, a demon dire.
Which was not of his nature, but had skill
To bind and form his opening mind to ill.

Then was I sent from heaven to set right
　The balance in his soul of truth and sin,
And I have waged a long relentless fight,
　Resolved that death-environed spirit to win.

If we had no guardian angel to balance this supernatural evil with supernatural good, to put a leash on the beast, we would have about as much chance against our tempting demon as a butterfly

against a volcano. To preserve our free choice, God limits the power of both spirits to a "balance," as Gandalf does in *The Lord of the Rings*. (In one of his letters, Tolkien explicitly identified Gandalf as an archangel!) He acted as an enabler or coach rather than a player.

That is why any and all war and drama exist on earth: because of this primary spiritual war and drama in the soul. As Solzhenitsyn famously said, the dividing line between good and evil cuts between not nations, races, regimes, or ideologies, but runs right through the middle of each human soul. That is the drama that unites all dramas. This warfare, this "jihad" between good and evil, is always first of all spiritual and then expressed in visible and bodily forms.

### (8)

The Angel wonders at man and praises God for this drama. (Angels wonder at man even more than man wonders at angels!)

O man, strange composite of heaven and earth!

. . . . . . . . . . . . . . . . . . . . . . . . . . . . . . . . . . . . .

How should ethereal natures comprehend
    A thing made up of spirit and of clay,
Were we not tasked to nurse it and to tend,
    Linked one to one throughout its mortal day?
More than the Seraph in his height of place,
The Angel-guardian knows and loves the ransomed race.

Note very carefully and literally Gerontius' response to this angelic revelation:

> Now know I surely that I am at length
> Out of the body: had I part with earth,
> I never could have drunk those accents in,
> And not have worshipped as a god the voice
> That was so musical; but now I am
>
> . . . . . . . . . . . . . . . . . . . . . . . . . . .
>
> As no temptation can intoxicate.

In this life, God does not let us see angels as they really are (they almost always come disguised as humans—see Heb. 13:2) because if we did, we would inevitably worship them. (See also Rev. 22:8–9.) Even the full vision of a glorified human being would probably be too great for us, as C.S. Lewis famously said in "The Weight of Glory": "It is a serious thing to live in a society of possible gods and goddesses, to remember that the dullest and most uninteresting person you can talk to may one day be a creature which, if you saw it now, you would be strongly tempted to worship, or else a horror and a corruption such as you now meet, if at all, only in a nightmare. All day long we are, in some degree, helping each other to one or other of these destinations."

### (9)

The Angel then reveals the paradoxical providential principle that renders human history maximally dramatic:

> All praise to Him, at whose sublime decree
>     The last are first, the first become the last;
> By whom the suppliant prisoner is set free,

By whom proud first-borns from their thrones are cast,
Who raises Mary to be Queen of heaven,
While Lucifer is left, condemned and unforgiven.

## (10)

Gerontius then asks his guardian angel (yes, we can speak with them; they are not deaf!) about the next step in his dramatic journey:

I ever had believed
That on the moment when the struggling soul
Quitted its mortal case, forthwith it fell
Under the awful Presence of its God,
There to be judged and sent to its own place.
What lets [hinders] me now from going to my Lord?

And the Angel answers:

Thou art not let; but with extremest speed
Art hurrying to the Just and Holy Judge:
For scarcely art thou disembodied yet.

. . . . . . . . . . . . . . . . . . . . . . . . . . . . . .

For spirits and men by different standards mete
The less and greater in the flow of time.
By sun and moon . . .

. . . . . . . . . . . . . . . . .

. . . men divide the hours,
Equal, continuous, for their common use.

> Not so with us in the immaterial world;
> But intervals in their succession
> Are measured by the living thought alone.

Even now we experience two different kinds of time, *kronos* and *kairos*, material time and spiritual time, time measured by bodies moving through space in the universe and time measured by souls moving toward or away from their end, which is God; that is, time measured by purpose and intention, which means, ultimately, by charity, *agape* love.

### (11)

Next in the conversation is the proper understanding of "the fear of God," which Scripture often calls "the beginning of wisdom," though not the end. Gerontius wonders:

> Dear Angel, say,
> Why have I now no fear at meeting Him?
> Along my earthly life, the thought of death
> And judgment was to me most terrible.
> . . . . . . . . . . . . . . . . . . . . . . . . . . . . . .
> Now that the hour has come, my fear is fled.

And the Angel's answer is wise and wonderful:

> It is because
> Then thou didst fear, that now thou dost not fear.

That is the difference between folly and wisdom. Fools fear the fear of God more than they fear God, and their present fearlessness

will end in fear. The wise, like Gerontius, fear now and therefore will end in fearlessness.

## (12)

Then comes the apotheosis of the drama, the heavenly court where eternal life or death is decided. The Angel announces:

> We are now arrived
> Close on the judgment court; that sullen howl
> Is from the demons who assemble there.
> It is the middle region, where of old
> Satan appeared among the sons of God,
> To cast his jibes and scoffs at holy Job.
> So now his legions throng the vestibule,
> Hungry and wild, to claim their property,
> And gather souls for hell. . . .

> . . . . . . . . . . . . . . . . . . . . . . .

> It is the restless panting of their being;
> Like beasts of prey, who, caged within their bars,
> In a deep hideous purring have their life,
> And an incessant pacing to and fro.

Having listened to their ugly, barking scorn, punctuated with many "Ha's," Gerontius reflects:

> How impotent they are! and yet on earth
> They have repute for wondrous power and skill;
> And books describe, how that the very face
> Of the Evil One, if seen, would have a force

Even to freeze the blood, and choke the life
Of him who saw it.

As C.S. Lewis writes, in *Perelandra*, "As there is one Face above all worlds merely to see which is irrevocable joy, so at the bottom of all worlds that face is waiting whose sight alone is the misery from which none who beholds it can recover. And though there seemed to be, and indeed were, a thousand roads by which a man could walk through the world, there was not a single one which did not lead sooner or later either to the Beatific or the Miserific Vision."

This is not Manichean dualism; it is simply spiritual warfare. As the Angel reminds Gerontius:

> In thy trial-state,
> Thou hadst a traitor nestling close at home,
> Connatural, who with the powers of hell
> Was leagued, and of thy senses kept the keys,
> And to that deadliest foe unlocked thy heart.
>
> . . . . . . . . . . . . . . . . . . . . . . . . . . . .
>
> But, when some child of grace . . .
>
> . . . . . . . . . . . . . . . . . . . . . . . . .
>
> . . . meets the demons on their raid,
> They scud away as cowards from the fight.

Newman knows that the demons of darkness have no power over the light of divine grace, and that their power over us cannot master and move our will or our intellect, only our senses and our

imagination, to tempt us. Even God cannot move our free will unfreely, *against our will*; how much less the demons!

## (13)

Once the demons disappear, Gerontius asks how it is that he can hear both angels and demons but not see them, or anything else? And the Angel answers that it is not a bodily hearing that he has:

> Thou livest in a world of signs and types,
> The presentations of most holy truths
> Living and strong, which now encompass thee.
> A disembodied soul, thou hast by right
> No converse with aught else beside thyself;
> But, lest so stern a solitude should load
> And break thy being, in mercy are vouchsafed
> Some lower measures of perception,
> . . . . . . . . . . . . . . . . . . . . . . . . . . . . .
> And thou art wrapped and swathed around in dreams,
> Dreams that are true, yet enigmatical.

The poem that contains all these speeches, events, and protagonists is itself "The *Dream* of Gerontius."

The Angel then compares Gerontius' apparent sensations to the strange but well-documented phenomenon of "the phantom limb" in this life:

> Hast thou not heard of those, who, after loss
> Of hand or foot, still cried that they had pains
> In hand or foot, as though they had it still?
> So is it now with thee.

Does this Platonic immaterialism (Gerontius' soul is now without his body) contradict his earlier experience of having some sort of temporary body? Not if "body" is not a univocal term.

### (14)

Gerontius then asks about the greatest thing of all, the beatific vision, which is guaranteed but postponed while he suffers his necessary purgation and cleansing:

> When I looked forward to my purgatory,
> It ever was my solace to believe
> That, ere I plunged amid th'avenging flame,
> I had one sight of Him to strengthen me.

And the Angel replies:

> Nor rash nor vain is that presentiment;
> Yes,—for one moment thou shalt see thy Lord.
> . . . . . . . . . . . . . . . . . . . . . . . . . . . . . . .
> One moment; but thou knowest not, my child,
> What thou dost ask: that sight of the Most Fair
> Will gladden thee, but it will pierce thee too.
> . . . . . . . . . . . . . . . . . . . . . . . . . . . . . .
> Learn that the flame of the Everlasting Love
> Doth burn ere it transform.

This momentary vision of God is minimally but significantly similar to Emily's momentary vision, in *Our Town*, of the beauty of her past ordinary life on earth from the viewpoint of the dead: it is unendurably painful and evokes tears, yet it is cleansing and clarifying and transforming. St. Catherine of Siena says, on the basis of her God-given visions of purgatory, that purgatory is simultaneously

more joyful and more painful than any earthly experience. It is more joyful because of the presence of God and the absolute certainty of our salvation, and also because all our pains are wanted, *willed*, by us because they are willed by God. And they are also more painful than anything on earth because they go deep into our heart and into the heart of our sin: a sorrow like St. Peter's tears of agony at having denied and disowned Christ (Luke 22:54–62).

This is why the angel speaks of

> . . . thy approaching agony,
> Which thou so eagerly didst question of:
> It is the face of the Incarnate God
> Shall smite thee with that keen and subtle pain;
> And yet the memory which it leaves will be
> A sovereign febrifuge [fever-remedy] to heal the wound;
> And yet withal it will the wound provoke,
> And aggravate and widen it the more.
>
> . . . . . . . . . . . . . . . . . . . . . . . . . . . . . .
>
> Thou wilt be sick with love, and yearn for Him.
>
> . . . . . . . . . . . . . . . . . . . . . . . . . . . . . . . . .
>
> There is a pleading in His pensive eyes
> Will pierce thee to the quick, and trouble thee.
> And thou wilt hate and loathe thyself; for, though
> Now sinless, thou wilt feel that thou hast sinned,
> As never thou didst feel; and wilt desire
> To slink away, and hide thee from His sight
> And yet wilt have a longing aye to dwell
> Within the beauty of His countenance.
> And these two pains, so counter and so keen,—
> The longing for Him, when thou seest Him not;

154

The shame of self at thought of seeing Him,—
Will be thy veriest, sharpest purgatory.

Purgatory is not an external, legal transaction to "pay" for our sins; it is simply the total truth about our sins, now fully seen, felt, and repented. C.S. Lewis, the Protestant, referred to *Gerontius* when he called this a purgatory he could firmly believe in.

## (15)

Though not yet capable of the full beatific vision, Gerontius' journey has taken him to the heaven of the angels:

We now have passed the gate, and are within
The House of Judgment; and whereas on earth
Temples and palaces are formed of parts
Costly and rare, but all material,
So in the world of spirits nought is found
But what is immaterial.

The "stones" that make up the "House" of Judgment are angelic *persons*.

## (16)

These angels then sing their story and ours, providentially and mysteriously mixed as they are:

The Angels, as beseemingly
To spirit-kind was given,
At once were tried and perfected
And took their seats in heaven.

For them no twilight or eclipse;
   No growth and no decay:
'Twas hopeless, all-ingulfing night,
   Or beatific day.

. . . . . . . . . . . . . . . . . . . . . . . .

And when, by blandishment of Eve
   That earth-born Adam fell,
He [Satan] shrieked in triumph, and he cried,
   "A sorry sentinel;

The Maker by His word is bound,
   Escape or cure is none;
He must abandon to his doom
   And slay His darling son."

. . . . . . . . . . . . . . . . . . . . . . . .

O loving wisdom of our God!
   When all was sin and shame,
A second Adam to the fight
   And to the rescue came.

O wisest love! that flesh and blood
   Which did in Adam fail
Should strive afresh against the foe,
   Should strive and should prevail;

. . . . . . . . . . . . . . . . . . . . . . . .

O generous love! that He who smote
   In man for man the foe

The double [body-and-soul] agony in man
For man should undergo.

Why is this whole cosmic drama of salvation inserted here? Because its protagonist is the Christ who made Gerontius' whole drama of salvation possible.

### (17)

Then, to show the interplay of earth and heaven, and of earthly and heavenly time, and of earthly and heavenly friends that constitute the communion of saints, the Angel lets Gerontius hear the earthly voices that he heard last on earth, at the very beginning of this play:

It is the voice of friends around thy bed,
Who say the "Subvenite" with the priest.
Hither the echoes come; before the Throne.

Heaven is not deaf! Every syllable of every prayer echoes clearly in the ears of heaven.

### (18)

And now Gerontius' soul is ready to go before the divine Judge. And its Angel says:

The eager spirit has darted from my hold,
And, with the intemperate energy of love,
Flies to the dear feet of Emmanuel;

. . . . . . . . . . . . . . . . . . . . . . . . . . .

O happy, suffering soul! for it is safe,
Consumed, yet quickened, by the glance of God.

. . . . . . . . . . . . . . . . . . . . . . . . . . . . . . . . . . . . .

Now let the golden prison ope its gates,

. . . . . . . . . . . . . . . . . . . . . . . . . . . . .

Angels of Purgatory, receive from me
My charge, a precious soul.

As the divided sides of a mountain unite at the top, so human op-
posites unite in heaven: the soul is both "happy" and "suffering,"
both "consumed, yet quickened," and purgatory is both "golden"
and a "prison." Gerontius' Angel bids him Godspeed, for he will
not be alone in this "golden prison":

Softly and gently, dearly-ransomed soul,
    In my most loving arms I now enfold thee,
And, o'er the penal waters, as they roll,
    I poise thee, and I lower thee, and hold thee.

. . . . . . . . . . . . . . . . . . . . . . . . . . . . .

Angels, to whom the willing task is given,
    Shall tend, and nurse, and lull thee, as thou liest;
And Masses on the earth, and prayers in heaven,
    Shall aid thee at the Throne of the Most Highest.

Farewell, but not for ever! brother dear,
    Be brave and patient on thy bed of sorrow;
Swiftly shall pass thy night of trial here,
    And I will come and wake thee on the morrow.

What is said here to Gerontius by his guardian angel after no less than eighteen postmortem experiences and learnings can be said to us by our angel at this and every moment of our lives.

# 12

# *The Sunset Limited*

## BY CORMAC MCCARTHY

In *Hamlet*, God is offstage but referred to or suggested, sometimes explicitly. In *The Dream of Gerontius*, he is centrally and clearly present, though unseen. In *The Sunset Limited*, he is definitively rejected by the central character, who deliberately seeks suicide by throwing himself under the train referred to by the ironic title.

The movie made from this play is totally faithful to, and therefore as effective as, the script for the play. I cannot recommend it highly enough. Samuel Jackson's portrayal of the poor, life-affirming "Black" is absolutely perfect, simultaneously serious and funny. The same is true of Tommy Lee Jones' portrayal of the burnt-out "White." In fact, the movie is so good that it is better than the written script of the play, and in this one case I would advise you to see the movie first and then read the play in light of the movie rather than vice versa.

There are only two characters, and they are named only "Black" and "White" because they are both pared down to their essential and opposite natures. Ironically, "Black" is in the light (he is a simple, uneducated, believing and practicing Christian), and "White" is in the darkness (an overeducated academic who

is not only an atheist but a nihilist). But though nameless, they are not stereotypes. They are complex flesh-and-blood characters. And their dialogue is not abstract (like that in *My Dinner with Andre*, to which it is often compared) but so concrete that life and death are literally at stake, because Black is trying to keep White from a second suicide attempt after having rescued him from the first. This is not a debate on the existence of God; it is a spiritual wrestling match.

Spoiler Alert! In the end, Black fails to persuade him or detain him, and White leaves, intent on death rather than life. Yet throughout the conversation, the uneducated Black slum dweller and ex-con shows up the educated nihilism of the educated professor as the sun shows up the dirt on a windshield or as a match lights up a dark room.

Both characters also show the truth that "orthopraxy is the root of orthodoxy"; that love elicits faith and hope, while lovelessness elicits unbelief and despair. The conversation eventually reveals the source of White's nihilism as practical and personal rather than theoretical and philosophical. White hates life not, most fundamentally, because of the failings of his culture (Black calls him a "culture junky") but because of his own life, which is bereft of friends and family by his own misanthropy.

The heart of the philosophical and moral difference between Black and White is revealed in the very first lines, when Black, having rescued White from suicide, says, "So what am I supposed to do with you, Professor?" and White responds, "Why are you supposed to do anything?" And when Black answers, "I done told you. This ain't none of my doin. I left out of here this morning to go to work you wasn't no part of my plans at all. But here you is," White's response reveals his philosophical nihilism: "It doesn't mean anything. Everything that happens doesn't mean something else." But it does, in Black's theistic world, and thus he replies, ironically, "Mm hm. It don't"—meaning that it does. For White,

life is "a tale told by an idiot, full of sound and fury, signifying nothing." For Black, it is a meaningful and mysterious providential plan, a story. The best way I've ever discovered for asking the question of "the meaning of life" is Sam's in *The Lord of the Rings*: "I wonder what sort of a tale we've fallen into."

The theme of the story, for Black, is brotherhood. Black rescued White because when he saw him jump, he thought: "Well, he don't *look* like my brother. But there he is. Maybe I better look again."

The theme is also life versus death. It is significant that White decided on suicide on his birthday, the day to celebrate life. Suicides always rise around Christmas.

> White: Maybe birthdays are dangerous. Like Christmas. Ornaments hanging from the trees, wreaths from the doors, and bodies from the steampipes all over America.
> Black: Mm. Don't say much for Christmas, does it?
> White: Christmas is not what it used to be.
> Black: I believe that to be a true statement. I surely do.

At least a dozen times White says, "I've got to go." Black doesn't argue, he just contradicts it: "You don't need to go, Professor." White thinks he wants to go to death. The drama here is not merely about philosophy or theology but about White's life. Is death its only end and the only relief or salvation? Or is something else its end, both its *finis* or last act and its *telos* or purpose?

That was precisely the cause of Tolstoy's despair and thoughts of suicide, as he relates it in his *Confession*. He found nothing that was stronger than death.

Black quickly reveals his very concrete answer to the question of what is stronger than death and what other than death is life's end and meaning:

White: Do you really think that Jesus is in this room?

Black: No. I don't think he's in this room.

White: You don't?

Black: I *know* he's in this room.

McCarthy teases us with the possibility that Black is really an angel:

Black: I was just standin there on the platform. Mindin my own business. And here you come. Haulin ass.

White: I'd looked all around to make sure there was no one there. Particularly no children. There was nobody around.

Black: Nope. Just me.

White: Well I don't know where you could have been.

Black: Mm. Professor you fixin to get spooky on me now. Maybe I was behind a post or somethin.

White: There wasn't any post.

Black: So what are we sayin here? You lookin at some big black angel got sent down here to grab your honky ass out of the air at the last possible minute and save you from destruction?

White: No. I don't think that.

Black: Such a thing ain't possible.

White: No. It isn't.

.............................

White: I don't believe in angels.

Black: What is it you believe in?

.............................

White: Lots of things. Cultural things, for instance. Books and music and art. Things like that.

Black: All right.

White: Those are the kinds of things that have value to me. They're the foundations of civilization. Or they used to have

163

value. I suppose they don't have so much any more.
Black: What happened to em?
White: People stopped valuing them. I stopped valuing them.

...........................

White: The things that I loved were very frail. Very fragile.
I didn't know that. I thought they were indestructible. They
weren't. [Western civilization finally went up in smoke in the
chimneys at Dachau. . . .]

...........................

Black: I got to ask what is the use of notions such as them
if it won't keep you glued down to the platform when the
Sunset Limited comes through at eighty mile a hour.

...........................

Black: So let me see if I got this straight. You sayin that all
this culture stuff is all they ever was tween you and the Sunset
Limited.

...........................

Black: You a culture junky.

White is intelligent enough to see that his humanistic former
answer to that question of what to believe in fails because it is
not stronger than death. (Tolstoy came to the same conclusion
in his *Confession*.) And without something superhuman, his only

alternative is nihilistic, subhuman, and suicidal. (As Tolstoy also perceived: he struggled with temptations to suicide for years.)

Black's answer to the question "What is stronger than death?" is, of course, God, in Christ, and in genuine love and friendship. But White reveals that he has no friends. And no family ties, with living mother or dying father, whom he both rejected. That is the heart of the matter. Friends (and family are the primary friends) are really the angels, the messengers of God that we need to show us life's meaning.

> White: I don't like people.
> Black: But you wouldn't hurt them people.
> White: No. Of course not.
> Black: You sure.
> White: Of course I'm sure. Why would I hurt them?
> Black: I don't know. Why would you hurt yourself?
> White: It's not the same thing.
> Black: You sure about that?

The issue, then, is simultaneously practical (what in life is stronger than death) and ethical (brotherhood) and even metaphysical; for as Black says, "If God walked the earth when he got done makin it then when you get up in the mornin' you get to put your feet on a real floor and you don't have to worry about where it come from. But if he didn't then you got to come up with a whole other description of what you even mean by real. And you got to judge everything by that same light. If light it is. Includin yourself. One question fits all."

In other words, the fundamental need is ontological. "To be or not to be, that is the question."

> White: You see everything in black and white.
> Black: It is black and white.

White: I suppose that makes the world easier to understand.
Black: You might be surprised about how little time I spend trying to understand the world.
White: You try to understand God.
Black: No I don't. I just try and understand what he wants from me.
White: And that is everything you need.
Black: If God aint everything you need you in a world of trouble.

White, like Ecclesiastes, is materially rich and spiritually poor, while Black, like Job, is materially poor and spiritually rich because he has the three most precious and necessary things: faith, and hope, and charity. Black lives in a material slum, while White lives (and seeks to die) in a spiritual slum.

Black: I guess you don't want to be happy.
White: Happy?
Black: Yeah. What's wrong with happy?

..........................

White: It's contrary to the human condition.
Black: Well. It's contrary to your condition. I got to agree with that.

..........................

White: Well you can't be happy if you're in pain.
Black: Why not? [Only the saints give that answer!]

..........................

Black: If you didn't have no pain in your life then how would you even know you was happy? As compared to what?

The first question Jesus asks in John's Gospel is the question that determines everything, in our time and our eternity: "What are you looking for?" (John 1:38). Black plays the part of Jesus here in asking that question of White (what he really wants) indirectly:

> Black: If you was to hand a drunk a drink and tell him he really don't want it what do you reckon he'd say?
>
> ..........................
>
> Black: What he really wants he can't get. Or he thinks he can't get it. So what he really don't want he can't get enough of.
> White: So what is it that he really wants.
> Black: You know what he really wants.
> White: No I don't.
> Black: Yeah you do.
>
> .........................
>
> Black: He wants what everybody wants.
> White: And that is?
> Black: He wants to be loved by God.
> White: I don't want to be loved by God.
> Black: I love that. See how you cut right to it? He don't either. Accordin to him. He just wants a drink of whiskey.
>
> ..........................
>
> White: Well I'm sorry, but to me the whole idea of God is just a load of crap.
> (The black puts his hand to his chest and leans back.)
>
> ...........................

(He closes his eyes and shakes his head, laughing silently.)
White: You don't find that an evil thing to say.
Black: Oh Mercy. No, Professor. I don't. But you does.

In the end, even though Black clearly wins the argument, White wins the fight. He leaves.

Black: What can I do to get you to stay a bit?
White: Why? Are you hoping that if I stay long enough God might speak to me?
Black: No, I'm hopin he might speak to me.

But apparently he doesn't, and White leaves, apparently for the Sunset Limited, even though Black, like God, tells him, "I'll be there. You hear? I'll be there in the mornin." Black's last words are to God: "If you wanted me to help him how come you didn't give me the words?" And there is no answer in words.

Except White's own words, which echo those of Sartre in *No Exit*, that "hell is other people." White confesses: "If I thought that in death I would meet the people I've known in life I don't know what I'd do. That would be the ultimate horror." He *loves* death more than life because it has "no community. My heart warms just thinking about it. Silence. Blackness. Aloneness. Peace. And all of it only a heartbeat away. . . . Show me a religion that prepares one for death. For nothingness. There's a church I might enter. Yours prepares one only for more life. For dreams and illusions and lies. If you could banish the fear of death from men's hearts they wouldn't live a day. Who would want this nightmare if not for fear of the next?" Those last words are almost a plagiarism of Hamlet's most famous soliloquy.

He reveals, unconsciously, that accepting others, accepting self, and accepting God are not three things but one thing, a package deal, when he adds: "You tell me that my brother is my salvation? My salvation? Well then damn him. Damn him in

every shape and form and guise. Do I see myself in him? Yes. I do. And what I see sickens me."

The "fundamental option" is indeed a package deal: love of God, of self, of neighbor. As Thomas Merton said, "We are not at peace with each other because we are not at peace with ourselves, and we are not at peace with ourselves because we are not at peace with God." For what you do to one of these his brethren (including yourself), you do to him. We see both the positive and the negative side of this truth "in black and white" in this play. At least one thing has to be black or white because those are the only two absolutes that can make up all the relative grays.

# Three Dramas
# About Damnation

# 13

PRE-CHRISTIAN

# *Macbeth*

BY WILLIAM SHAKESPEARE

*Hamlet* was about death; *Macbeth* is about damnation. It is a psychology of damnation, an answer to this question: How could any apparently sane human being choose damnation over salvation, eternal misery and despair over joy and hope? It also shows us what damnation looks like psychologically in its earthly, beginning stages. My focus in *Macbeth* will be narrower than in *Hamlet* because damnation is more specific than death. It is also less often portrayed, and today less often believed in.

Shakespeare did not write *Macbeth* to convince unbelievers of the reality of damnation, for he lived in a society of believing Christians. Yet his treatment of Macbeth's gradual descent into hell is an effective apologetic for many modern unbelieving readers because of its psychological realism. (So is Charles Williams' *Descent into Hell*, a truly terrifying book, and without any appeals to physical terrors.)

The danger of damnation is what makes death so terrifying and so practical. For what does it profit a man to gain the world (whether Scotland or Wales) and lose his own soul? That belief deterred Hamlet from suicide:

For in that sleep of death what dreams may come
When we have shuffled off this mortal coil,
Must give us pause . . .
. . . . . . . . . . . . . . . . . .
. . . the dread of something after death,
The undiscovered country from whose bourn
No traveller returns.

It is our very ignorance of what we will find when we have shuffled off this mortal coil that makes Pascal's "wager" very reasonable.

Belief in an afterlife and in some kind of damnation as well as salvation was common to both Judeo-Christian-Muslim monotheism and pagan polytheism. On this issue, Shakespeare, like all medieval Christians, was no more post-pagan than he was post-Christian.

Our focus on Macbeth's and Lady Macbeth's damnation will omit the external steps in its visible plot and its murderous outworkings and will explore only (1) its supernatural origins (evil spirits), (2) its psychological strategy (self-blinding), (3) its effects on the psyche (no peace), and (4) its philosophy of life (nihilism).

**(1)**

The play begins with an unholy trinity of witches, the most famous witches in literary history:

*Act I, Scene I . . . thunder and lightning.*
*Enter three Witches.*
1 Witch: When shall we three meet again
In thunder, lightning, or in rain?
2 Witch: When the hurly-burly's done
When the battle's lost and won.
3 Witch: That will be ere the set of sun.
1 Witch: Where the place?

2 Witch: Upon the heath.
3 Witch: There to meet with Macbeth.
1 Witch: Come, Graymalkin!
All: Paddock calls:—anon!—
Fair is foul, and foul is fair:
Hover through the fog and filthy air.
*Witches vanish.*

The play's very first line is a warning, which is almost the same one that is put at the end of the truly hellish comedy movie *Dr. Strangelove*, when the background music for the nuclear bomb that is about to fall and cause World War III and the end of nearly all human life on earth is the song with the lyrics "We'll meet again, don't know where, don't know when." Not all witches wear pointed hats; some wear Texan cowboy hats and ride nuclear bombs like horses.

To take *Macbeth* seriously, one does not have to believe in witches, in either the popular sense, as Shakespeare depicts them, or in the most sophisticated theological sense, as humans who have sold their souls to the devil in exchange for some supernatural spiritual powers. But one does have to believe in real human evil, in real free will and thus responsibility, and in cosmic justice and therefore the possibility of damnation. As Macbeth says, "Blood will have blood." God himself says, "Listen; your brother's blood is crying out to me from the ground!" (Gen. 4:10). God cannot ignore or contradict his own eternal nature, which includes justice as well as mercy.

### (2)

The strategy of hell is always to first dim the lights, to confuse truth with lies, light with darkness, good with evil, fair with foul. That is why St. Paul tells us to "take every *thought* captive to obey Christ" (2 Cor. 10:5). Buddha understood this well. The beginning of the most popular Buddhist text, the *Dhammapada*, tells

us that "all that we are depends on our thoughts. It begins where our thoughts begin, it moves where our thoughts move, it ends where our thoughts end." Therefore, the first step in damnation is to suppress the truth, or even to reverse it.

Thus, Macbeth's first words and thoughts ("So foul and fair a day I have not seen") echo the witches' last ones: "Fair is foul, and foul is fair." In Milton's *Paradise Lost*, Satan's choice, like Macbeth's, is the choice of might over right, power over justice: "Better to reign in hell than serve in heaven." That also seems to be Macbeth's choice. But to make it, he must first blind himself and reverse good and evil. That is why Satan himself, like Lord and Lady Macbeth, first reverses good and evil, and invokes evil as good, when he says, in his rebellion against God, "Evil, be thou my good" (i.e., my end and goal and purpose, my heart's love, my God). One cannot love or choose evil or death as itself and for itself; one must first see it as somehow involving some kind of goodness or life. The first step is always to turn off the lights, refusing to discriminate, to judge, to listen to reason, truth's prophet.

Macbeth is under the sway of these supernatural spiritual powers, disguised or incarnated as visible witches, which confuse his mind as well as corrupting his will. (Those two things always go together, so much so that a true case can be made for each of them as the root cause of the other.)

The witches speak in two kinds of contradictions. Some are outright lies, like "Fair is foul, and foul is fair." Others are riddling paradoxes, which are *apparent* contradictions, like "Lesser than Macbeth, and greater," which elicits Macbeth's response: "Stay, you imperfect speakers, tell me more." Both kinds "hover through the fog and filthy air" of the soul.

When Macduff, who is not under this spell, encounters Macbeth, it is Macduff who plays the part of the prophet to bring the light of truth into Macbeth's fog. Since Macbeth's own

conscience has been conquered, the voice of God speaks to him now only from Macduff, who is Macbeth's external conscience, so to speak, when Macduff says: "Turn, hell-hound, turn!" It is God's prophetic warning, a final chance for "turning" or repentance, like Jesus' to Judas (Matt. 26:45–50).

But it is far too late. Macduff reveals the treachery of the witches' tricky assurance to Macbeth that "none of woman born / Shall harm Macbeth" when he tells Macbeth that he was not born of woman naturally but "from his mother's womb / Untimely ripped" by the artifice of what we now call caesarian section. The other riddling "impossibility," that Macbeth could not be defeated until Birnam Wood should come to Dunsinane, was also made possible and actual when Macbeth's enemies disguised themselves behind trees cut down from Birnam Wood and came up to Dunsinane to conquer his castle.

### (3)

Shakespeare gives us a searingly bright insight into Macbeth's hell-bound soul. Its darkness is double: mental and moral, darkened reason and bent will. He also shows us how these two are related. Plato taught that evil was caused by ignorance, and he was half right but incomplete because he forgot that ignorance is also caused by evil, the moral evil of choosing to ignore, to suppress the truth known by the mind. The will is the captain of the ship of the soul, and it has the power to tell the reason, which is the soul's navigator, to simply shut up.

And when this is done, all the sailors who are supposed to be under the authority of the captain and his navigator, the will and the reason, mutiny. The passions within and former friends and helpers without turn on us and become our enemies, including even the forces of nature, as Macbeth confesses: "How is 't with me, when every noise appals me?" These fears in the passions are

the revenge of conscience. Conscience can be suppressed, but it can never be killed, as bodies can.

When conscience is suppressed, so is peace, and even sleep. Thus, Macbeth says:

> Methought I heard a voice cry, *Sleep no more!*
> *Macbeth does murder sleep!*—the innocent sleep;
> Sleep, that knits up the ravell'd sleave of care.

This is indeed the psychology of damnation. When we are not at peace with God, we cannot be at peace with ourselves.

Nothing can excuse the self-blinding that is the necessary condition for clear and deliberate evils like murder, either for Macbeth ("Will all great Neptune's ocean wash this blood / Clean from my hand? No . . .) or for Lady Macbeth ("Out, damned spot! Out, I say! . . . All the perfumes of Arabia will not sweeten this little hand").

And it all began with the deliberate will to untruth rather than truth. This is seen clearly when Lady Macbeth deliberately asks her supernatural enemies for the gift of the suppression of her receptive conscience that every person has, whether male or female, but which finds its physical symbol in a woman's biological and psychological receptivity. Lady Macbeth is like the Amazons, who cut off their own breasts (and hearts) so that they could swing swords like men, unimpeded by their femininity. (*A-mazon* means literally "without a breast.") She prays:

> Come you spirits
> That tend on mortal thoughts, unsex me here;
> And fill me, from the crown to the toe, top-full
> Of direst cruelty! Make thick my blood,
> Stop up the access and passage to remorse;
> That no compunctious visitings of nature

Shake my fell purpose, nor keep peace between
The effect and it! Come to my woman's breasts
And take my milk for gall, you murdering ministers,
Wherever in your sightless substances
You wait on nature's mischief! Come, thick night,
And pall thee in the dunnest smoke of hell,
That my keen knife see not the wound it makes;
Nor heaven peep through the blanket of the dark,
To cry, *Hold, hold!*

## (4)

The consummation of Shakespeare's psychology of damnation is Macbeth's justly famous "To-morrow, and to-morrow, and to-morrow" speech, the very manifesto of nihilism.

Nihilism means literally nothing-ism, the ideology of nothingness. Obviously, things still exist, but their value and purpose, their meaning and teleology, is gone, and therefore so is our hope. Dante was right to put over hell's door the warning: "Abandon all hope, ye who enter here."

Conscience is at the very heart of man, so that when God and conscience are dead in a man, as they are in Macbeth, when the voice of God dies, man dies as well, since man is God's image—just as your reflection disappears from the mirror when you disappear from the room. We are God's reflection in the mirror of time and matter.

Hope has to do with time, and future. Thus, Macbeth begins with a complaint about time, specifically about the future, about the loss of the crucial virtue of hope, of "final causes" and teleology. Macbeth's utilitarian philosophy, that deeds are to be judged by their practical consequences, prioritizes tomorrow, which is where consequences are placed, not today, where deeds

are actually done, so that a subjectively good (desirable) end justifies an objectively evil means.

Faith, repentance, and charity can happen only in the present. But tomorrow is not present. As a famous, fictional, red-haired, ten-year-old philosopher famously sang, "Tomorrow [is] always a day away." That is a refutation of the chorus in the favorite song of the "progressives": "Don't stop thinkin' about tomorrow." "Don't Stop" was the theme song of the Clinton campaign in 1992. If we obey the words of that song, and never stop thinking about the desired consequences tomorrow, we will make ourselves able not to think about the morally good and evil deeds we are doing today. In other words, if we keep thinking about success, we can stop thinking about morality.

Faulkner understood this undoing of the meaning of time very well when he wrote *The Sound and the Fury*, whose title deliberately invoked Macbeth's "Tomorrow" speech. Faulkner is Shakespeare inside out, in the sense that Faulkner explored Macbeth's world not from without, from the frame of Shakespeare's Christian (and pagan!) worldview, but from within, from the mind of Macbeth himself. Thus, the image of time and timepieces looms large in that novel.

Macbeth is living in an anticipation of his eternity in hell, whose entrance ticket is abandoning all hope and whose philosophy is nihilism: nothingness, purposelessness, meaninglessness. Life is not a story told by a wise and loving God but "a tale / Told by an idiot, full of sound and fury, / Signifying nothing."

"Signifying" means "meaning." A sign is a meaning. At the beginning of *The Sunset Limited*, when Black has rescued White from his suicide attempt, he asks:

Black: So what am I supposed to do with you, Professor?
White: Why are you supposed to do anything?
Black: I done told you. This ain't none of my doin. I left out

of here this morning to go to work you wasn't no part of my
plans at all. But here you is.
White: It doesn't mean anything. Everything that happens
doesn't mean something else.
Black: Mm hm. It don't.
White: No. It doesn't.
Black: What's it mean then?
White: It doesn't mean anything. You run into people and
maybe some of them are in trouble or whatever but it doesn't
mean that you're responsible for them.
Black: Mm hm.

Here is the classic manifesto of nihilism:

> To-morrow, and to-morrow, and to-morrow,
> Creeps in this petty pace from day to day,
> To the last syllable of recorded time;
> And all our yesterdays have lighted fools
> The way to dusty death. Out, out, brief candle!
> Life's but a walking shadow; a poor player,
> That struts and frets his hour upon the stage,
> And then is heard no more: it is a tale
> Told by an idiot, full of sound and fury,
> Signifying nothing.

"All the world's a stage," a shadow, a sign, a story. Is the stage sur-
rounded by nothing or by heavenly spectators? If it is a shadow,
is the shadow simply darkness itself, or is it cast by and therefore
relative to something more real, more substantial, more heavenly,
as in Plato? If it is a sign, is the "sign" the one over the door of hell
or of heaven? A sign of hopelessness or of hope? If it is a story, is
the story told by infinite Wisdom and Love, signifying something
so wonderful that "no eye has seen, nor ear heard, nor the human

heart conceived" (1 Cor. 2:9), or is the story "told by an idiot . . . signifying nothing"?

Sam's question in *The Lord of the Rings*, "I wonder what sort of a tale we've fallen into?" is indeed the overarching question. Is human life a story about something real, about being, or not? "To be or not to be, that is the question."

Deconstructionism is today's "not to be," today's nihilism. For it, things are not signs; events have no sign-ificance. Even signs (words) are not signs but only things ("A poem should not mean / But be"), weapons of warfare and oppression between economic classes, races, or genders. Even the most obvious sign, meaning, icon, or divine message—namely, "male and female," the thing God designed for mutual love, as a physical and psychological sign pointing in very large letters to the image in our very bodies as well as our souls of the self-giving Trinity itself, the life of mutual love and self-giving—is, for deconstructionism, only a thing, not a sign, and a thing to be used and weaponized as we will. Radical "feminists," like the ancient Amazons, speak Lady Macbeth's self-curse and invoke the powers invented not by heaven but by hell when they say, "Unsex me here." They use hell's deceptive language in calling themselves "feminists." (They'd probably call cannibals "chefs.") They refuse to read the sign in their bodies and then say, "Our bodies, ourselves."

From the beginning, in Eden, that was Satan's strategy: to invert language, to call God the oppressor and himself the savior. To fight against this real enemy, we must know its reality and its strategy. We must make light our friend and darkness our enemy instead of vice versa, like Macbeth. *Macbeth*, like Nietzsche, is a prophetic warning that is utterly up to date. For our age has ignored both pagan and Christian wisdom.

# 14

## CHRISTIAN

# *The Great Divorce*

## BY C.S. LEWIS

Why do I include this short novel in a book about plays? Because *The Great Divorce* is a play disguised as a novel. I have seen it performed on stage four times, between 1956 and 2005, by groups of very varied talent, for audiences of very varied beliefs, and with very varied props, either minimal or nonexistent. Every single time, the audience was fascinated and sometimes even stunned to silence—that special silence that comes from not only not moving but not *breathing*. This was because the play was totally faithful to the book, both when it was condensed for the stage production and even when it was not condensed.

I have read two scripts for a movie version of this book, and both were predictably bad for the same reason: the scriptwriters felt that they had to add clever gimmicks, bells, and whistles. They thought their imagination was better than Lewis'. It wasn't. (What a surprise!)

The book is mainly a series of vignettes, mini-acts, each of which is a conversation between a human being who has died, gone to heaven, and come down from "Deep Heaven" into a kind of purgatorial suburb of heaven, where everything is terrifyingly

more heavenly—that is, more real and solid—than it is on earth, to meet someone they had known on earth who has been one of the passengers on a flying bus trip from the dreary gray town of hell (more like Sartre's hell in *No Exit* than a fiery torture pit) to this heavenly suburb. In this place between heaven and hell, they are asked to choose whether they want to go back down to hell or to come up to heaven. All but one choose to return to hell, for reasons that are disturbingly familiar. Those reasons constitute Lewis' psychology of damnation.

The bus, the trip, and the details of the place they are in are not to be taken literally. Lewis writes in his preface, "The transmortal conditions are solely an imaginative supposal: they are not even a guess or a speculation at what may actually await us. The last thing I wish is to arouse factual curiosity about the details of the after-world." But the details, though symbolic, are to be taken seriously. Facts are not the only serious things. The heavenly after-death symbols here are all symbols of earthly experiences and earthly choices that we all make every day *before* death.

Lewis in this book is attempting to answer one of the hardest of all questions for a Christian: Why would anyone freely choose damnation rather than salvation? If they know the difference, only insanity would choose misery over joy, it seems; and if they don't know the difference, they are insane and not responsible for their choice.

Lewis' point is to show us, in many different ways in each of the different mini-acts, how all of us often choose misery over joy when in various ways we choose "My will be done" over "Thy will be done"—that is, when we worship idols of our own invention.

Thus, the story is implicitly about God because it is about that fundamental free choice, which is God's dangerous gift to us. For God is not the Godfather, who makes us an offer we can't refuse, but God the Father, who makes us an offer we *can* refuse. Lewis shows us many different motives for that refusal. His

pictures are disturbing, and they are meant to be, for they are pictures we can often identify with when we look in the mirror.

The plot is similar to Dante's: a trip from hell to heaven through something like purgatory. Lewis' images, like Dante's, are what T.S. Eliot calls "objective correlatives" to inner states of soul.

But to answer the hard question about the psychology of damnation is only Lewis' secondary purpose. Lewis' primary purpose is put clearly in his preface:

> Blake wrote the Marriage of Heaven and Hell. If I have written of their Divorce, this is not because I think myself a fit antagonist for so great a genius, nor even because I feel at all sure that I know what he meant. But in some sense or other the attempt to make that marriage is perennial. The attempt is based on the belief that reality never presents us with an absolutely unavoidable "either-or"; that, granted skill and patience and (above all) time enough, some way of embracing both alternatives can always be found; that mere development or adjustment or refinement will somehow turn evil into good without our being called on for a final and total rejection of anything we should like to retain. This belief I take to be a disastrous error. You cannot take all luggage with you on all journeys; on one journey even your right hand and your right eye may be among the things you have to leave behind. We are not living in a world where all roads are radii of a circle and where all, if followed long enough, will therefore draw gradually nearer and finally meet at the centre: rather in a world where every road, after a few miles, forks into two, and each of those into two again, and at each fork you must make a decision.

God is on stage here because every such choice is a choice for or against God. In Dantean terms, all virtues are roads toward God and all vices are roads away from him. God is onstage here

185

precisely by being offstage, at the end of one of those roads. If he ever came onto our stage without emptying himself of his divine prerogatives as he did two thousand years ago, his beauty would be so compelling that we would lose our freedom to refuse him, and we would lose that freedom involuntarily. Believers have voluntarily chosen, in time, roads that lead to heaven, where we happily lose that freedom-to-choose-evil; thus, for believers, the compulsion of the beatific vision is voluntary, freely chosen. The damned, in contrast, make the opposite choice: to preserve rather than freely give up their own autonomy, their lower freedom. And this makes them not only bereft of the higher heavenly freedom but also unfree addicts to their lower freedom (autonomy). Lewis puts the point simply and memorably in a single line: "There are only two kinds of people in the end: those who say to God: 'Thy will be done' and those to whom God says, in the end, 'Thy will be done.'" Thus, Dante's great line "His will, our peace." It is an equation.

Lewis is a master of both reason and imagination. The "hell" chapter of his *The Problem of Pain* is the clearest and most persuasive rational apologetic argument I have ever read for the most difficult dogma in Christianity to believe. But *The Great Divorce* is even more persuasive because it is imaginable and concrete. It makes the invisible visible.

The power of *The Great Divorce* is that this terrible truth (damnation) is not merely preached but practiced, and seen. Time and life are the prism by which both the white light of heaven and the black light of hell break up into many different colors. These colors are choices and motives. Heaven's roads and choices are unified by the one and only God; hell's are divided by the multitude of idols. As Chesterton says, there are many angles at which we can fall, but only one at which we can stand up.

But that statement seems pale and abstract compared to seeing Lewis' concrete versions of it. So rather than summarize

each act of this play in my own dull words, I will try to "sell" it by quoting appetizing excerpts from a few of the acts in Lewis' sharper words. The passages are chosen not just because they are clever, even brilliant, theology, but because I think they can make a radical "existential" or personal difference to your life, both in this world and in the next, especially if you did not fully realize these truths before.

The first conversation is between a man who had committed a murder but repented and converted, who comes from heaven (and thus is a "Bright Spirit"), and his apparently respectable and moral fellow worker, who comes from hell (and thus is a "Ghost") because he has not. (Remember, this is a fantasy. Lewis is not teaching that we literally have a second chance to repent and convert after death.)

"What I'd like to understand," said the Ghost, "is what you're here for, as pleased as Punch, you, a bloody murderer, while I've been walking the streets down there and living in a place like a pigsty all these years."

"That is a little hard to understand at first. But it is all over now. You will be pleased about it presently. Till then there is no need to bother about it."

"No need to bother about it? Aren't you ashamed of yourself?"

"No. Not as you mean. I do not look at myself. I have given up myself. I had to, you know, after the murder. That was what it did for me. And that was how everything began."

"Personally," said the Big Ghost with an emphasis which contradicted the ordinary meaning of the word, "Personally, I'd have thought you and I ought to be the other way round. That's my personal opinion."

"Very likely we soon shall be," said the other. "If you'll stop thinking about it."

"Look at me, now," said the Ghost, slapping its chest (but the slap made no noise). "I gone straight all my life. I don't say I was a religious man and I don't say I had no faults, far from it. But I done my best all my life, see? I done my best by everyone, that's the sort of chap I was. I never asked for anything that wasn't mine by rights. If I wanted a drink I paid for it and if I took my wages I done my job, see? That's the sort I was and I don't care who knows it."

"It would be much better not to go on about that now."

"Who's going on? I'm not arguing. I'm just telling you the sort of chap I was, see? I'm asking for nothing but my rights. You may think you can put me down because you're dressed up like that (which you weren't when you worked under me) and I'm only a poor man. But I got to have my rights same as you, see?"

"Oh no. It's not so bad as that. I haven't got my rights, or I should not be here. You will not get yours either. You'll get something far better. Never fear."

"That's just what I say. I haven't got my rights. I always done my best and I never done nothing wrong. And what I don't see is why I should be put below a bloody murderer like you."

"Who knows whether you will be? Only be happy and come with me."

"What do you keep on arguing for? I'm only telling you the sort of chap I am. I only want my rights. I'm not asking for anybody's bleeding charity."

"Then do. At once. Ask for the Bleeding Charity. Everything is here for the asking and nothing can be bought."

The very stupidest thing we can ever do at the Last Judgment is ask for justice!

A second dialogue is not only tragic but also hilarious. It is an exposé of "modernist" theology. An apostate bishop from hell confronts his orthodox friend Dick, from heaven:

"Ah, Dick, I shall never forget some of our talks. I expect you've changed your views a bit since then. You became rather narrow-minded towards the end of your life: but no doubt you've broadened out again."

"How do you mean?"

"Well, it's obvious by now, isn't it, that you weren't quite right. Why, my dear boy, you were coming to believe in a literal Heaven and Hell!"

"But wasn't I right?"

"Oh, in a spiritual sense, to be sure. I still believe in them in that way. I am still, my dear boy, looking for the Kingdom. But nothing superstitious or mythological . . ."

"Excuse me. Where do you imagine you've been?"

"Ah, I see. You mean that the grey town with its continual hope of morning (we must all live by hope, must we not?), with its field for indefinite progress, is, in a sense, Heaven, if only we have eyes to see it? That is a beautiful idea."

"I didn't mean that at all. Is it possible you don't know where you've been?"

"Now that you mention it, I don't think we ever do give it a name. What do you call it?"

"We call it Hell."

"There is no need to be profane, my dear boy. I may not be very orthodox, in your sense of that word, but I do feel that these matters ought to be discussed simply, and seriously, and reverently."

"Discuss Hell reverently? I meant what I said. You have been in Hell: though if you don't go back you may call it Purgatory."

"Go on, my dear boy, go on. That is so like you. No doubt you'll tell me why, on your view, I was sent there. I'm not angry."

"But don't you know? You went there because you are an apostate."

"Are you serious, Dick?"

"Perfectly."

"This is worse than I expected. Do you really think people are penalised for their honest opinions? Even assuming, for the sake of argument, that those opinions were mistaken."

"Do you really think there are no sins of intellect?"

"There are indeed, Dick. There is hide-bound prejudice, and intellectual dishonesty, and timidity, and stagnation. But honest opinions fearlessly followed—they are not sins."

"I know we used to talk that way. I did it too until the end of my life when I became what you call narrow. It all turns on what are honest opinions."

"Mine certainly were. They were not only honest but heroic. I asserted them fearlessly. When the doctrine of the Resurrection ceased to commend itself to the critical faculties which God had given me, I openly rejected it. I preached my famous sermon. I defied the whole chapter. I took every risk."

"What risk? What was at all likely to come of it except what actually came—popularity, sales for your books, invitations, and finally a bishopric?"

"Dick, this is unworthy of you. What are you suggesting?"

"Friend, I am not suggesting at all. You see, I know now. Let us be frank. Our opinions were not honestly come by. We simply found ourselves in contact with a certain current of ideas and plunged into it because it seemed modern and

successful. At College, you know, we just started automatically writing the kind of essays that got good marks and saying the kind of things that won applause. When, in our whole lives, did we honestly face, in solitude, the one question on which all turned: whether after all the Supernatural might not in fact occur? When did we put up one moment's real resistance to the loss of our faith?"

The dialogue continues:

"And—I have come a long journey to meet you. You have seen Hell: you are in sight of Heaven. Will you, even now, repent and believe?"

"I'm not sure that I've got the exact point you are trying to make," said the Ghost.

"I am not trying to make any point," said the Spirit. "I am telling you to repent and believe."

"But my dear boy, I believe already. We may not be perfectly agreed, but you have completely misjudged me if you do not realise that my religion is a very real and a very precious thing to me."

"Very well," said the other, as if changing his plan. "Will you believe in me?"

"In what sense?"

"Will you come with me to the mountains? It will hurt at first, until your feet are hardened. Reality is harsh to the feet of shadows. But will you come?"

"Well, that is a plan. I am perfectly ready to consider it. Of course I should require some assurances . . . I should want a guarantee that you are taking me to a place where I shall find a wider sphere of usefulness—and scope for the talents that God has given me—and an atmosphere of free inquiry—in short, all that one means by civilisation and—er—the spiritual life."

"No," said the other. "I can promise you none of these things. No sphere of usefulness: you are not needed there at all. No scope for your talents: only forgiveness for having perverted them. No atmosphere of inquiry, for I will bring you to the land not of questions but of answers, and you shall see the face of God."

"Ah, but we must all interpret those beautiful words in our own way! For me there is no such thing as a final answer. The free wind of inquiry must *always* continue to blow through the mind, must it not? 'Prove all things' . . . to travel hopefully is better than to arrive."

"If that were true, and known to be true, how could anyone travel hopefully? There would be nothing to hope for."

"But you must feel yourself that there is something stifling about the idea of finality? Stagnation, my dear boy, what is more soul-destroying than stagnation?"

"You think that, because hitherto you have experienced truth only with the abstract intellect. I will bring you where you can taste it like honey and be embraced by it as by a bridegroom. Your thirst shall be quenched."

"Well, really, you know, I am not aware of a thirst for some ready-made truth which puts an end to intellectual activity in the way you seem to be describing. Will it leave me the free play of Mind, Dick? I must insist on that, you know."

"Free, as a man is free to drink while he is drinking. He is not free still to be dry." The Ghost seemed to think for a moment. "I can make nothing of that idea," it said.

"Listen!" said the White Spirit. "Once you were a child. Once you knew what inquiry was for. There was a time when you asked questions because you wanted answers, and were glad when you had found them. Become that child again: even now."

"Ah, but when I became a man I put away childish things."

"You have gone far wrong. Thirst was made for water; inquiry for truth. What you now call the free play of inquiry has neither more nor less to do with the ends for which intelligence was given you than masturbation has to do with marriage."

"If we cannot be reverent, there is at least no need to be obscene. The suggestion that I should return at my age to the mere factual inquisitiveness of boyhood strikes me as preposterous. In any case, that question-and-answer conception of thought only applies to matters of fact. Religious and speculative questions are surely on a different level."

"We know nothing of religion here: we think only of Christ. We know nothing of speculation. Come and see. I will bring you to Eternal Fact, the Father of all other fact-hood."

"I should object very strongly to describing God as a 'fact.' The Supreme Value would surely be a less inadequate description. It is hardly . . ."

"Do you not even believe that He exists?"

"Exists? What does Existence mean? You *will* keep on implying some sort of static, ready-made reality which is, so to speak, 'there,' and to which our minds have simply to conform. These great mysteries cannot be approached in that way. If there were such a thing (there is no need to interrupt, my dear boy) quite frankly, I should not be interested in it. It would be of no *religious* significance. God, for me, is something purely spiritual. The spirit of sweetness and light and tolerance—and, er, service, Dick, service. We mustn't forget that, you know."

"If the thirst of the Reason is really dead . . . ," said the Spirit, and then stopped as though pondering. Then suddenly he said, "Can you, at least, still desire happiness?"

"Happiness, my dear Dick," said the Ghost placidly, "happiness, as you will come to see when you are older, lies in the path of duty."

After explaining his new paper on Jesus for the Theological Society in hell ("He would have outgrown some of his earlier views, you know, if he'd lived"), the apostate departs:

> The Ghost nodded its head and beamed on the Spirit with a bright clerical smile—or with the best approach to it which such unsubstantial lips could manage—and then turned away humming softly to itself "City of God, how broad and far."

A third vignette is an old lady from hell who appears to be simply a grumbler but has become only a grumble. Lewis, the Dante-like tourist and observer, asks George MacDonald, the Virgil-like guide, "How can there be a grumble without a grumbler?" and MacDonald explains to him: "The whole difficulty of understanding Hell is that the thing to be understood is so nearly Nothing. But ye'll have had experiences. . . . It begins with a grumbling mood, and yourself still distinct from it: perhaps criticizing it. . . . Ye can repent and come out of it again. But there may come a day when you can do that no longer. Then there will be no you left to criticize the mood, nor even to enjoy it, but just the grumble itself going on forever like a machine."

A fourth vignette presents Pam, a "smother mother" from hell who wants her son Michael to leave heaven and come to live with her in hell. The Bright Spirit says to her:

> "You're treating God only as a means to Michael. But the whole thickening treatment consists in learning to want God for His own sake."
>
> "You wouldn't talk like that if you were a mother."
>
> "You mean, if I were *only* a mother. But there is no such thing as being only a mother. You exist as Michael's mother only because you first exist as God's creature. That relation is

older and closer. No, listen, Pam! He also loves. He also has suffered. He also has waited a long time."

"If He loved me He'd let me see my boy. If He loved me why did He take Michael away from me? I wasn't going to say anything about that. But it's pretty hard to forgive, you know."

"But He had to take Michael away. Partly for Michael's sake . . ."

"I'm sure I did my best to make Michael happy. I gave up my whole life . . ."

"Human beings can't make one another really happy for long. And secondly, for your sake. He wanted your merely in- stinctive love for your child (tigresses share *that*, you know!) to turn into something better. He wanted you to love Michael as He understands love. You cannot love a fellow-creature fully till you love God. Sometimes this conversion can be done while the instinctive love is still gratified. But there was, it seems, no chance of that in your case. The instinct was uncontrolled and fierce and monomaniac. (Ask your daughter, or your husband. Ask our own mother. You haven't once thought of *her*.) The only remedy was to take away its object. It was a case for sur- gery. When that first kind of love was thwarted, then there was just a chance that in the loneliness, in the silence, something else might begin to grow."

"This is all nonsense—cruel and wicked nonsense. What *right* have you to say things like that about Mother-love? It is the highest and holiest feeling in human nature."

"Pam, Pam—no natural feelings are high or low, holy or unholy, in themselves. They are all holy when God's hand is on the rein. They all go bad when they set up on their own and make themselves into false gods."

"My love for Michael would never have gone bad. Not if we'd lived together for millions of years."

"You are mistaken. . . ."

They continue:

> "Oh, of course. I'm wrong. Everything I say or do is wrong, according to you."
>
> "But of course!" said the Spirit, shining with love and mirth so that my eyes were dazzled. "That's what we all find when we reach this country. We've all been wrong! That's the great joke. There's no need to go on pretending one was right! After that we begin living."

George MacDonald explains to Lewis that

> "someone must say in general what's been unsaid among you this many a year: that love, as mortals understand the word, isn't enough. Every natural love will rise again and live forever in this country: but none will rise again until it has been buried."
>
> "The saying is almost too hard for us."
>
> "Ah, but it's cruel not to say it. They that know have grown afraid to speak. That is why sorrows that used to purify now only fester."

MacDonald explains also a remarkable truth:

> "Both good and evil, when they are full grown, become retrospective. Not only this valley but all their earthly past will have been Heaven to those who are saved. Not only the twilight in that town, but all their life on earth too, will then be seen by the damned to have been Hell. That is what mortals misunderstand. They say of some temporal suffering, 'No future bliss can make up for it,' not knowing that Heaven, once attained, will work backwards and turn even that agony into a glory."

Lewis discovers that, from the heavenly perspective, hell is so tiny that the whole of it fits down a little crack in the ground of heaven (which, by the way, is also so real that the Ghosts from hell cannot walk on the sword-like grass or endure the weight of its fruit). For "a damned soul is nearly nothing: it is shrunk, shut up in itself. Good beats upon the damned incessantly as sound waves beat on the ears of the deaf, but they cannot receive it. Their fists are clenched, their teeth are clenched, their eyes fast shut. First they will not, in the end they cannot, open their hands for gifts, or their mouths for food, or their eyes to see."

We need to end by repeating our beginning: that the point of Lewis' drama is not what will happen in the next life but what begins to happen in this one.

# 15

POST-CHRISTIAN

## *No Exit*

### BY JEAN-PAUL SARTRE

Sartre's philosophy of life is similar to that of White in *The Sunset Limited*. It is nihilism.

God's absence is more massive in this play than his presence is in most religious plays. Since there is no God, there is no purpose, reason, value, or design for human life, except the ones we invent ourselves.

The reason Sartre does not seek suicide, as White did, comes clear in his novel *Nausea*, where the protagonist, Roquentin, who is Sartre's mouthpiece, muses: "Superfluity was the only relationship I could establish [with others]. . . . I thought vaguely of doing away with myself, to do away with at least one of these superfluous existences. But my death—my corpse, my blood poured out on this gravel, among these plants, in this smiling garden [for absent God and immortality, death is nothing more than that]—would have been superfluous as well. I was superfluous to all eternity." If everything is meaningless, so is suicide. Suicide is not an escape from nihilism. There is no escape. There is "no exit." The ultimate message of Sartre, who puts himself forward as

the apostle of total human freedom (which is the primary reason for his atheism), is that we do not have the freedom to choose anything meaningful.

Sartre takes only one dogma from Christianity in this play—the dogma of hell, the dogma Christians cherish the least—and he rejects the ones they cherish the most, especially heaven and God's forgiving love. Of course, Sartre does not believe in a supernatural hell, only a natural one. The after-death place in this play is symbolic of life before death, like Lewis' dream in *The Great Divorce* and unlike *The Dream of Gerontius*.

The three protagonists—Garcin, Inez, and Estelle—are all flawed sinners, who are in fact responsible for others' deaths in different ways. What unites them all is the surprise that hell is different than they thought it would be. Garcin is the first to arrive, and the Valet issues him into his ordinary room full of ugly furniture.

> Garcin: I certainly didn't expect—this! You know what they tell us down there?
> Valet: What about?
> Garcin: About *(makes a sweeping gesture)* this—er—residence.
> Valet: Really, sir, how could you believe such cock-and-bull stories? Told by people who'd never set foot here. For, of course, if they had—
> Garcin: Quite so. *(Both laugh. Abruptly the laugh dies from Garcin's face.)* But, I say, where are the instruments of torture?

The answer to Garcin's question is the very person who asks it. The instruments of torture, for all of hell's inhabitants, exemplified by the three who will occupy this room, turn out to be—themselves. Thus, the point of the play is its famous line, at the end: "Hell is—other people."

This is one of the most profound lines in literature, for it is *profoundly* false. Sartre's concept of hell and heaven is almost

exactly the reverse of what they really are. Heaven is really relationship, love, friendship, "withness"—images of the Trinity. Hell is the lack of God and therefore of that which God is. It is precisely the lack of otherness; it is aloneness, emptiness, hopeless loneliness.

There are three reasons for this nihilism in Sartre's philosophy, one for each of the first three numbers.

The first reason is in the number three, which for Sartre is the number of hell, and for Christianity is the number of God and heaven. Threeness makes for hell because if there were only two persons, they could perhaps love each other, if only in a false and fantasizing way (as explained in the second reason, below); but if there are three, there is always a third who knows the other two and reduces them to objects, to what Sartre calls "being-in-itself." Only a subject (a "being-for-itself") is free. I am free to think or not to think, to think of A or of B, to think well of A or ill of A. But the object I think of is not free to escape the searchlight of my thought. That is one reason why Garcin and Estelle cannot have even a fleeting physical love: because Inez is watching.

A second reason applies even to two persons: that according to Sartre, loving and knowing, the two most essential and "spiritual" powers we have, exclude each other. We can only love what is lovable; and when we know others, we know they are not lovable. Each of the three in hell have been responsible for the death of the others (the details do not matter; they come out in the gradually revealing plot), and we are all flawed failures and nothing more, since for Sartre you are nothing more than what you have done, since there is no ontologically valuable personal substance behind our choices and acts, no being behind our doing, because "you are—your life, and nothing else." Therefore, to know you as a whole, as you really are, is to not love you; and to love you (insofar as it is possible at all) is to not know you, the real you.

In other words, two of our deepest desires contradict each other: love and truth, joy and truth, freedom and truth. We are tortured, not freed or blessed, by truth. The truth does not make us free; it makes us unfree. There is no true love of a truly real other self, only of fantasies and illusions.

Estelle cannot love Garcin because she knows him as the coward he is; Garcin cannot love Inez because he knows her as cruel, hard, and selfish; Inez cannot love Estelle because she knows her as false and hypocritical. The impossibility of both knowing and loving, together, cuts across sexual differences and also across homosexual (Inez) and heterosexual differences.

Garcin naïvely and idealistically tries to escape this when he says to Estelle: "I dare say we can really love each other. Look at it this way. A thousand of them are proclaiming I'm a coward; but what do numbers matter? If there's someone, just one person, to say quite positively I did not run away, that I'm not the sort who runs away, that I'm brave and decent and the rest of it—well, that one person's faith would save me. Will you have that faith in me? Then I shall love you and cherish you for ever, Estelle—will you?" And she replies, laughing, "Oh, you dear silly man, do you think I could love a coward?"

And here is a third reason for the inescapability of hell in Sartre's philosophy: Even if we could forgive others (which we can't), we cannot forgive ourselves because we know ourselves. Garcin knows he is a coward and a liar, and he needs Estelle to love him as what he is. But she cannot love a coward; she can only pretend that Garcin is not a coward. Estelle knows that she killed her own child, and she needs Garcin to love her as what she is, but Garcin cannot do that; he can only love her pretty, pornographic image in his senses.

So even if we could endure another, we cannot endure ourselves.

And this seeing, which freezes us to the wall of truth as a dead butterfly is pinned to a page of a book, cannot be relieved by

sleep. There are "no eyelids, no sleep. . . . I shall never sleep again. But then—how shall I endure my own company?"

When Garcin realizes this, he says, "So one has to live with one's eyes open all the time?" and the Valet answers, ironically, "To *live*, did you say?" Hell is for the dead, not the living. But the point of the play is not that hell is after death but that it is before death.

C.S. Lewis suggests that those in heaven see their past life on earth as the first part of their heaven (as a person who is born sees their life in the womb as part of their life in the world, though that part of life was unseen when it was lived) and that those in hell see their past life on earth as the first part of their hell. This "retrospection" is what Sartre does in *No Exit*, minus the possibility of heaven and minus the possibility of any real after-death existence.

For Sartre, the word "we," the word that lovers discover is magically wonderful, is really meaningless and impossible. There cannot be a collective subject. Each individual person plays God to all others. There can only be one sun in the solar system. There can be no human trinity, and no divine Trinity. Sartre unwittingly shows how these two things go together.

Perhaps the simplest way to see Sartre's hellish vision of life, without his abstract metaphysical categories of subject and object, "being-for-itself" and "being-in-itself," is to "deconstruct" each person, to observe the gap between what we are and what we know we ought to be:

> Inez: What's the point of play-acting, trying to throw dust in each other's eyes? We're all tarred with the same brush.
> Estelle *(Indignantly)*: How dare you!
> Inez: Yes, we are criminals—murderers—all three of us. We're in hell, my pets; they never make mistakes, and people aren't damned for nothing.
> Estelle: Stop! For heaven's sake—
> Inez: In hell! Damned souls—that's us, all three!

> Estelle: Keep quiet! I forbid you to use such disgusting words.
> Inez: A damned soul—that's you, my little plaster saint. And
> ditto our friend there, the noble pacifist.

Although Sartre poses as the champion of total human freedom, we are not free, in his philosophy, to escape this hell. There is no alternative, "no exit" from hell either after entering it or before. When Inez announces the truth that "each of us will act as torturer of the two others," Garcin replies, "No, I shall never be your torturer. I wish neither of you any harm, and I've no concern with you. None at all." But Garcin is wrong. Hell is not chosen; it is inevitable. It is a metaphysical necessity.

One way of seeing this is to reflect on the significance that there are no mirrors in the room, so that each person must be the mirror to the others, subjecting them to objectification:

> Estelle: I've six big mirrors in my bedroom. There they are.
> I can see them. But they don't see me. They're reflecting the
> carpet, the settee, the window—but how empty it is, a glass in
> which I'm absent! When I talked to people I always made sure
> there was one near by in which I could see myself. I watched
> myself talking. . . . No, I can't do without a looking-glass for
> ever and ever. I simply can't.
> Inez: Suppose I try to be your glass? . . . You're lovely, Estelle.
> Estelle: But how can I rely upon your taste? Is it the same as
> *my* taste? . . . You scare me rather. My reflection in the glass
> never did that.

Later, Inez complains to Garcin, who knows her and therefore cannot love her: "You can't prevent your *being there.* Can you stop your thoughts? . . . Why, you've even stolen my face; you know it and I don't!"

What's impossible is not just giving genuine love but also receiving it. Inez says: "It's no use. I'm all dried up. I can't give and

I can't receive." In other words, there is no hope because there is no faith (which is the trustful receiving of love) and no charity (which is the self-forgetful giving of love).

The point of the play's title emerges at the end, when the exit door opens and the three damned souls realize that they cannot leave. Inez, the smartest of the three, realizes the situation: they cannot leave because "We're—inseparables!"

> Garcin: Will night never come?
> Inez: Never.
> Garcin: You will always see me?
> Inez: Always.

Ironically, they are "inseparable" because they are so separate that they cannot form a "we."

Sartre's primary argument for atheism is that if God existed, we could not be free; we would be objects to him—in fact, artifacts. Yet in the end, he denies the most fundamental freedom of all: the freedom to choose to love, the freedom to choose heaven over hell.

Understanding a great atheist like Sartre or Nietzsche can be a powerful impetus to faith, hope, and charity. That's why clever atheists don't like Sartre: he sends us screaming into the arms of priests.

# Appendix

## THE THREE GREATEST DRAMAS OF ALL TIME

My candidates for the three greatest real historical dramas of all time, and thus the three potentially greatest plays of all time, are the trial and death of Socrates, the trial and death of Jesus, and the Holocaust.

They are also, incidentally, central to the pre-Christian, Christian, and post-Christian eras. But that is not why I chose them. The main point of this book is not the difference between these three eras, but God on stage: how great playwrights have portrayed his presence or his absence. My choices for fifteen great plays came first; they happened to fit into this threefold historical pattern only secondly.

No one has ever, to my knowledge, made a great stage play about any one of these historical dramas. The first, it seems to me, obviously could and should be done. The other two may or may not be possible. All three have been put onscreen in movie form, with very varying degrees of success. Peter Ustinov portrayed a memorable Socrates in a less-than-memorable film half a century ago. Jim Caviezel portrayed Jesus in what was to my mind the only truly successful Jesus movie, Mel Gibson's *The Passion of the Christ*. And there have been scads of movies about the Holocaust, some very good, though none is as powerful as Elie

Wiesel's autobiographical book *Night*, which begs to be faithfully transformed from page to screen.

But no truly great stage plays, as far as I know, exist about any of the three. At least none that will go down as classics for all future ages. Perhaps the challenge is just too great to meet.

Socrates, Jesus, and the Nazis were all put on trial and found guilty—the first two unjustly, the third justly—so these three dramas have in common the theme of telling the truth about justice and injustice. *Judgment at Nuremberg* was a truly great film about German guilt, though only incidentally about the Holocaust itself. *Schindler's List* was a great movie, but, like *The Passion of the Christ*, it could not, I think, possibly be a great play. I hope someone proves me wrong about this someday.

Plays are like sonnets, and movies are like free verse. Plays are more unified and constrained by time and place as well as characters. Aristotle's rules for dramatic "unities" may apply somewhat to plays but not to movies, which can do almost anything they want with the imagination, and which depend much more on mood, images, and music and less on dialogue.

I will not be so foolish as to attempt to instruct potential playwrights how to do any one of the three plays I have called for. But I want to throw out some scattered reflections and suggestions that should interest anyone who loves drama, whether in the form of novel, play, or film, and who feels the deep significance of all three of these real-life dramas.

### Socrates

A drama about the life, trial, and death of Socrates has plenty of historical data for its foundation. No one knows how accurate Plato's portrait of the historical Socrates is, but if it had been radically idealized, radically different than the historical Socrates, Plato would have been laughed at and not admired and imitated,

because his Socratic dialogues were well known by the generation that had known Socrates.

A four-act play could begin with the *Euthyphro*, where Euthyphro and Socrates meet on their way to court and ironically talk about piety, the virtue Socrates is about to be condemned for lacking, though he knows and lives it more deeply than Euthyphro and the rest of Athens, who claim to know it. It would then proceed to the *Apology* as its central act, showing Socrates not merely as a personal martyr but as a martyr for philosophy itself, which is what is really on trial here. It would move through the scene in prison in the *Crito*, where Socrates refuses the utilitarian ethos of his friends, who have bribed the guards for his escape. Finally, it would conclude with the *Phaedo*, omitting the abstract arguments about the immortality of the soul and finishing with the death scene, one of the very greatest and most unforgettable scenes in all of world literature.

This play would almost write itself, since Plato has given us so much information and detail, and he is a great psychologist and dramatist as well as a great philosopher. The playwright's most difficult job would be to resist the temptation to be unfaithful to the text and to add anything to Plato's already full and adequate treatment. I am amazed that it has not been done.

## Jesus

A play about Jesus would be "God on Stage" literally. Silly and/or sentimental attempts to do this have been made, most famously the sixties hippie musical, but never anything approaching a classic. The constraints of the stage would necessitate concentration, probably on his trial. This would be broad and universal in meaning, for every single person who has ever lived is a courtroom in which Jesus is on trial, and every person is, in the end, either a Caiaphas, whose goal is death; or a Judas, whose goal is use; or a Pilate, whose

goal is peace at any price; or the disciples, whether they are as weak as Peter or as loyal as John.

I was about to say that there is another option: looking away, a comfortable agnosticism, shutting one's eyes; but this is not an option according to Jesus himself, because he said that whatever you do to one of these his brethren, you do to him. Jesus appears and appeals to every person on earth—usually in disguise.

The irony of Jesus' trial could be the unifying point of the play, as it was for Plato regarding Socrates in the *Apology*. The one on trial here is really the judge, and the judge is really on trial (Pilate, the name Christians repeat every Sunday in their Creed). Creatures are judging, condemning, and crucifying their Creator. The characters are condemning their Author; the players condemning their Playwright. The guilty are finding the only innocent man who ever lived guilty of the greatest crimes. Sin is judging sanctity. Hypocrisy is judging honesty. Darkness is judging light. Ignorance is judging truth ("What is truth" anyway?). Folly is judging Wisdom. Pride is judging humility. Selfishness is judging selflessness. Hate is judging love. The saved are crucifying their Savior. The guests are devouring their Host. A false man is condemning the true Man so that a false god can crucify the true God.

This irony, this upside-down-izing, is itself ironic because it is the only real, perfect, complete, and total example of what Nietzsche called for, a "transvaluation of all values." And, of course, it is also the only real example of the thing he exulted in, the death of God, which was the cause of this "transvaluation of all values."

Dostoevsky saw this connection too, from the opposite point of view: "If God does not exist, everything is permissible." Nietzsche would have been astonished at how his two prophecies were in fact fulfilled—and in the actual past, not the called-for future. And at how what happened in the Holocaust

was what happened on Calvary. It was the same event because he is "the same yesterday and today and forever" (Heb. 13:8).

Elie Wiesel wrote, in *Night*, of this most terrible upside-down-izing in his soul: "I felt very strong. I was the accuser, God the accused. My eyes had opened and I was alone—terribly alone in a world without God, without man. Without love or mercy. I was nothing but ashes now, but I felt myself to be stronger than this Almighty."

How to dramatize this irony on stage, concretely, is the great challenge: how to make the invisible visible. It is the challenge God accepted when he created the world.

Perhaps one possible way to dramatize the trial and death of Jesus would be the device MacLeish used in *J.B.*—namely, to juxtapose two dramas, the heavenly drama and also the earthly drama, which "played out" the heavenly one, but from the theist's point of view instead of the atheist's, as MacLeish did. Perhaps even from God's point of view, with the Father interpreting the earthly events from heaven as stage directions to the Holy Spirit, who carries them out, while simultaneously the disciples (probably only one of them, Peter or John) see and feel them from the human point of view.

Even more ambitiously, the play could begin (how?) with the Logos, the Mind of God, and end with the Logos breaking through, first when the temple veil that hid the Holy of Holies was torn asunder at Christ's death, then again at the Resurrection, and perhaps even including Matthew 27:52–53.

The play, in any case, has already been performed on the stage of Planet Earth. It's not fiction; it's what C.S. Lewis called "myth become fact." The creative problem is how to stage it.

## The Holocaust

Thinking about how to make the Holocaust present on stage must begin with thinking about the Holocaust itself. And the best such thinking stays the closest to the events themselves, and their immediate effects on its victims, yet also thinks about them philosophically and theologically. The best example of the events themselves that I know of is Elie Wiesel's *Night*, and the three best examples of such thinking about them are Viktor Frankl's rightly famous *Man's Search for Meaning*—which combines a narration of the events he experienced in Auschwitz with the psychological and philosophical principles that he learned from these events— and the two best short pieces, I think, written on the Holocaust: the preface and foreword to *Night* (1986), the first by Robert McAfee Brown and the second by François Mauriac. In both cases, reflection is directed not merely to the events themselves but to their relationship to us and our relationship to them.

First, from the theologian Brown:

> When Elie Wiesel was liberated from Buchenwald in 1945, having also been in Birkenau, Auschwitz, and Buna, he imposed a ten-year vow of silence upon himself before trying to describe what had happened to him and over six million other Jews. When he finally broke that silence, he had trouble finding a publisher. Such depressing subject matter.
>
> When *Night* was finally published . . . few people wanted to read about the Holocaust. Such depressing subject matter.
>
> But we cannot indefinitely avoid depressing subject matter, particularly if it is true, and . . . the world has had to hear a story it would have preferred not to hear—the story of how a cultured people turned to genocide, and how the rest of the world, also composed of cultured people, remained silent in the face of genocide. . . .

He tells the story, out of infinite pain, partly to honor the dead, but also to warn the living—to warn the living that it could happen again. . . .

The descriptive term imaging the author at the book's end is that of a corpse.

Here is that passage: "I had not seen myself since the ghetto. From the depths of the mirror, a corpse gazed back at me. The look in his eyes, as they stared into mine, has never left me."

Who is that corpse? It is not merely Wiesel. It is man, and it is *zoe*, God's life in man's soul. It is the triumph of Hitler and of the devil, who inhabited him.

Mauriac, the philosophical novelist, adds,

Nazi methods of extermination . . . who could have imagined them! . . . [They] exceeded anything we had so far thought possible. . . .

The dream which Western man conceived in the eighteenth century, whose dawn he thought he saw in 1789, and which, until August 2, 1914, had grown stronger with the progress of enlightenment and the discoveries of science—this dream vanished finally for me before those trainloads of little children. . . .

Have we ever thought about the consequence of a horror that, though less apparent, less striking than the other outrages, is yet the worst of all to those of us who have faith: the death of God in the soul of a child who suddenly discovers absolute evil?

That child is Wiesel, who writes: "Never shall I forget those flames which consumed my Faith forever. Never shall I forget that nocturnal silence which deprived me, for all eternity, of the desire to

live. Never shall I forget those moments which murdered my God and my soul and turned my dreams to dust."

Mauriac writes: "For him, Nietzsche's cry expressed an almost physical reality: God is dead, the God of love. . . ." Wiesel's question needs an answer: "'Where is God? Where is He? Where can He be now?' And a voice within me answered: 'Where? Here He is—He has been hanged here, on these gallows.'"

Mauriac's answer is this: "What did I say to him? Did I speak of that other Jew, his brother, who may have resembled him—the Crucified. . . . Did I affirm that the stumbling block to his faith was the cornerstone of mine?"

The answer is not easy or immediate. As Brown says, "We must not make that journey too quickly." As Mauriac reminds us, "If the Eternal is the Eternal, the last word for each one of us belongs to Him."

The problem of evil is the strongest argument against God. No one has stated this argument more passionately and persuasively than Ivan Karamazov, in Dostoevsky's incomparably great novel, when he describes in detail recorded accounts of deliberate delight in the torture of innocent children. The Holocaust is that argument magnified six million times, the most monstrous evil in history—so far.

"Never again"—that was what we said after World War I. We are moving today; we are not standing still. We are moving toward a double totalitarianism, what Alexis de Tocqueville called a "hard totalitarianism" on the Right and a "soft totalitarianism" on the Left (a "Brave New World"), more and more eviscerating the moderate middle, which is both liberal in the classic sense and conservative in the classic sense. This is happening even inside the Church.

The horrors of the Right are hard and clear, and have little chance of winning. (Am I being naïve here?) Those on the Left are soft and more attractive. Every refugee from Eastern European

communism who has lived in Western Europe or North America says the same thing: "The things I am seeing in this country today remind me of when communism came to my homeland." The signs along the road we are taking are not very clear to us. They are to them. If what happened almost a century ago was not sufficient to puncture our dream, what will? A nuclear holocaust? Six billion corpses instead of six million?

Two of the most famous *and* most ignored bits of wisdom in our time are these: "The only thing necessary for the triumph of evil is that the good do nothing" and "Those who do not learn from the past are condemned to repeat it."

The problem of staging the Holocaust in a theater is trivial compared to the problem of un-staging it in the theater of the real world. For "all the world's a stage, and all the men and women merely players."

There have been many very good movies about the Holocaust, but no great plays. *Judgment at Nuremberg* is a great play, and a great movie, but it is not about the Holocaust itself, and the issue of God does not appear in it. But it raises the most practical question of all: How could this have happened? How could a cultured, sophisticated, advanced, civilized people have fallen into allowing this hell on earth?

Unless we answer that question, we are not safe from it happening again, just as unless we know the cause of a disease, and deal with it, we cannot be sure we are safe from it.

Especially in a post-Christian world. If Christianity is true, it is not just one among many options, or even one among many religions. For Christ said, "Apart from me you can do nothing" (John 15:5). Christ is either everything or nothing. If he is not the universal Savior, he is not a particular Savior either.

# Concluding Unscientific Postscript

The single most important idea in this book is about a play that is not among these fifteen. It is the play that is your life.

The whole meaning and value of that play is that the same God who is the eternal, transcendent Author of absolutely every detail in that play, and whose unlimited power, unlimited wisdom, and unlimited love logically and necessarily entail the conclusion of the astonishing good news of Romans 8:28—that all things, even the most horrible and apparently unintelligible, work together for good for all who love and trust this Author; that he will bring some greater good out of every single evil that he allows to enter this play, your life—that that same transcendent, eternal, and perfect God who is the Author of every syllable of the play in your life, namely your life itself, is also the one who is so intimately *present* in every one of the events of that play that he knows, feels, loves, experiences, and fully understands absolutely every hair that falls from your head and every impossibly horrible event that he allows to enter that play, because he is in you, living it.

He is experiencing all the evils, all the sorrows and horrors, that you are experiencing. "I am with you always, to the end of the age [i.e., the end of time, the end of your play]" (Matt. 28:20). No matter how alone and helpless you feel, you are never

alone, and you have the strongest helper that there is or ever can be. He is the first actor, the "proto-agonist," of your play, not you.

Take your hand off the tiller of the ship that is your life and put it into his hands. He will, in many different ways, hand the tiller back to you, but then it will be his hand, not yours, that hands that tiller to you, so that the very fallible steering that you do on this ship is in his name and with his authority. ("All authority in heaven and on earth has been given to me," he said! ) All your trials, errors, failures, and sorrows are part of his because you are a member—that is, an organ—in his Body. In his great plot and plan, even the sins he allows you to commit through your free will are used by him for a greater good if only they pass under the golden door of repentance.

And you don't have to feel this. It's true, actively true, even when you feel the most total opposite of it. Faith's object is fact, not feeling. Feeling comes along for the ride—or doesn't. But the ride happens anyway. You can know that, by faith, even when you don't feel it.

You are indeed in a very great play. And God is very, very much on stage there.